CW00552766

NICK WAPLINGTON

THE ISAAC MIZRAHI PICTURES
NEW YORK CITY 1989-93

[DAMIANI]

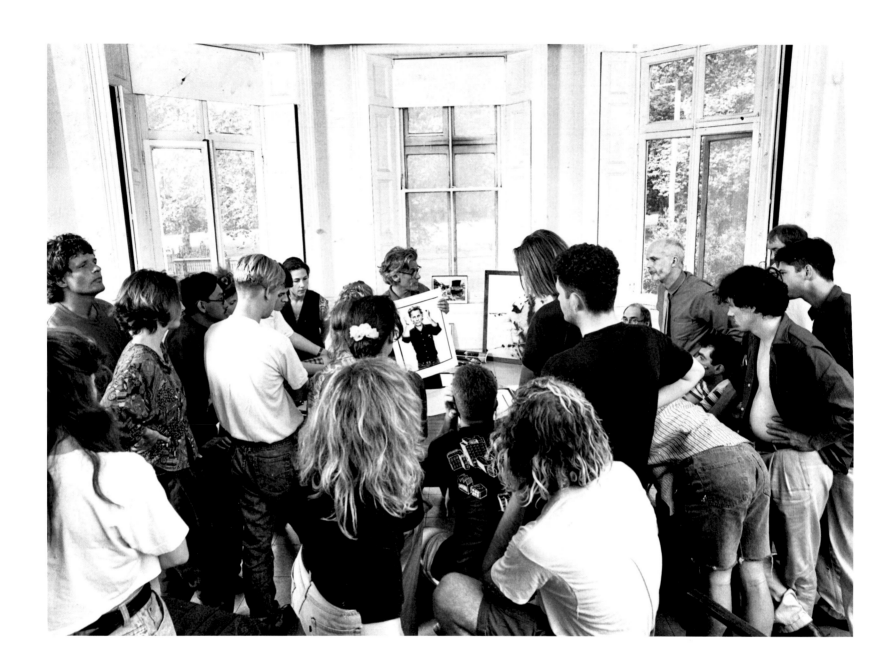

FOREWORD
NICK WAPLINGTON

During the summer of 1989, I regularly visited Richard Avedon in his Upper East Side studio. On each visit we would share work and discuss art, sometimes he would cook me dinner, and occasionally we would take trips to exhibits. That fall, Avedon introduced me to the fashion designer Isaac Mizrahi - he thought that despite our very different backgrounds we would get on and should work together. Luckily he was right, and so for the next three years I spent time photographing the goings-on behind the scenes in the Mizrahi fashion house in downtown in SoHo. Some of the pictures ended up in advertisements designed by Tibor Kalman, who also designed my first book Living Room, the rest have not been seen until now. It was a strange time; by day I would be taking pictures of the glamorous world of fashion in the era of the supermodels, and by night I would go out to the house and techno music clubs I loved, particularly Save the Robots and the Sound Factory, and take pictures there. I have juxtaposed the two sets of images here to produce a work which describes the vibrancy of a vanished moment in New York's cultural history.

407 EAST SEVENTY FIFTH STREET
NEW YORK. N. Y. 10021

Nick Waplington
220 Alfreton Road
Nottingham
N67 3PE
ENGLAND

Dear Nick Waplington,

I just received your address from Professor Hedgecoe, tried
you on the phone, but no answer - it's Tuesday, August 8th,
6 PM your time. I really was impressed, moved by the work
you brought to my class and I would like to consider
acquiring a complete set of them signed by you. Are you
interested and if so, how many would there be and what would
they cost?

And please, whatever comes of this, don't stop working.
You're really on your unique way.

Sincerely,

Richard Avedon

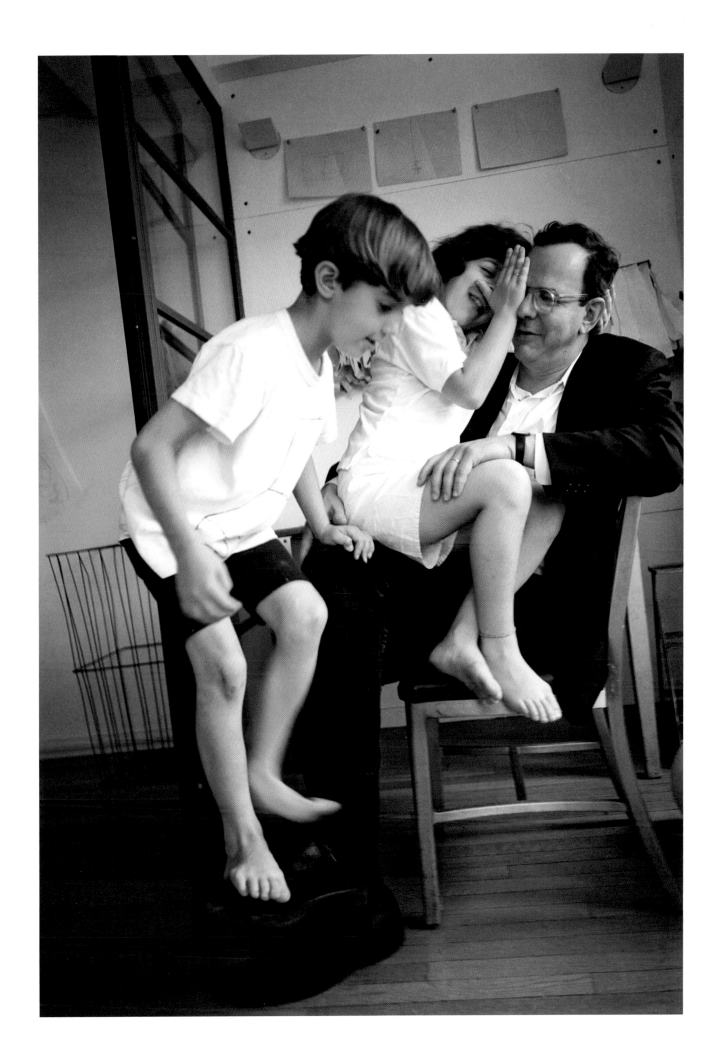

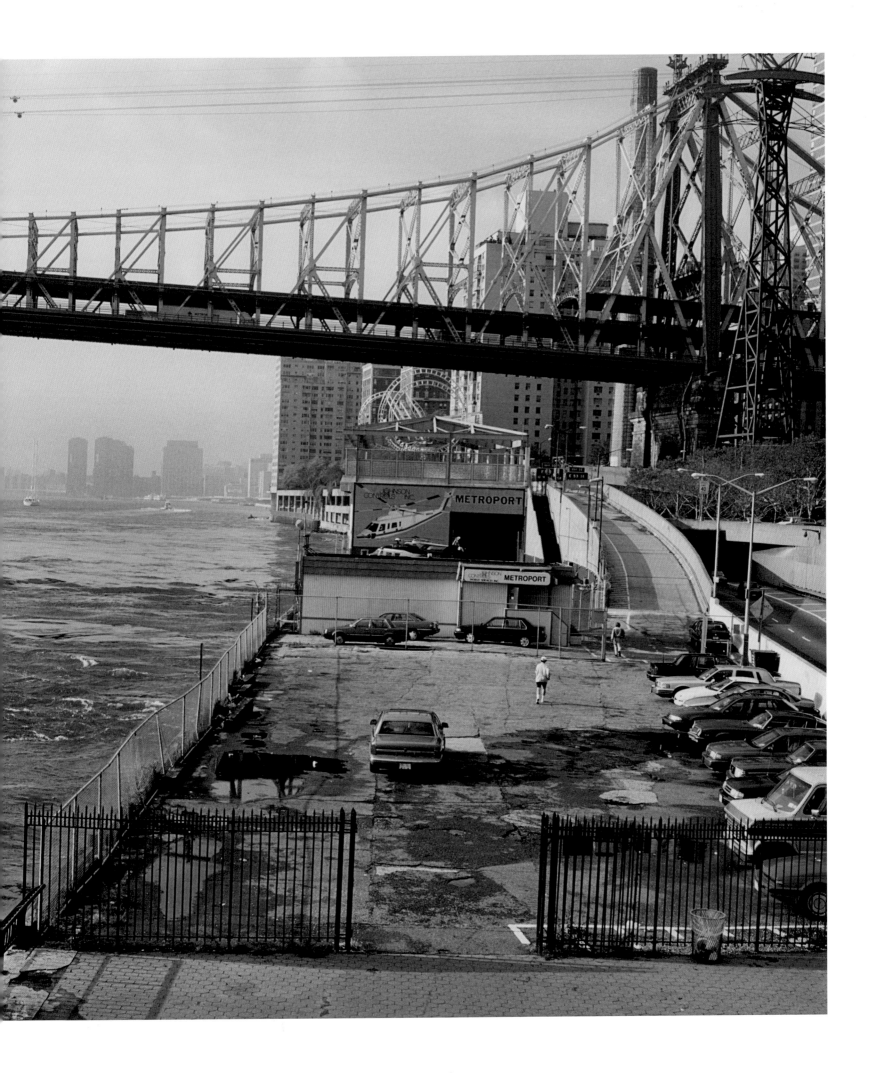

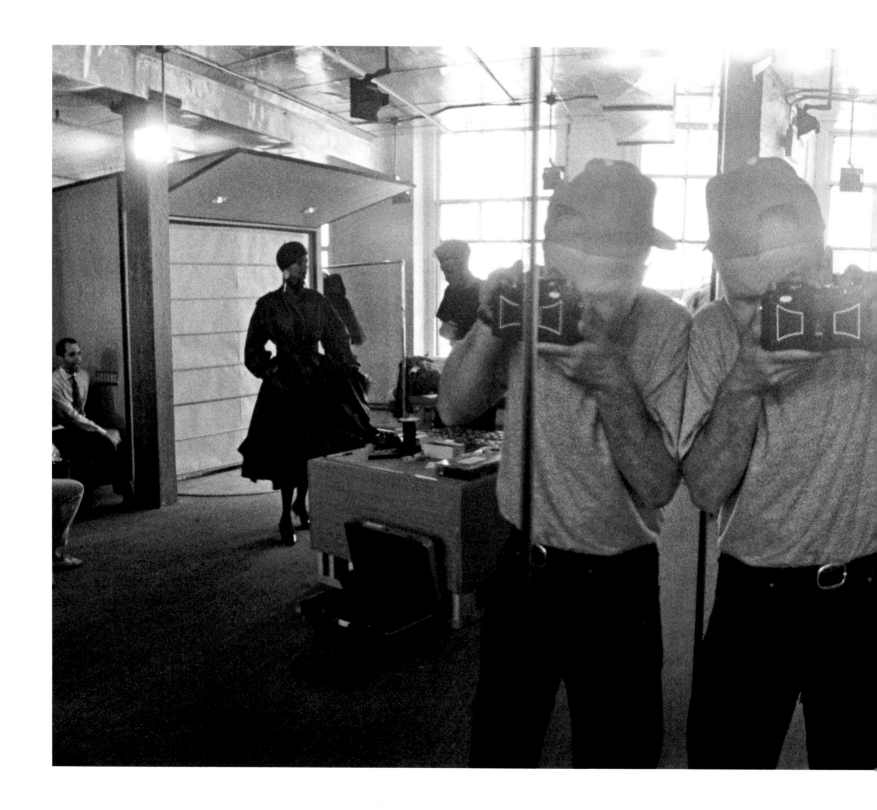

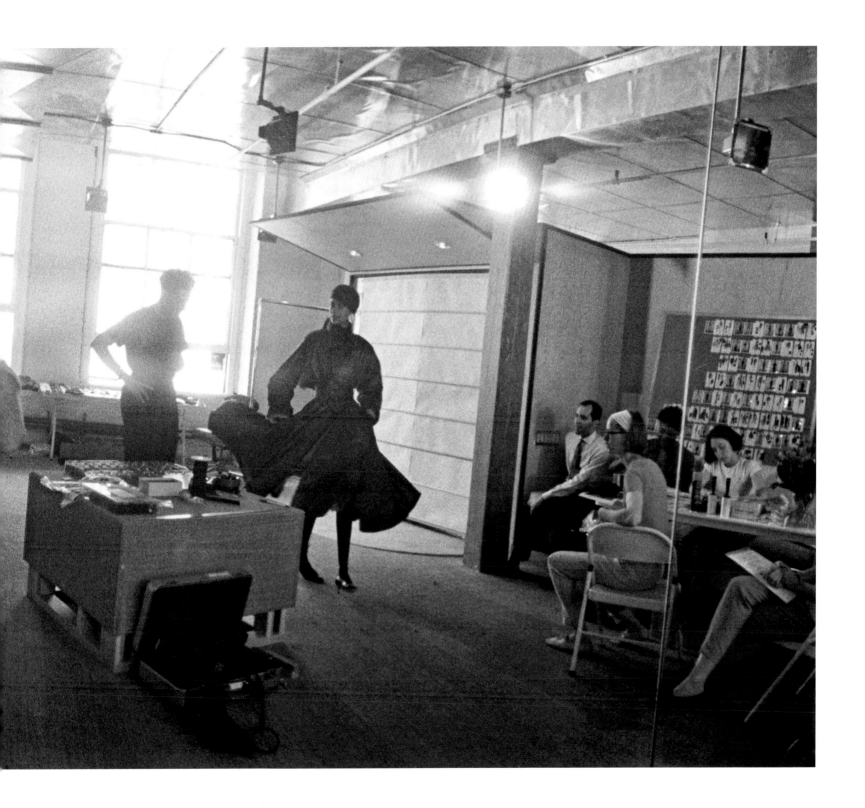

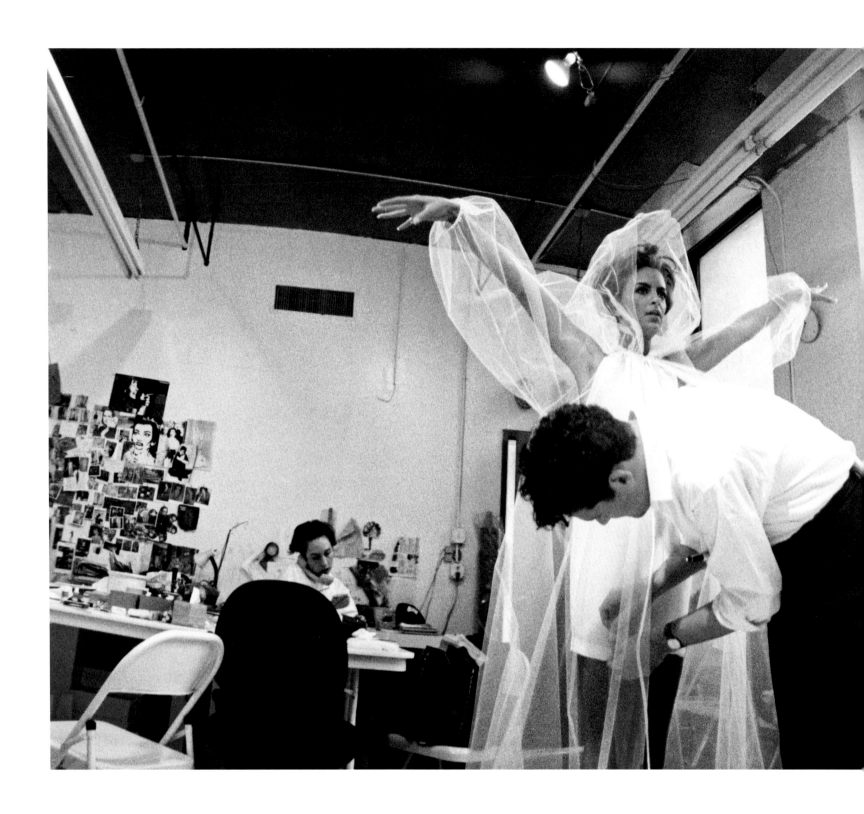

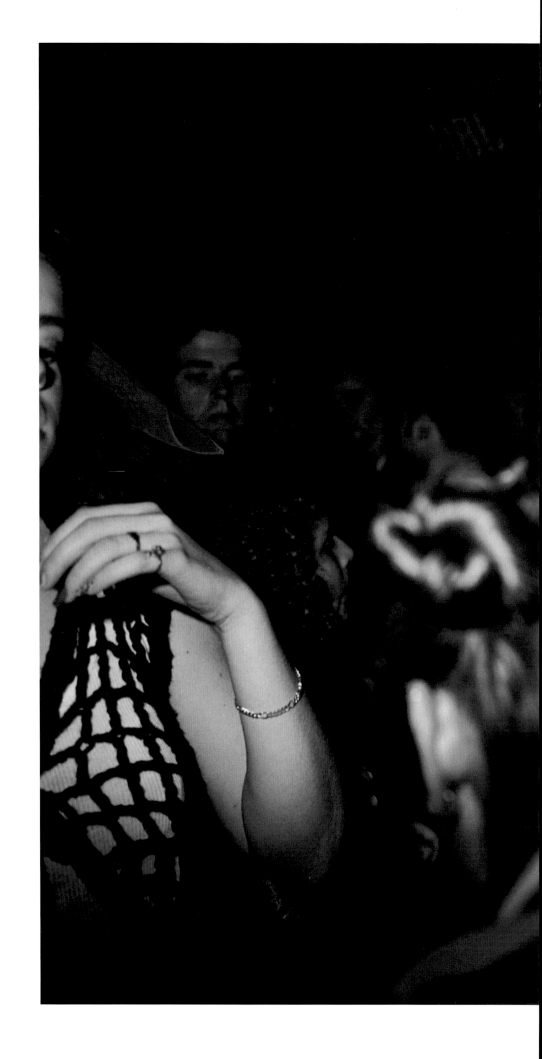

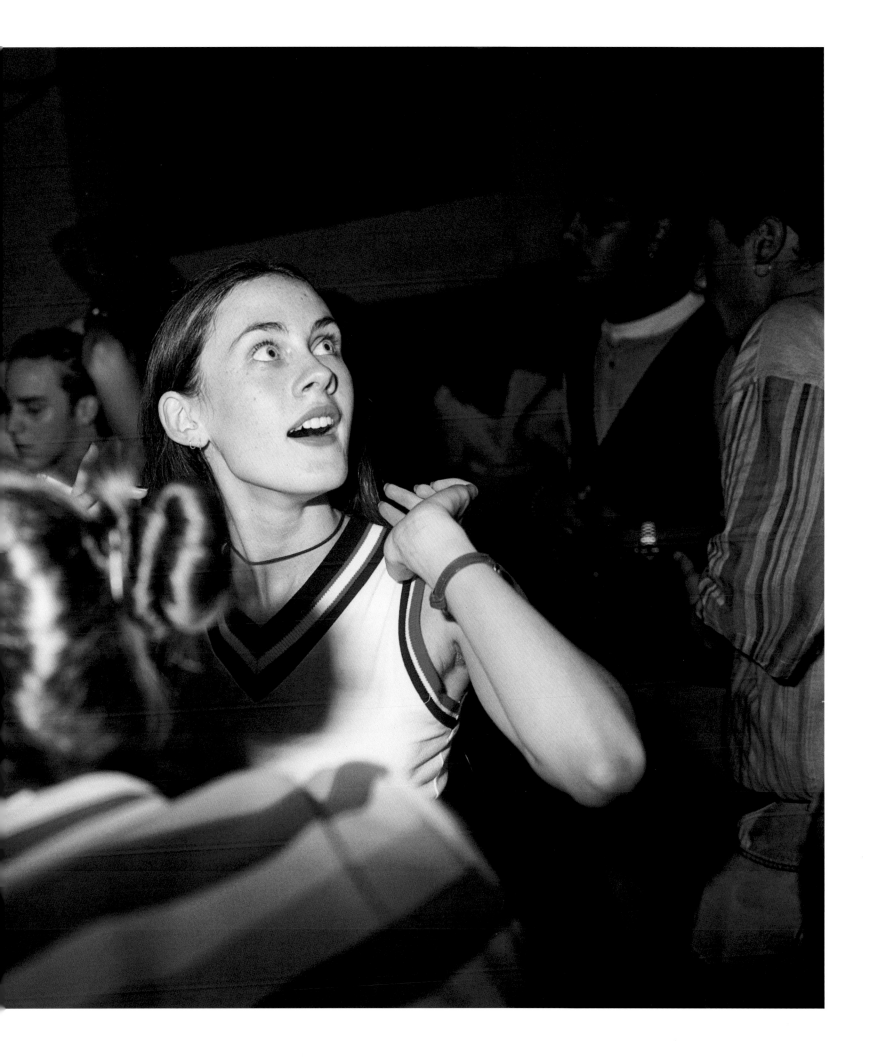

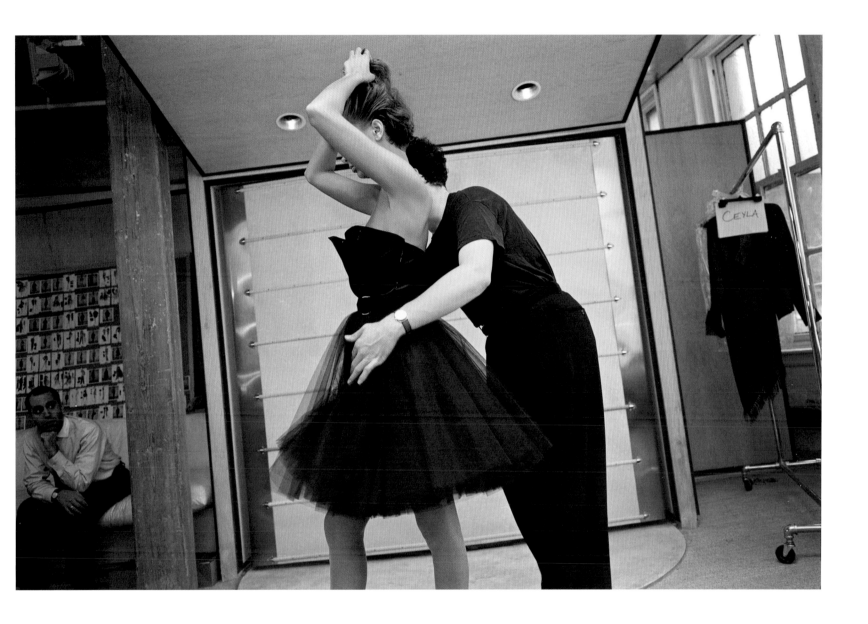

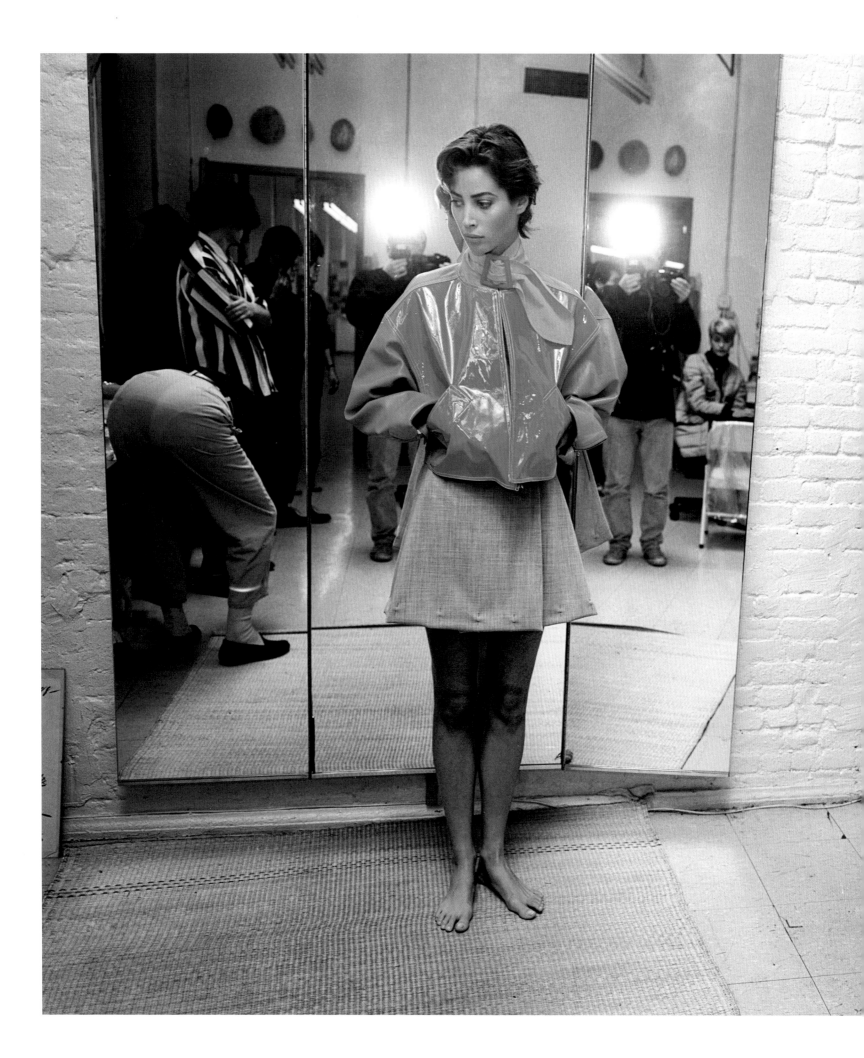

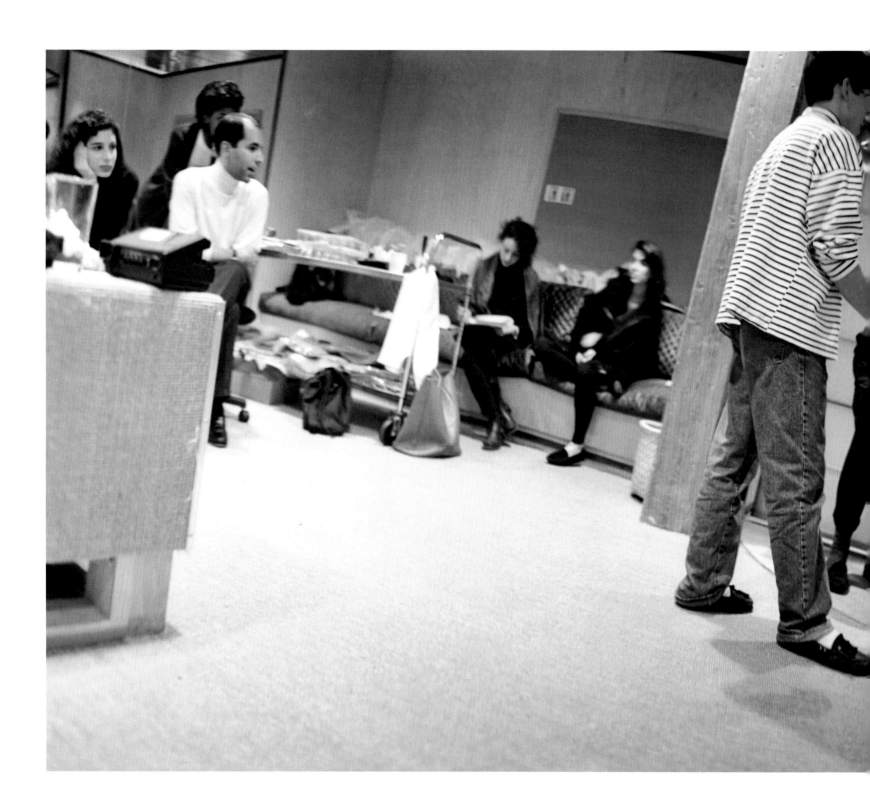

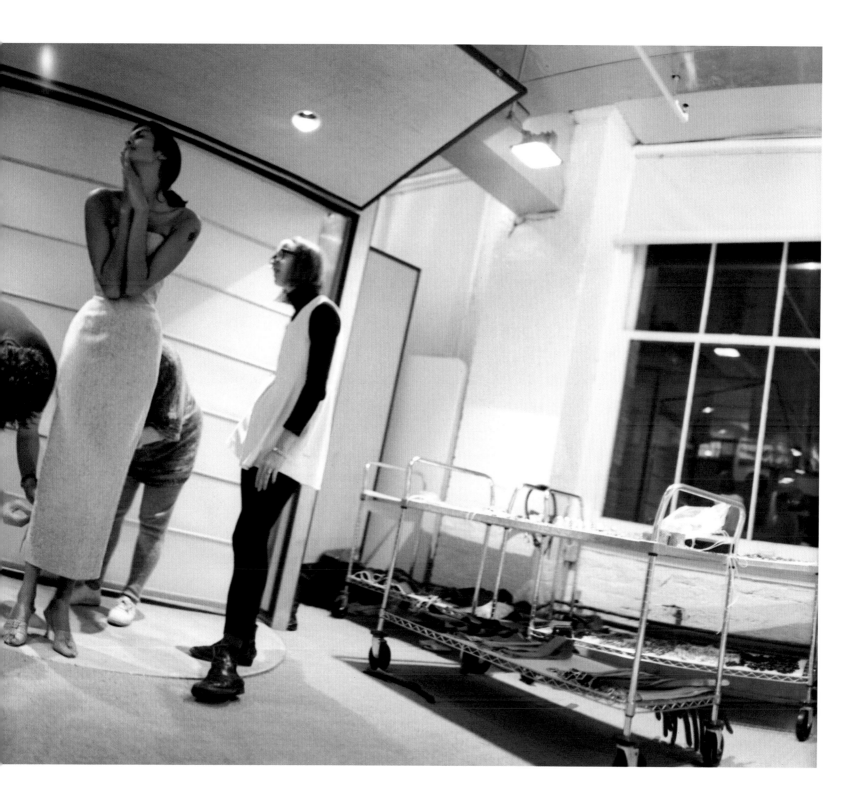

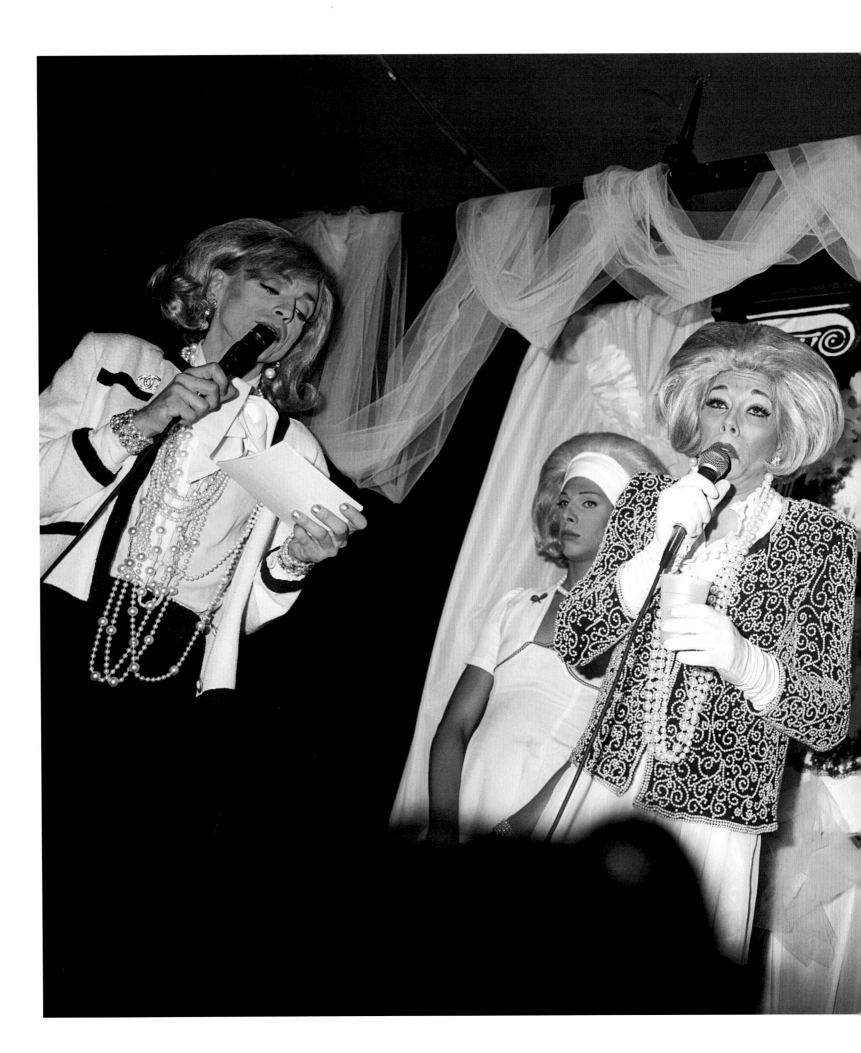

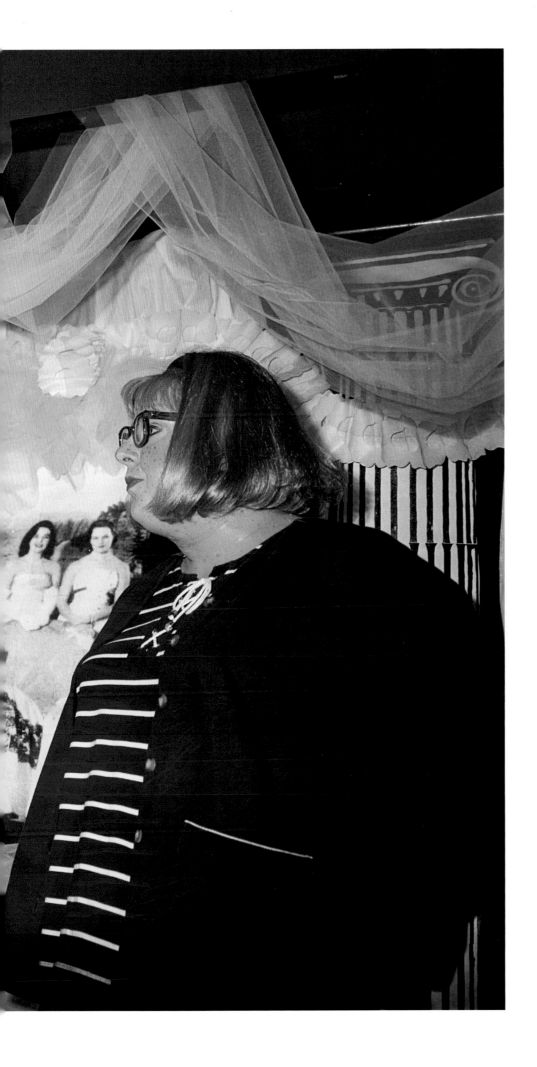

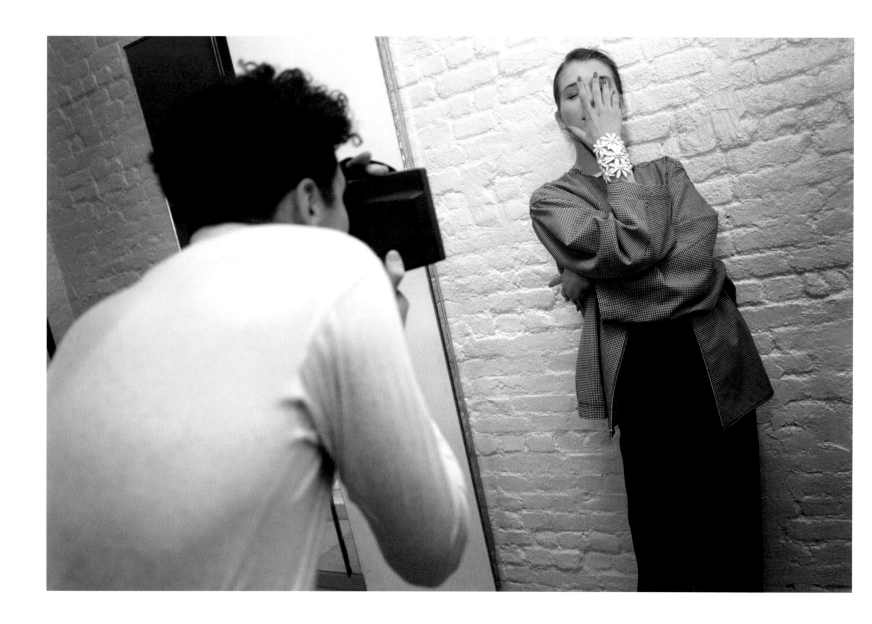

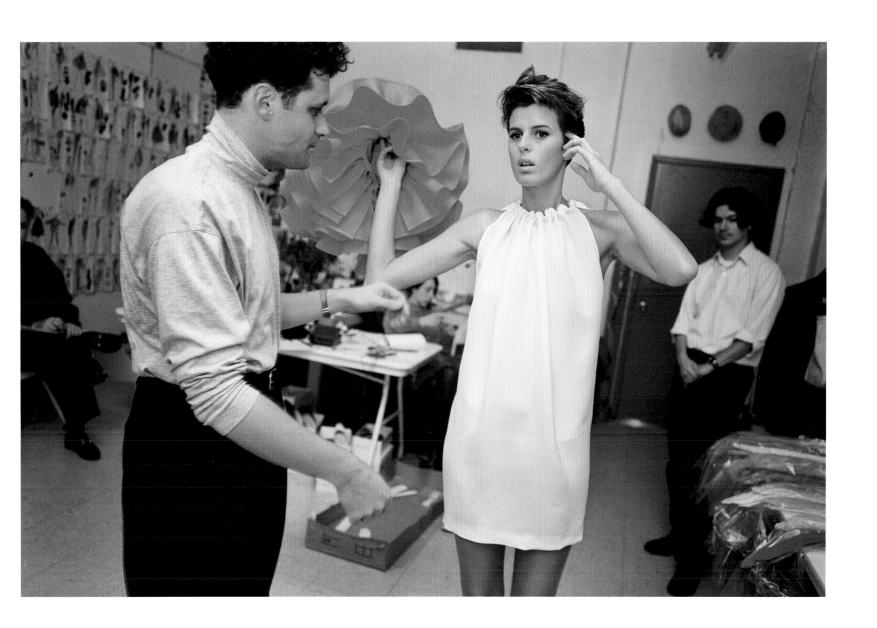

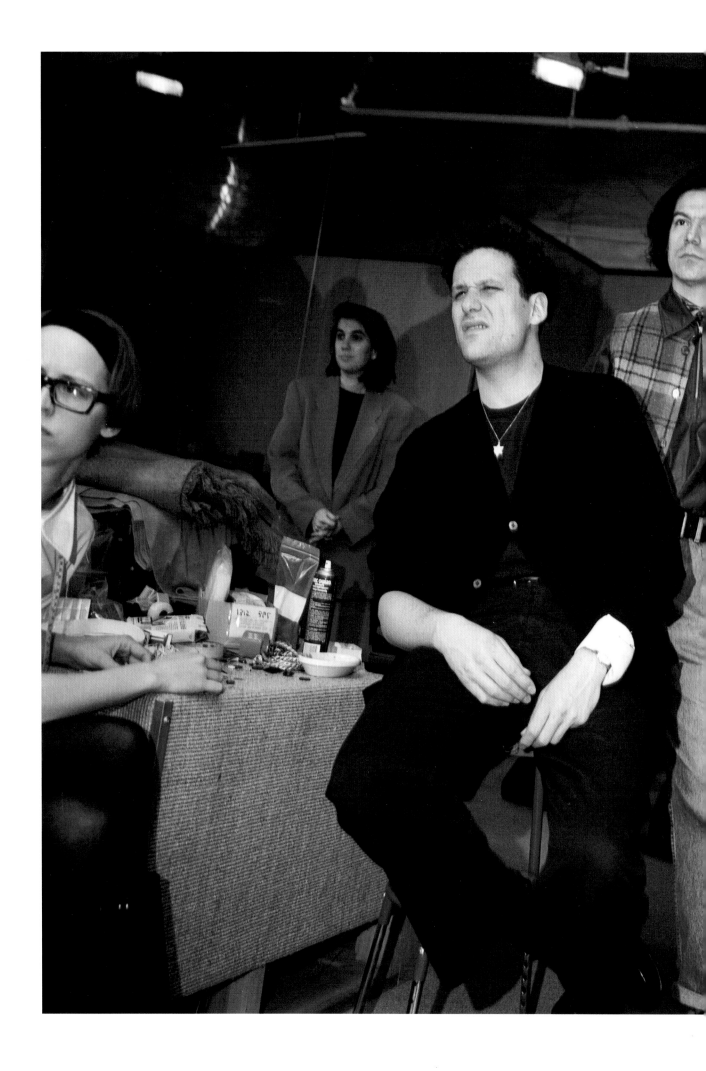

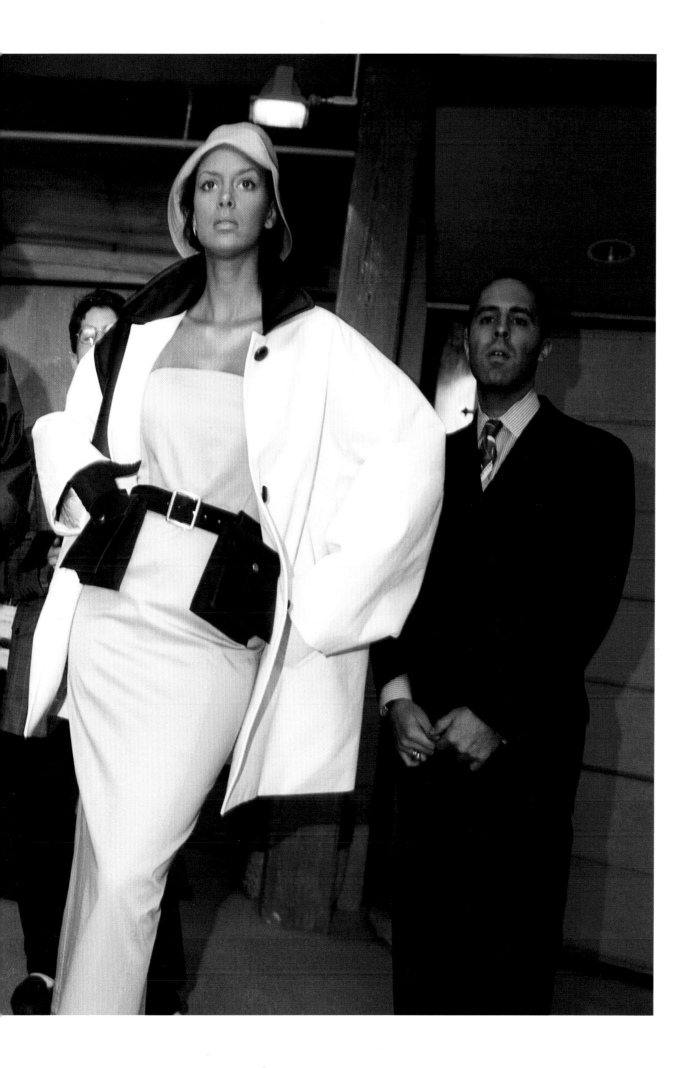

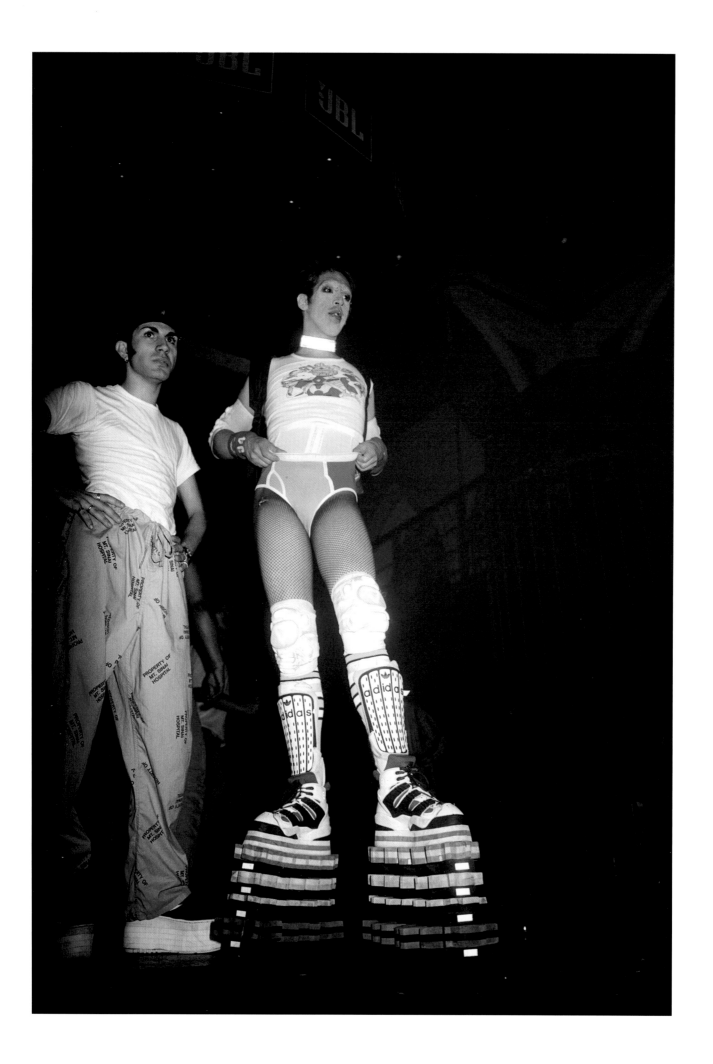

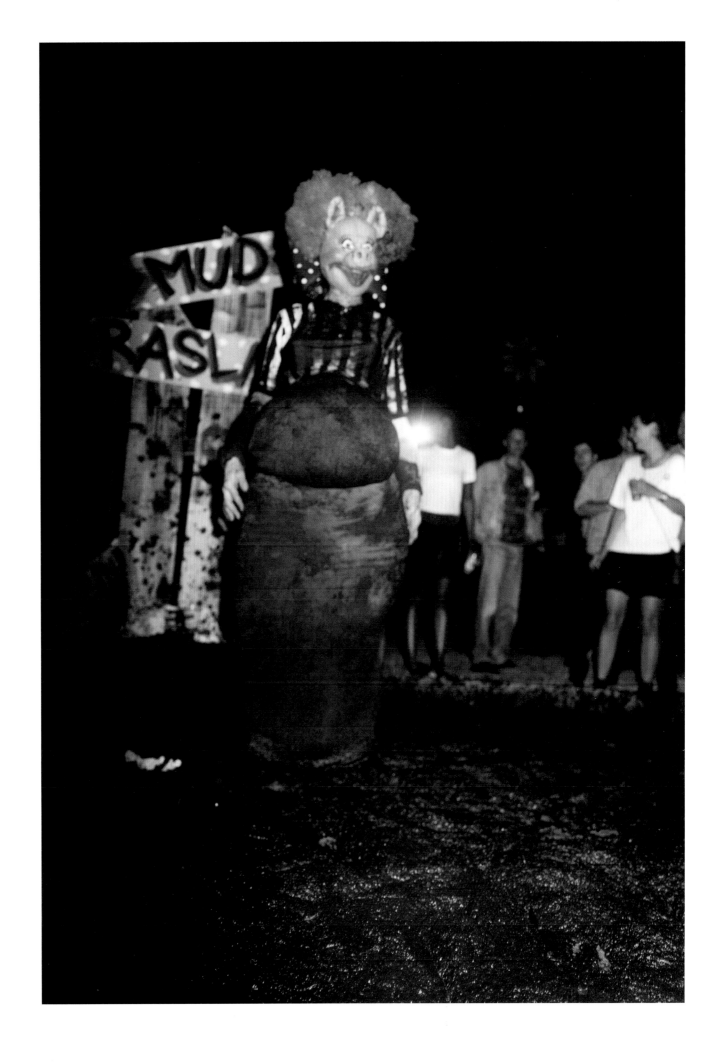

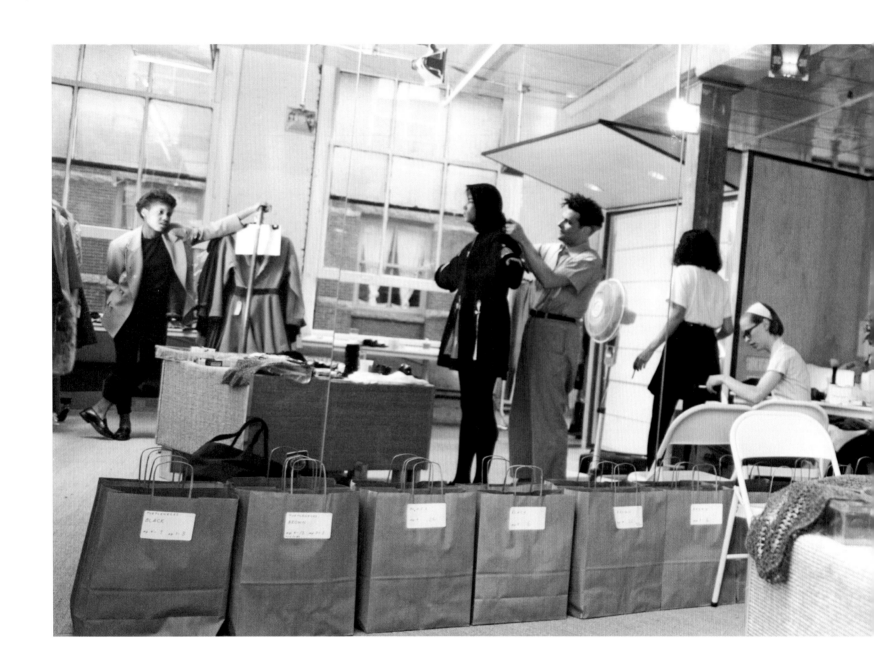

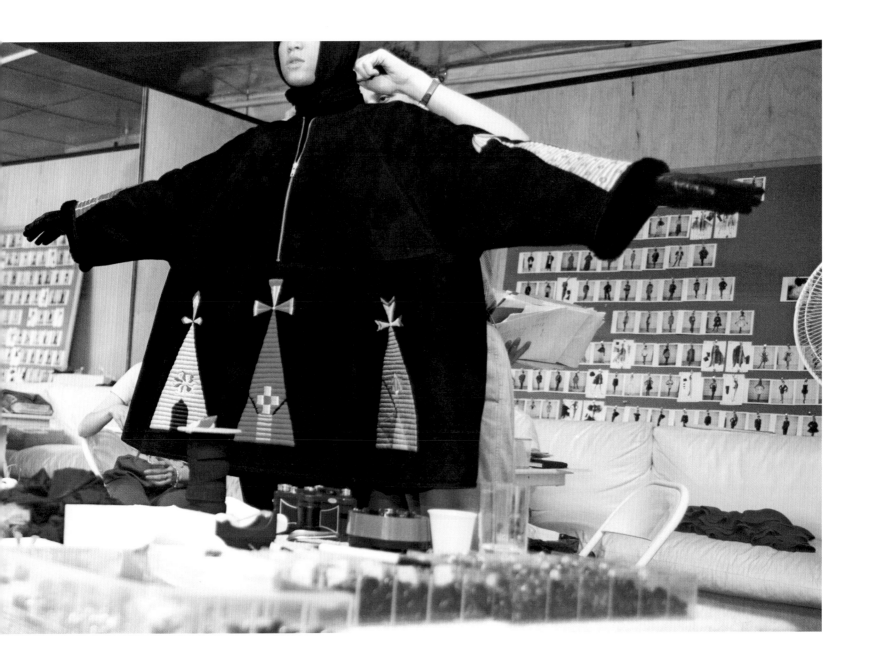

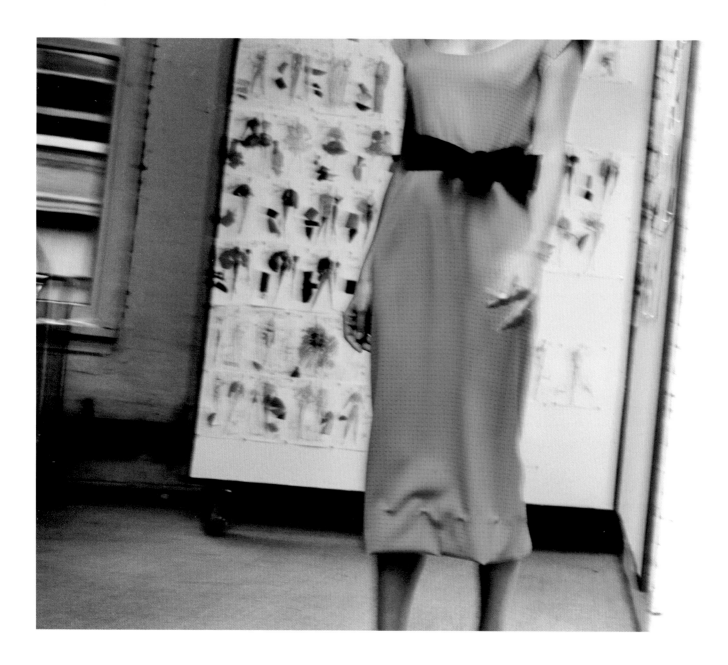

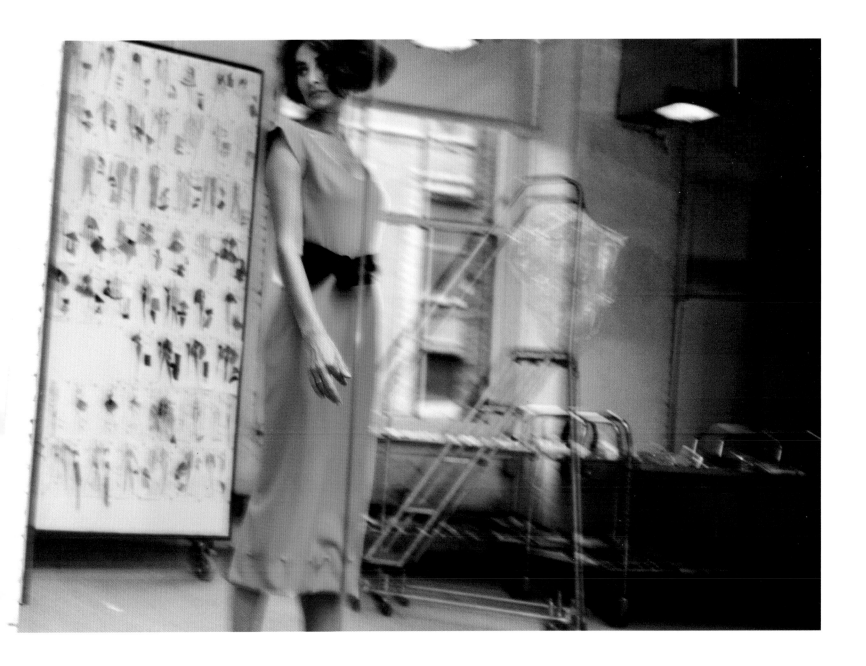

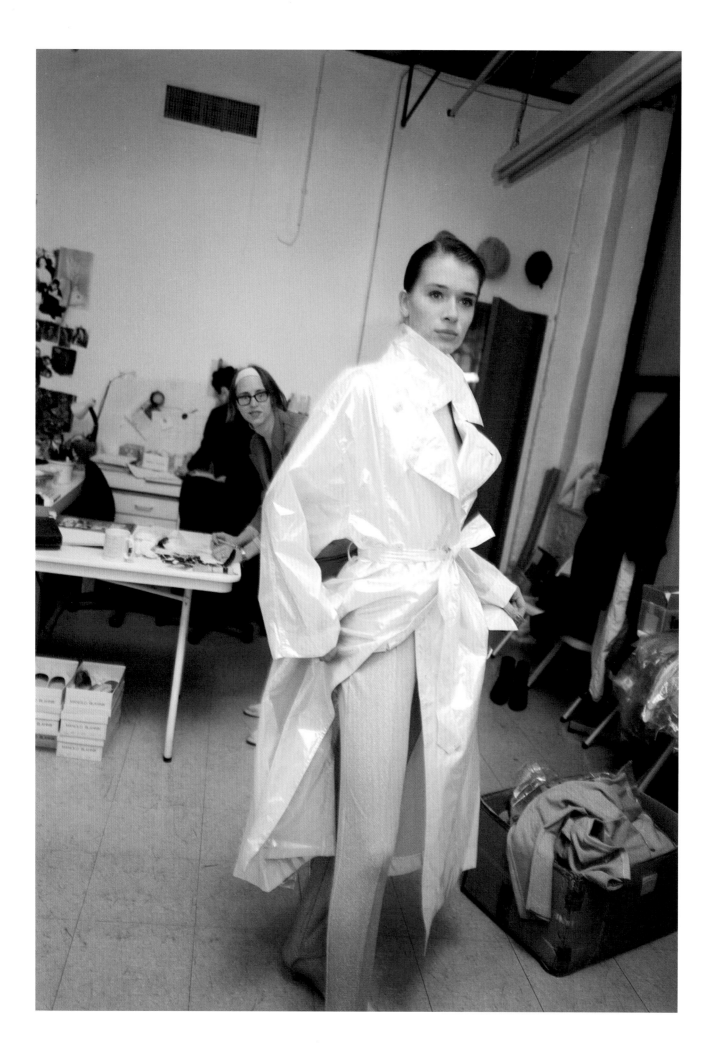

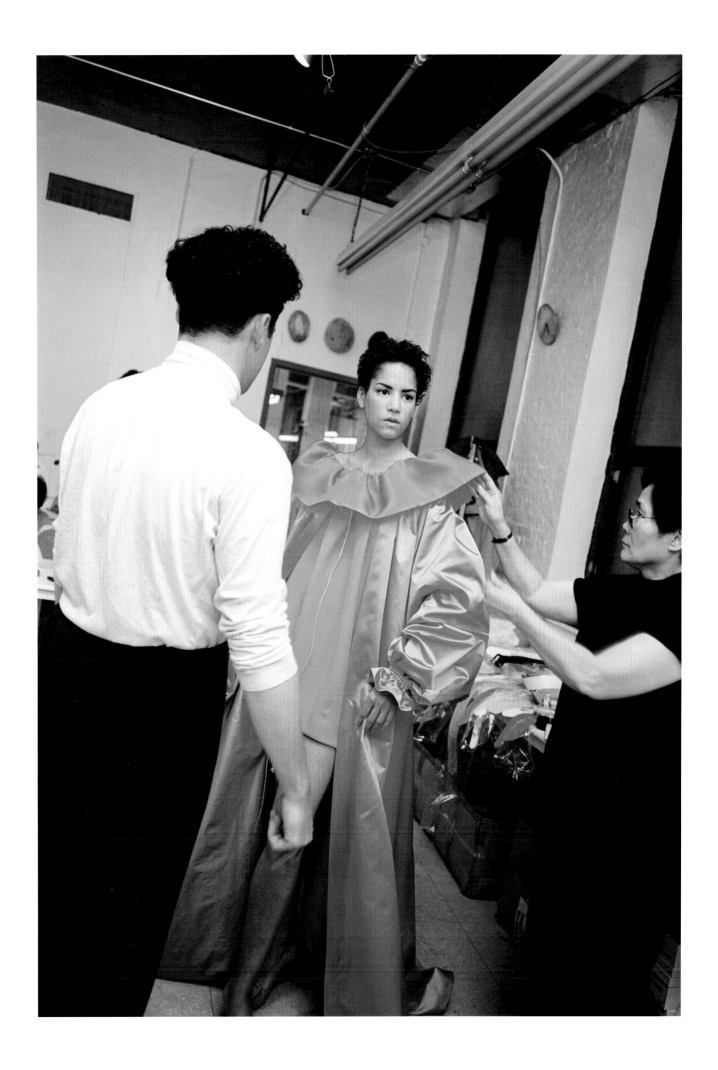

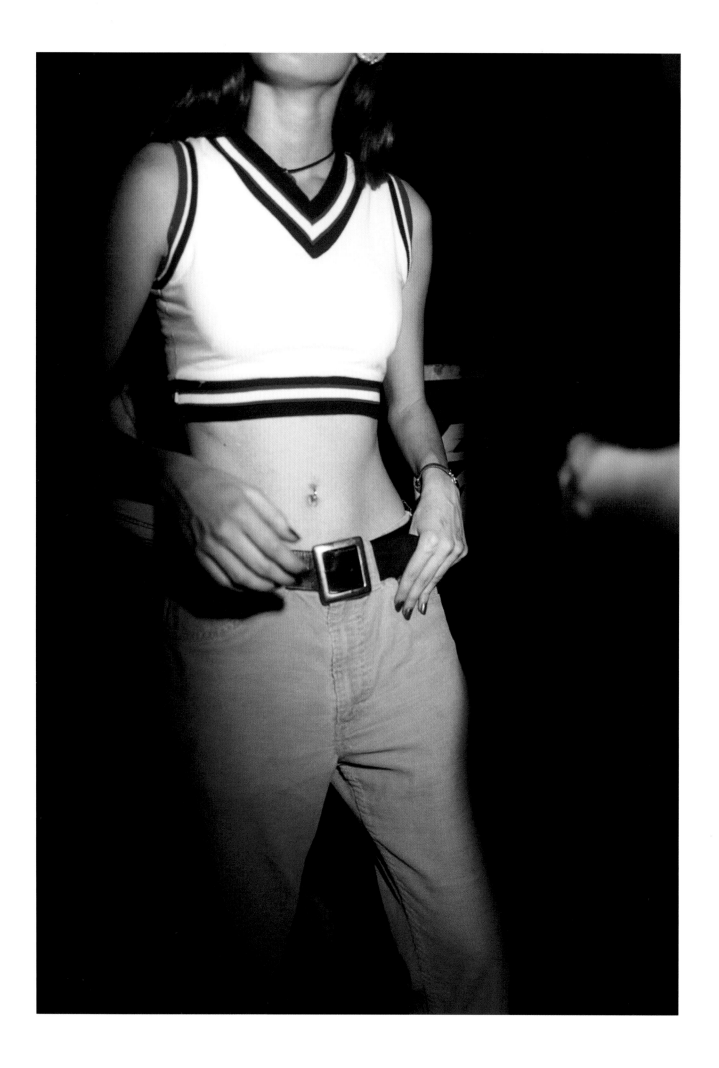

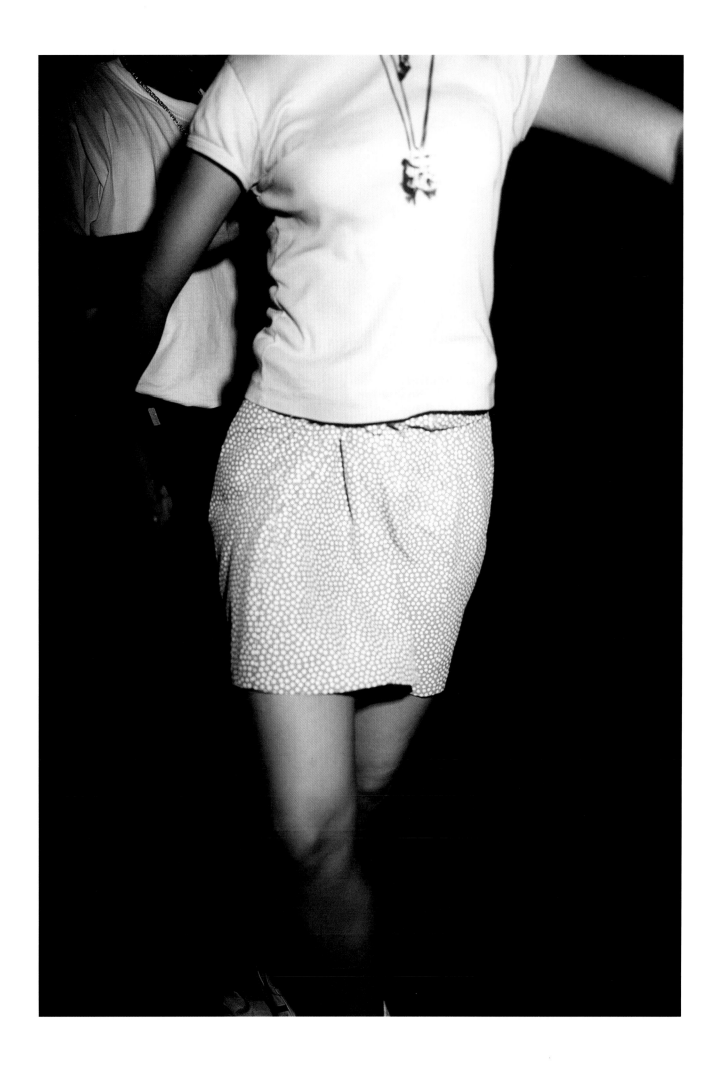

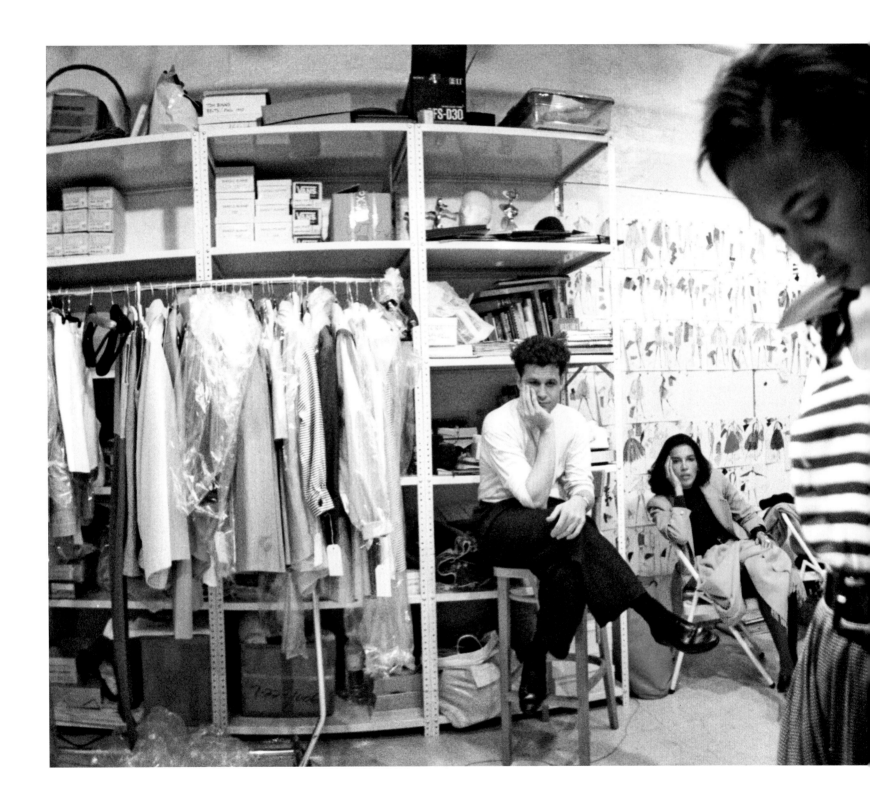

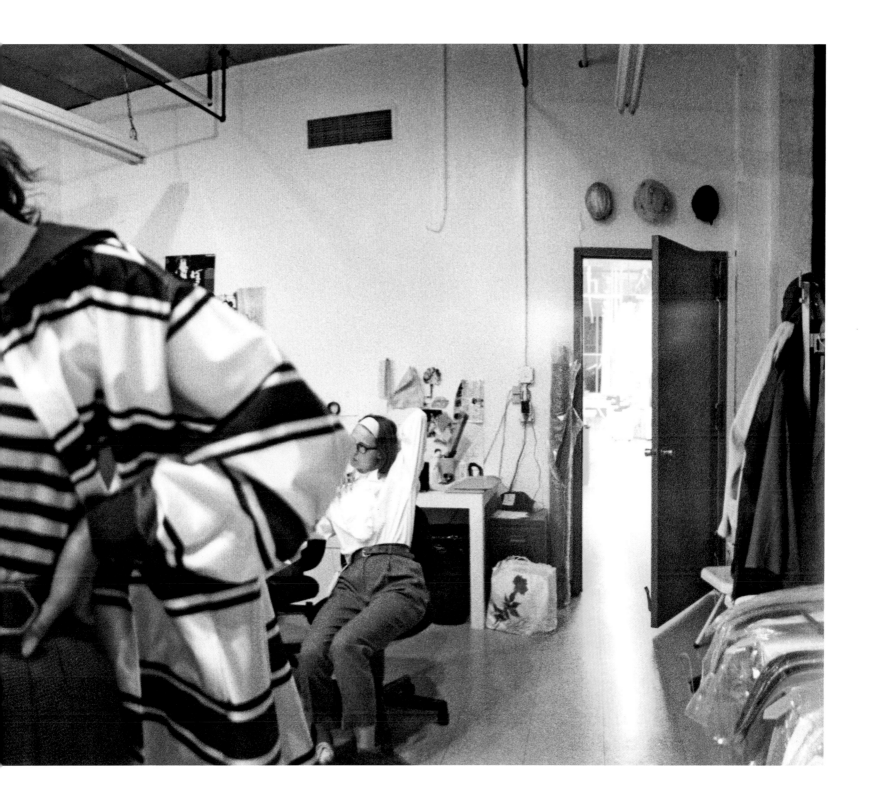

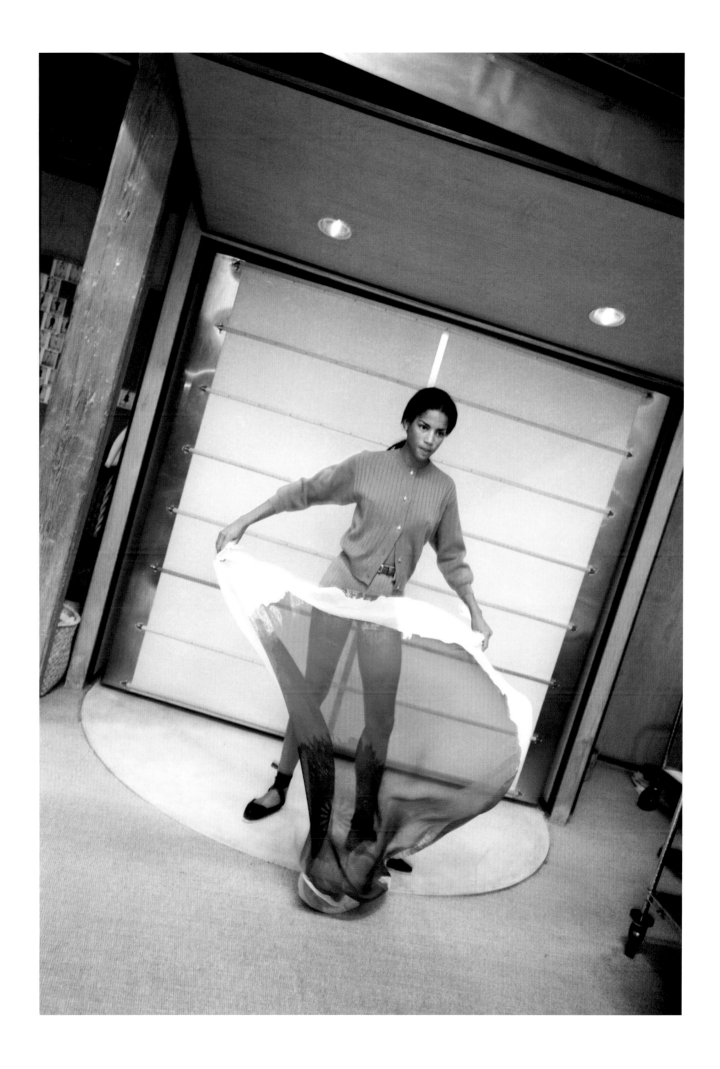

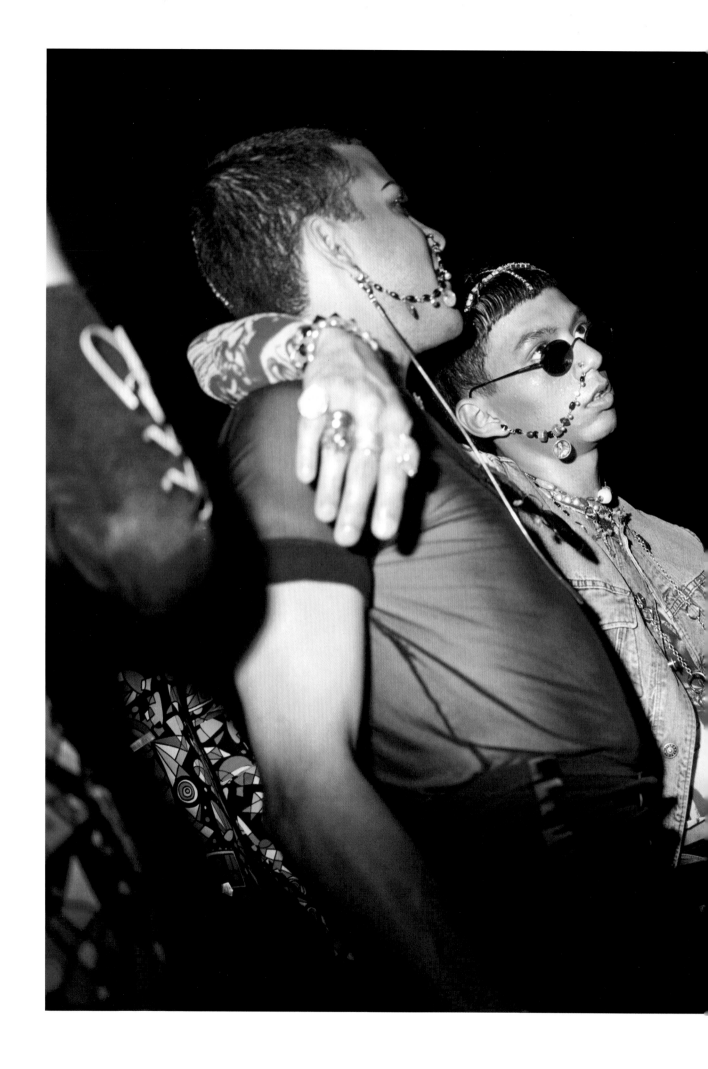

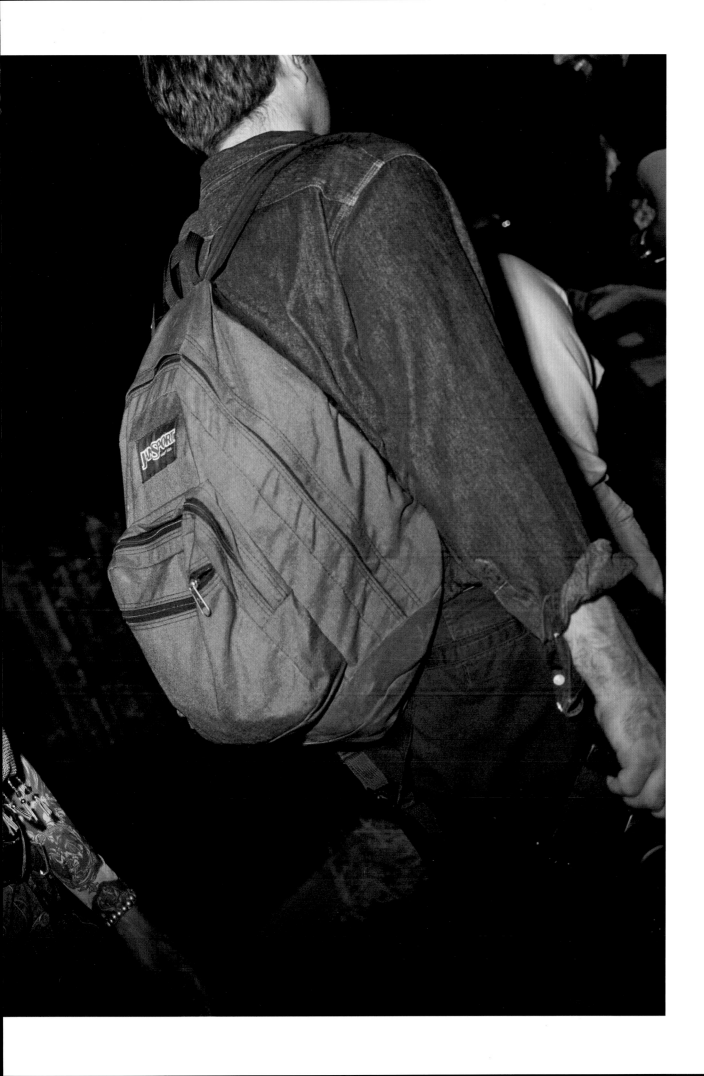

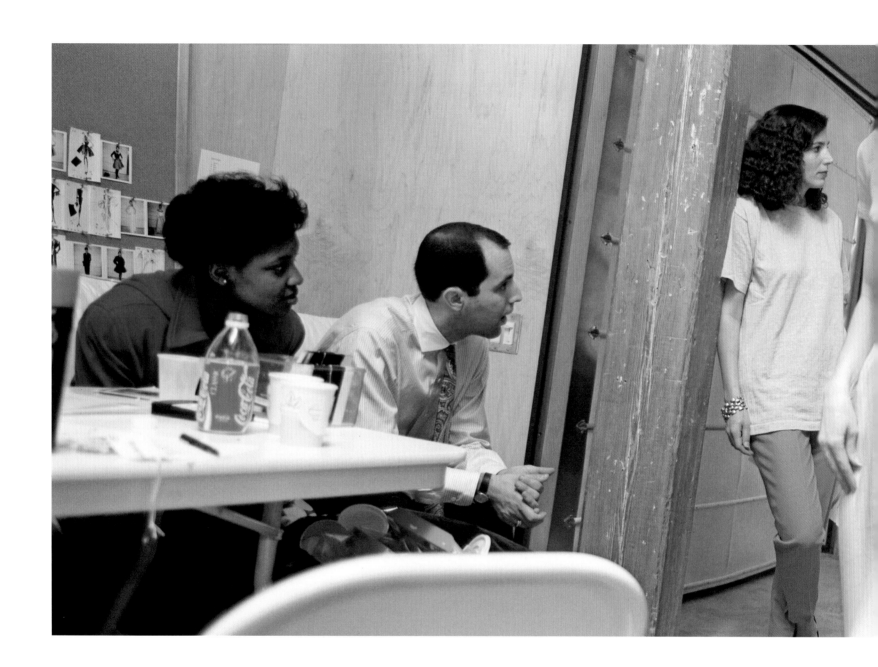

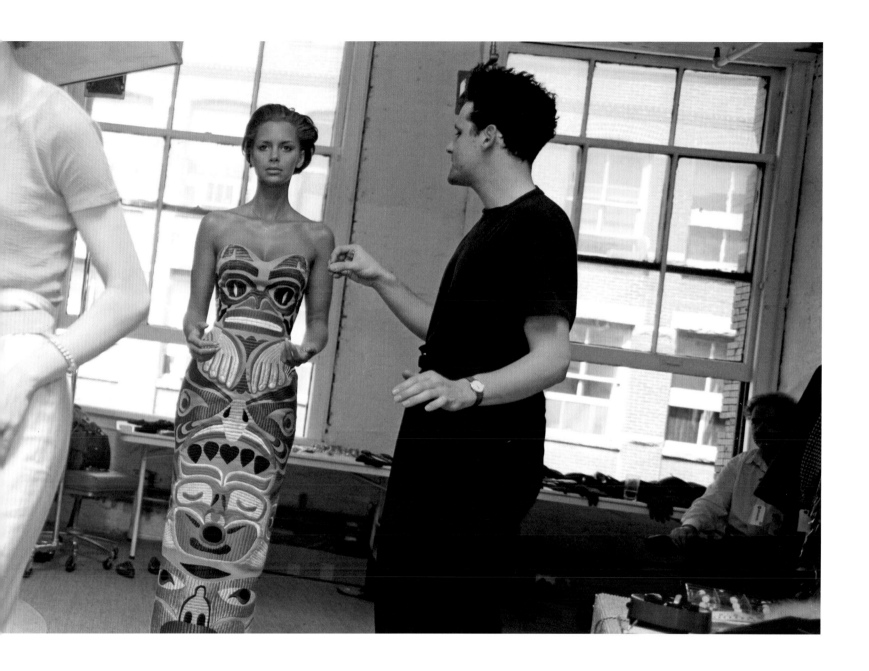

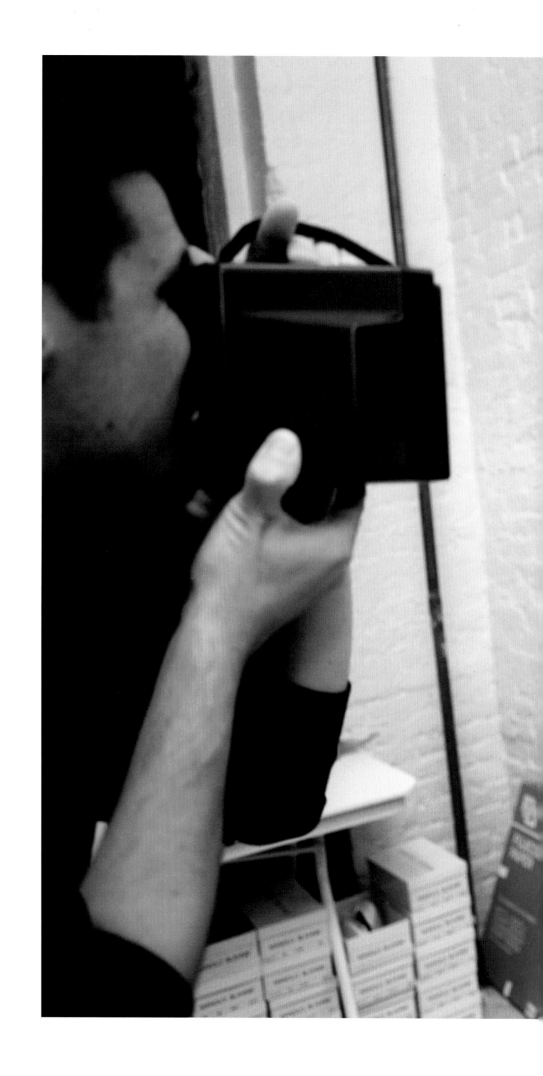

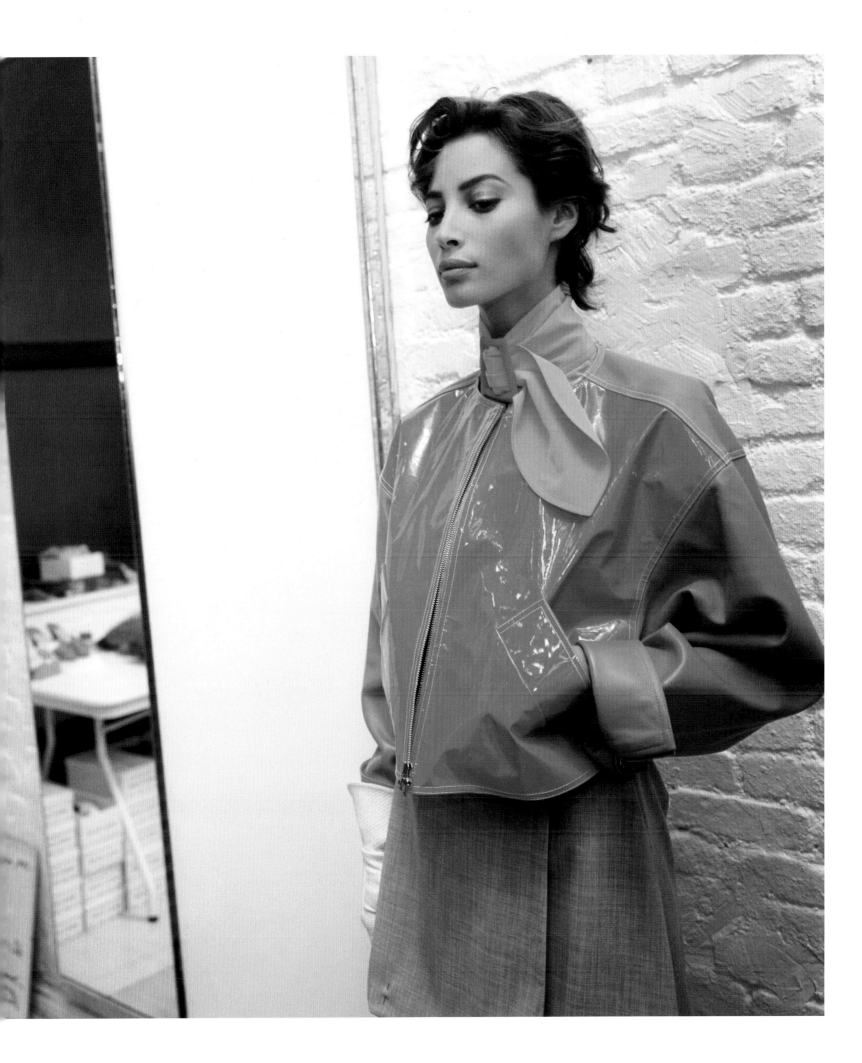

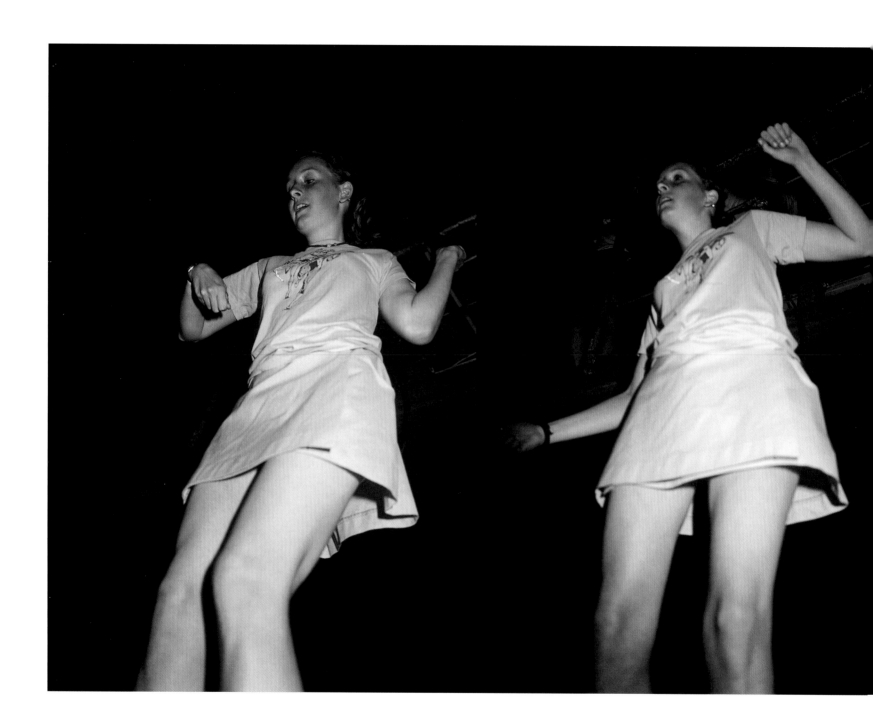

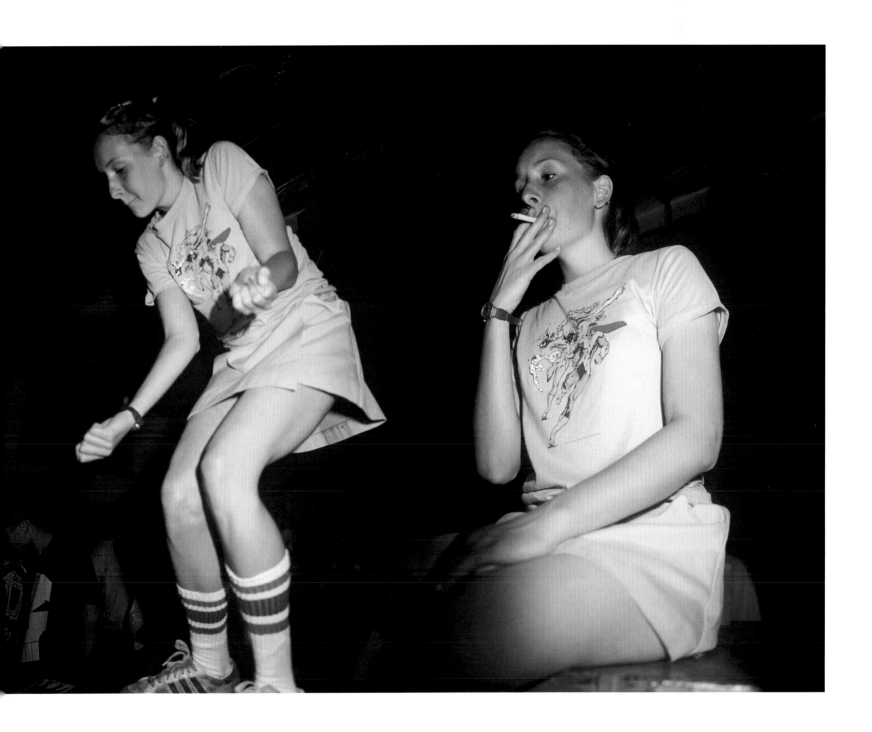

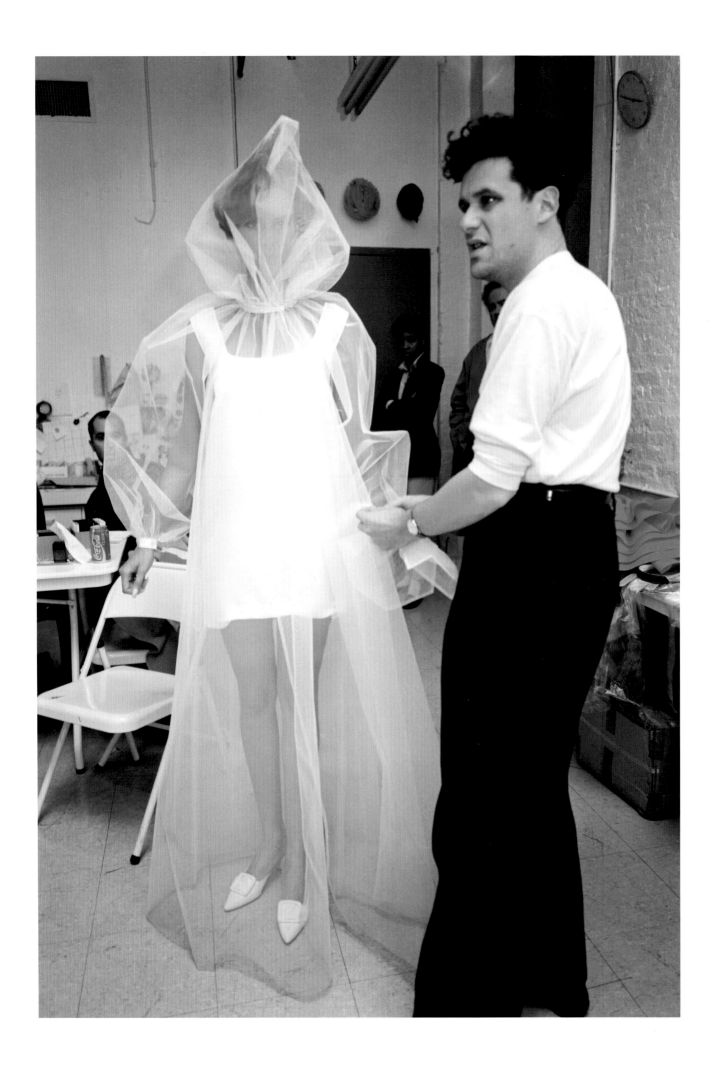

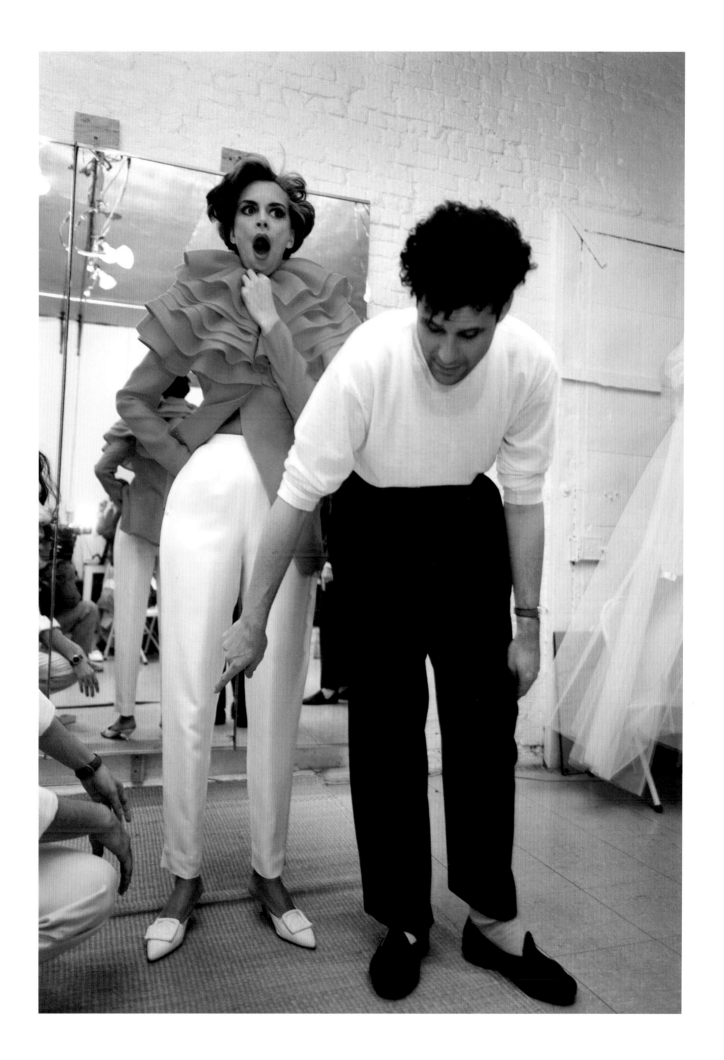

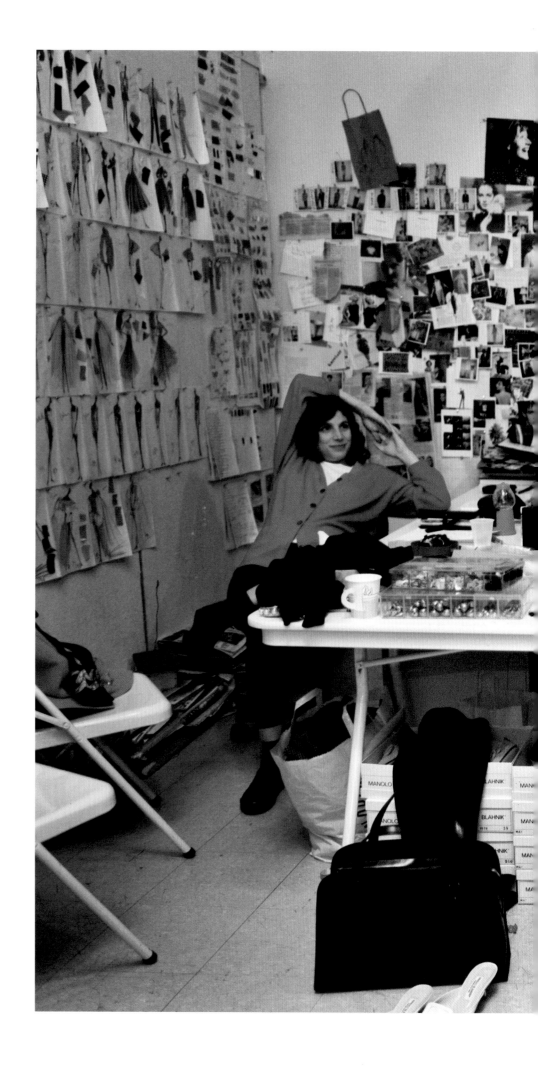

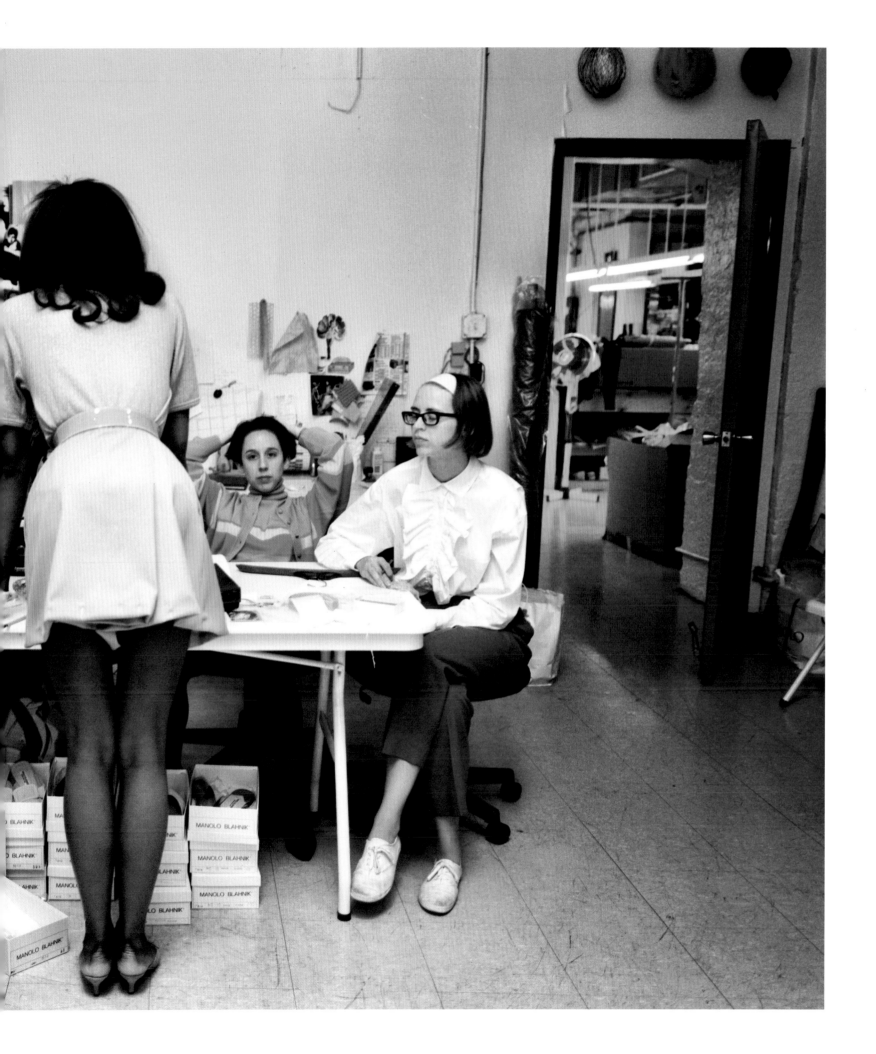

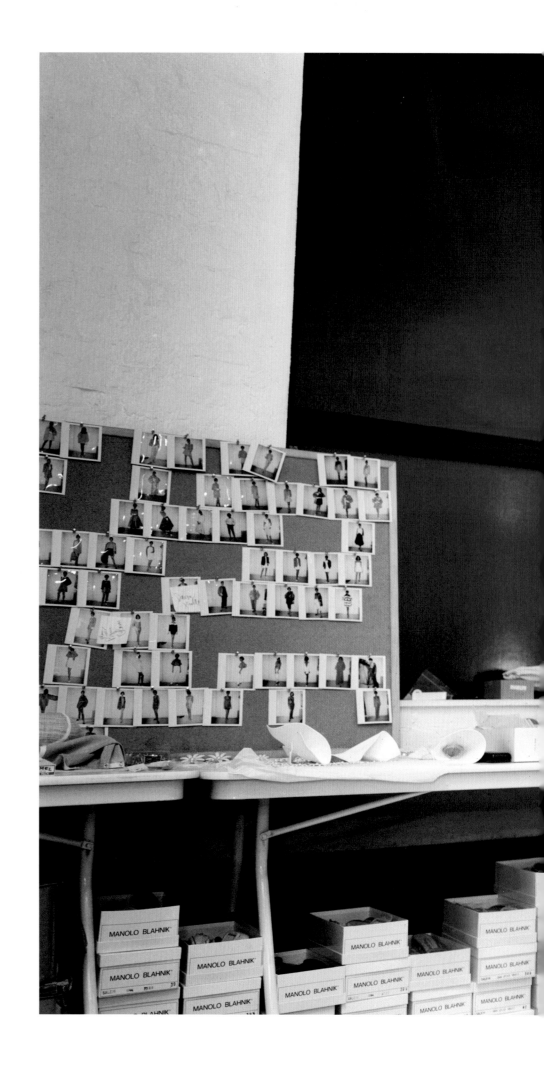

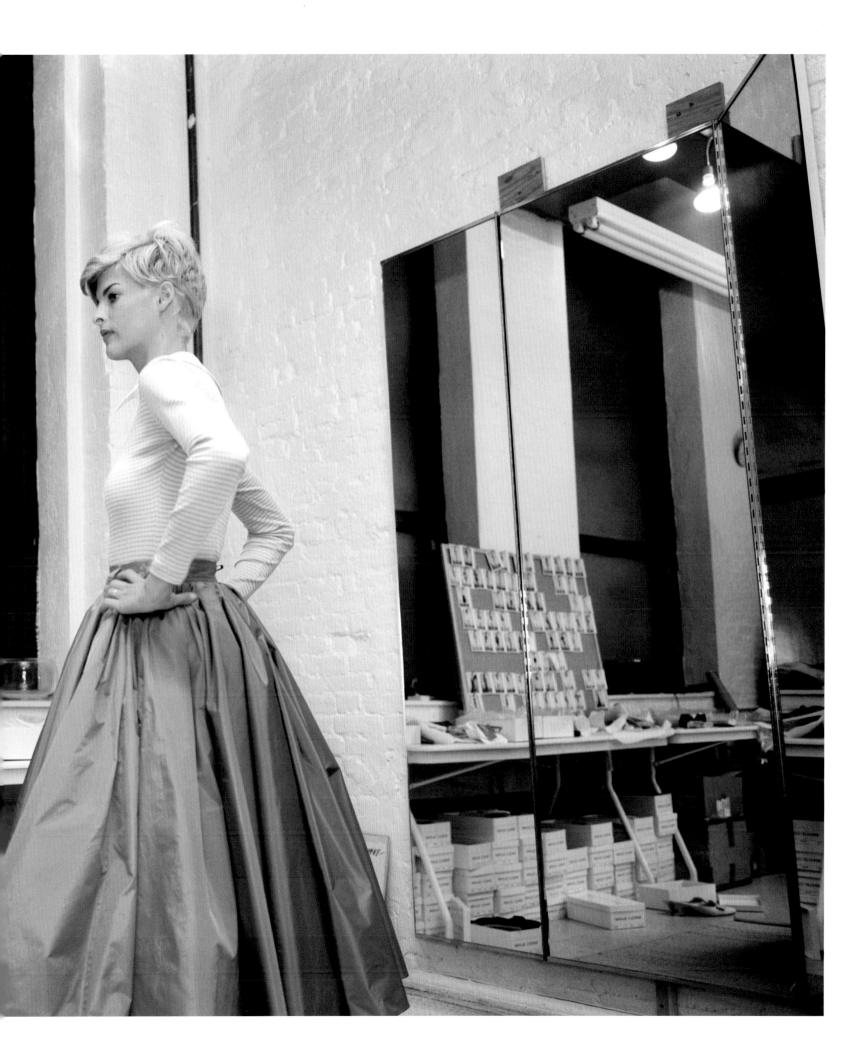

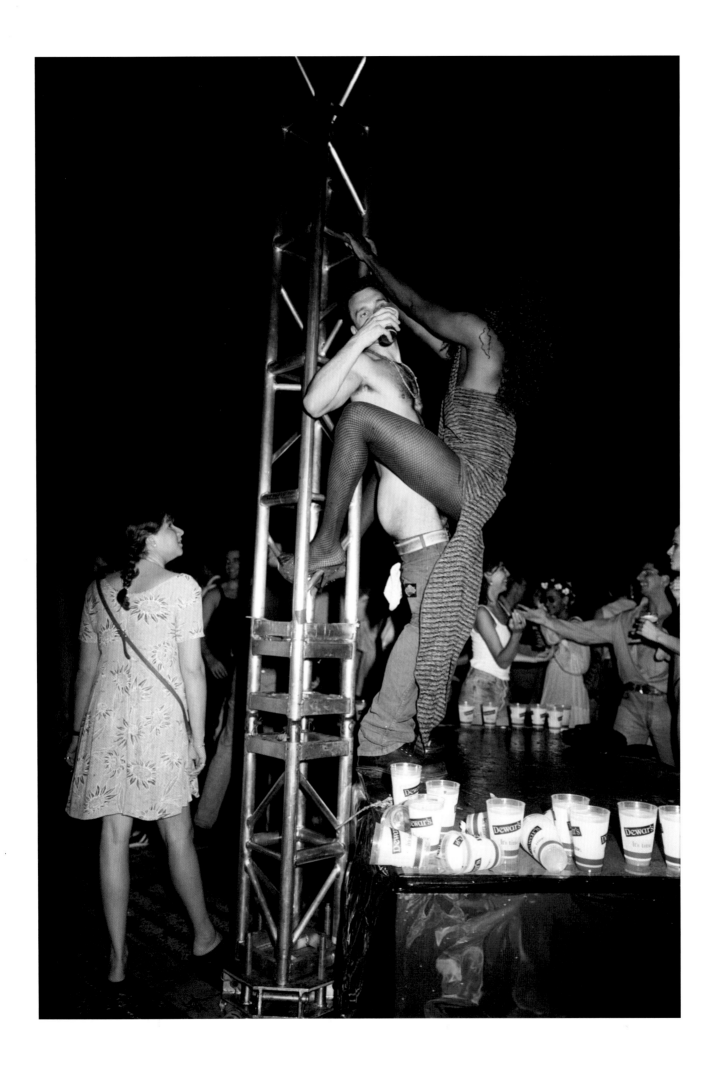

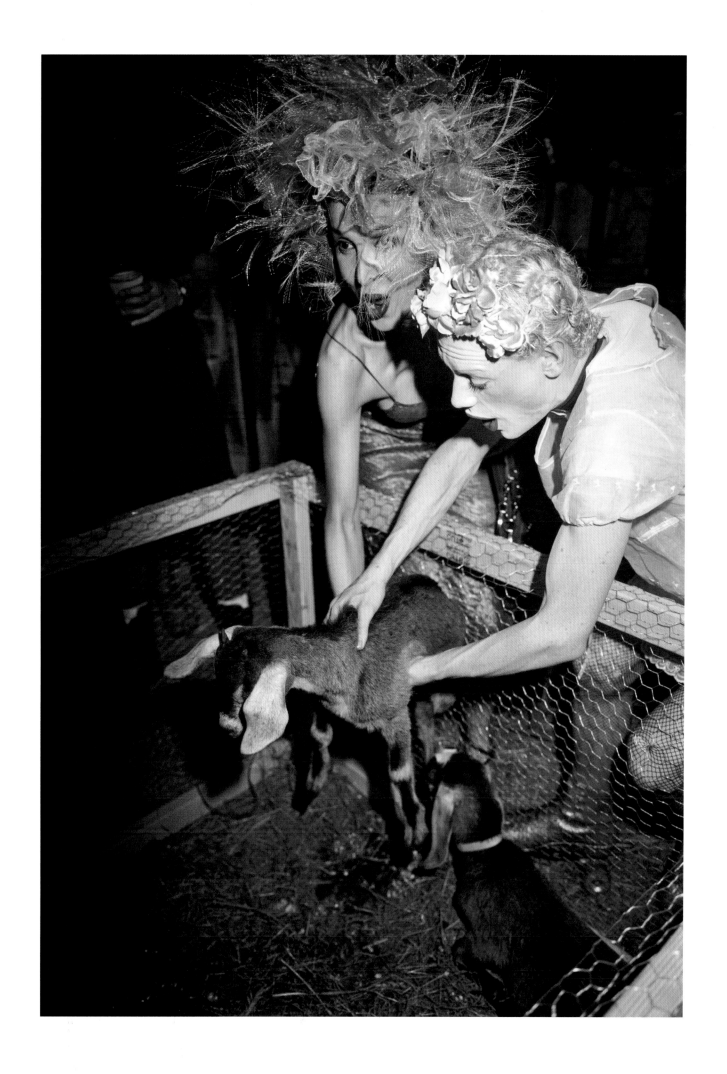

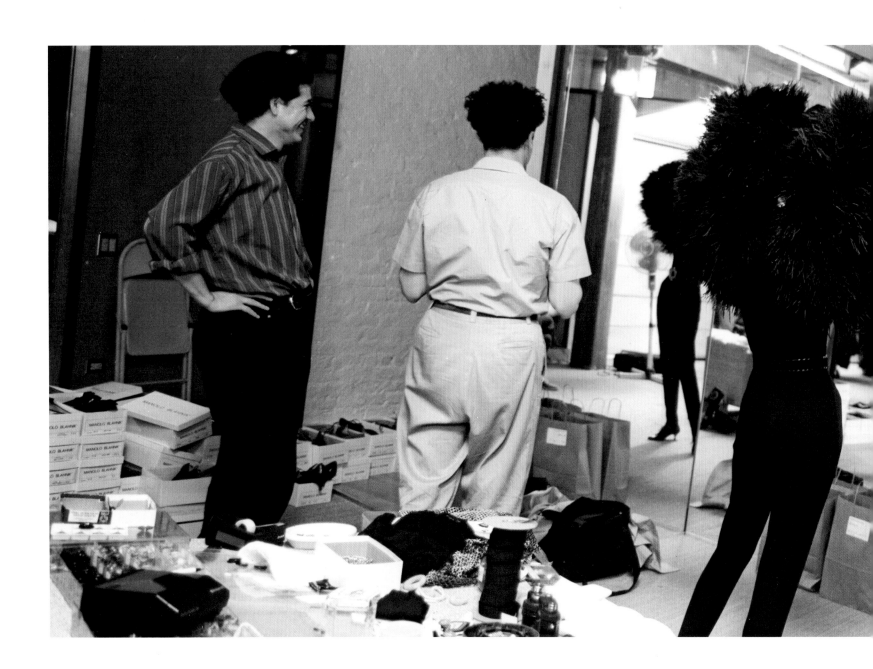

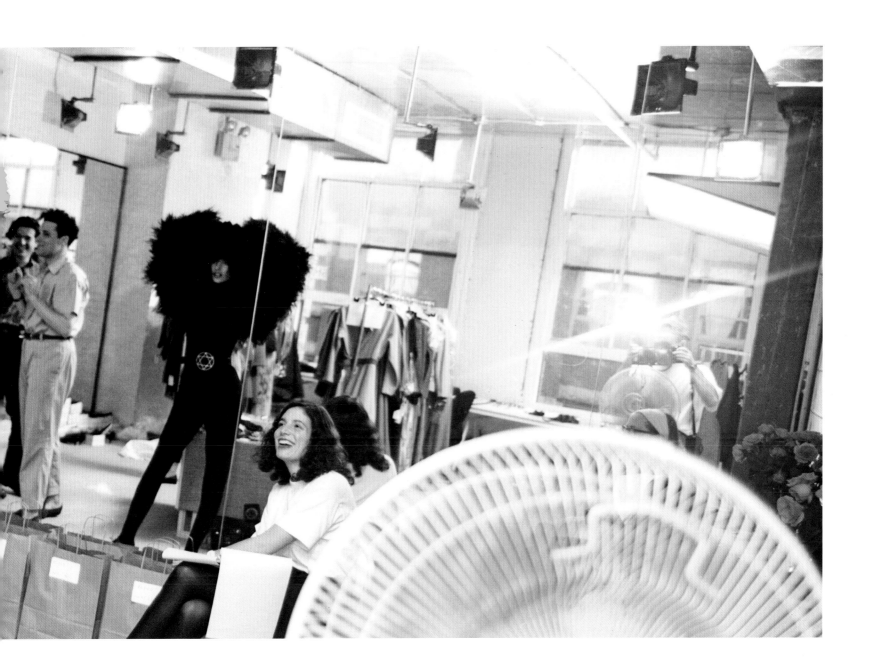

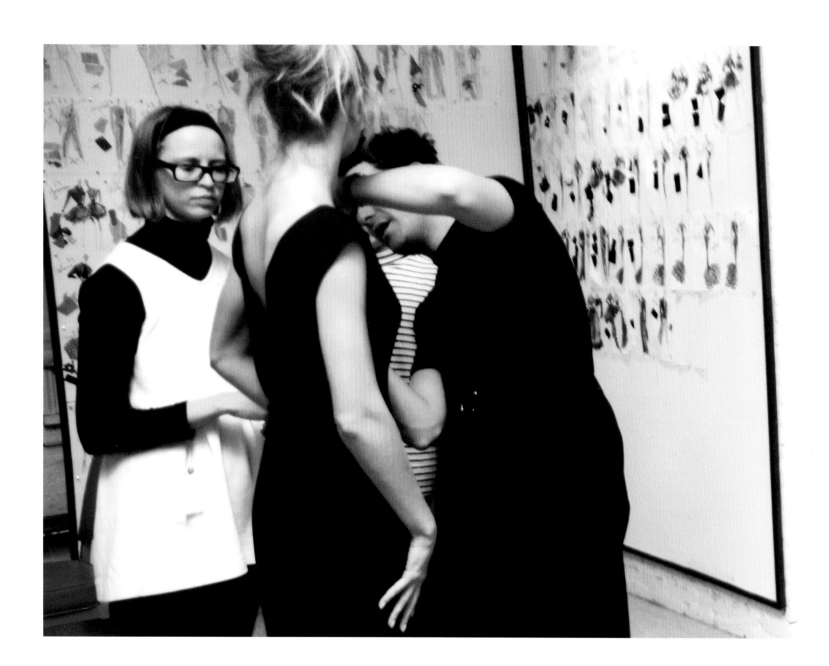

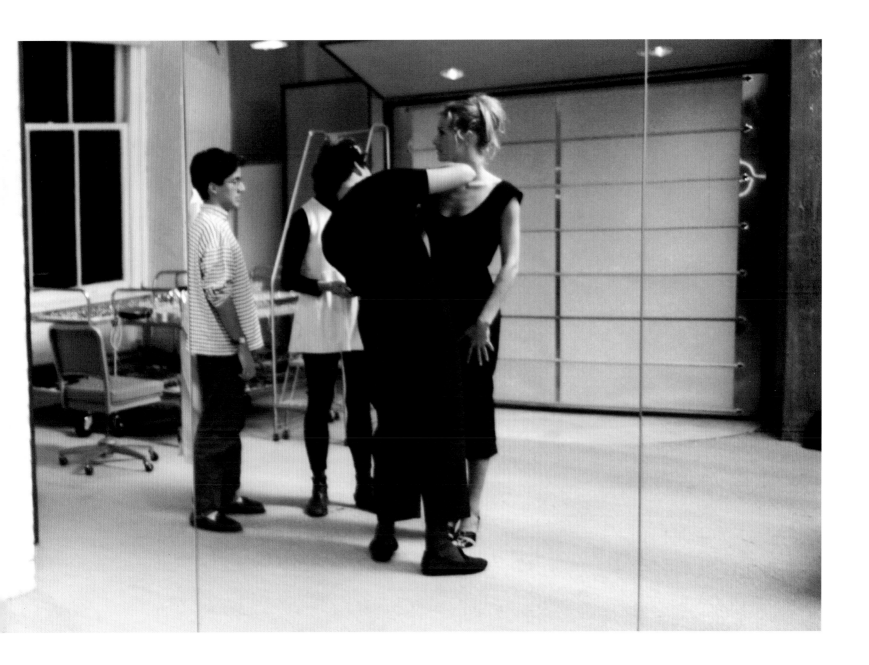

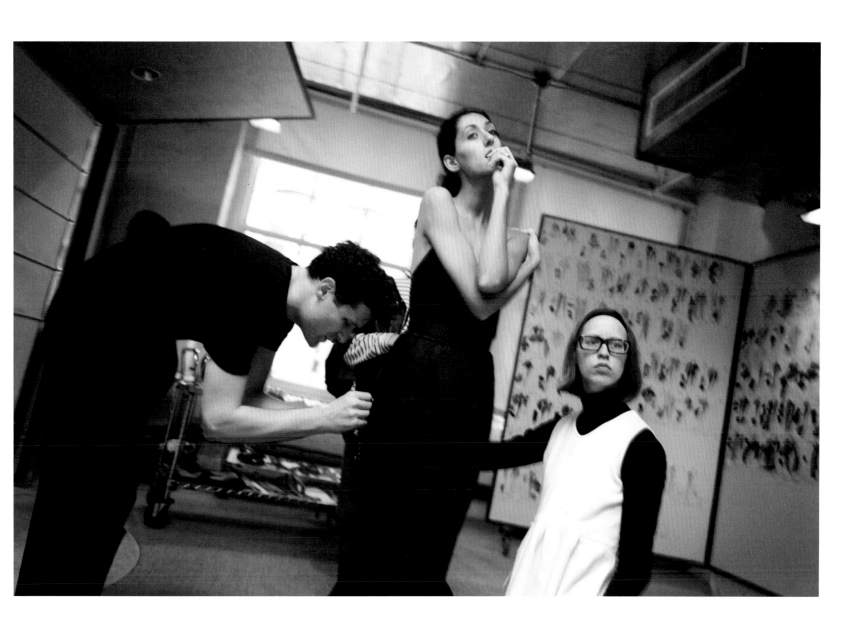

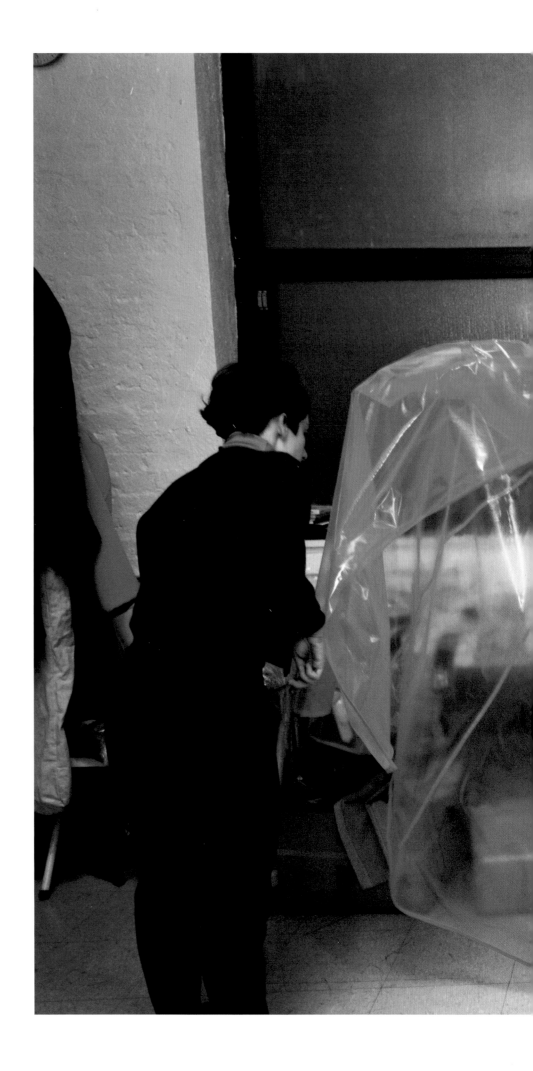

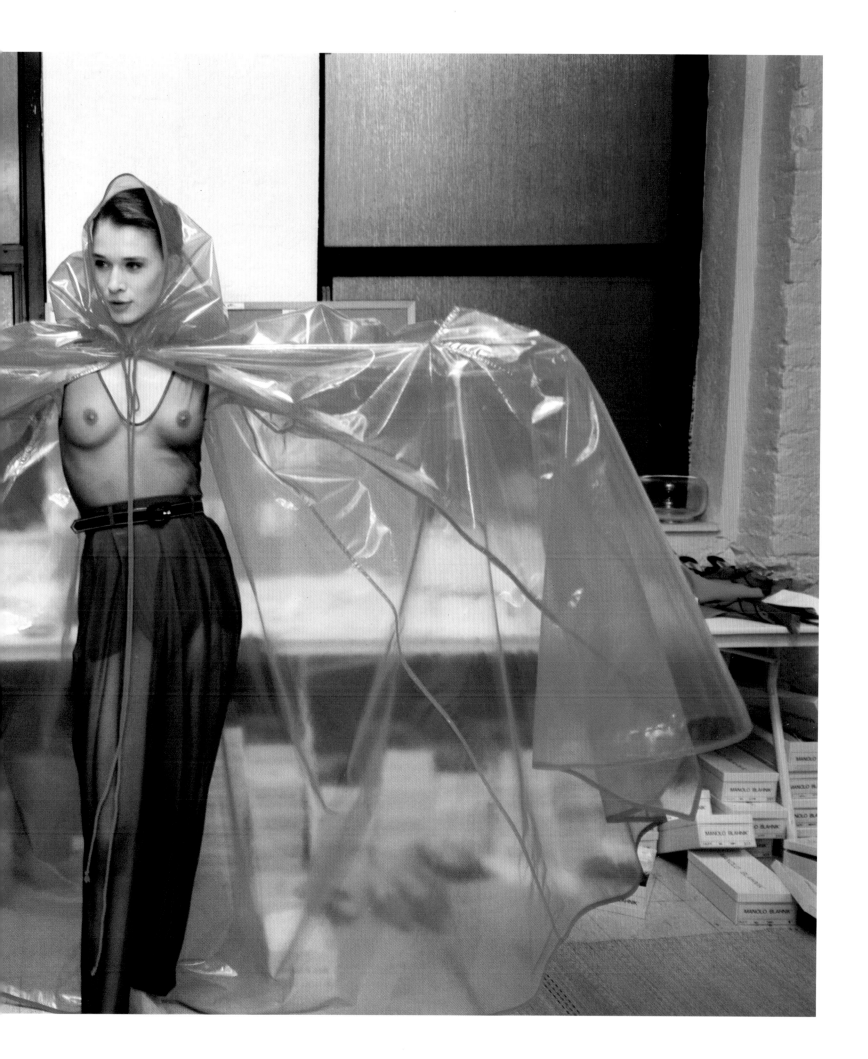

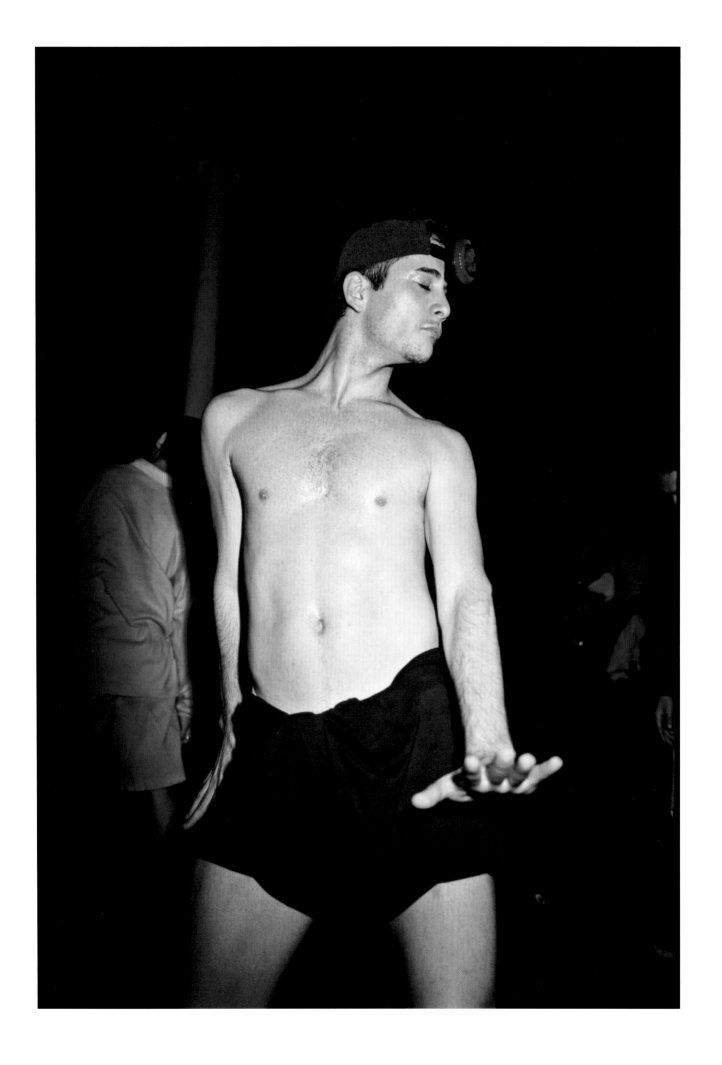

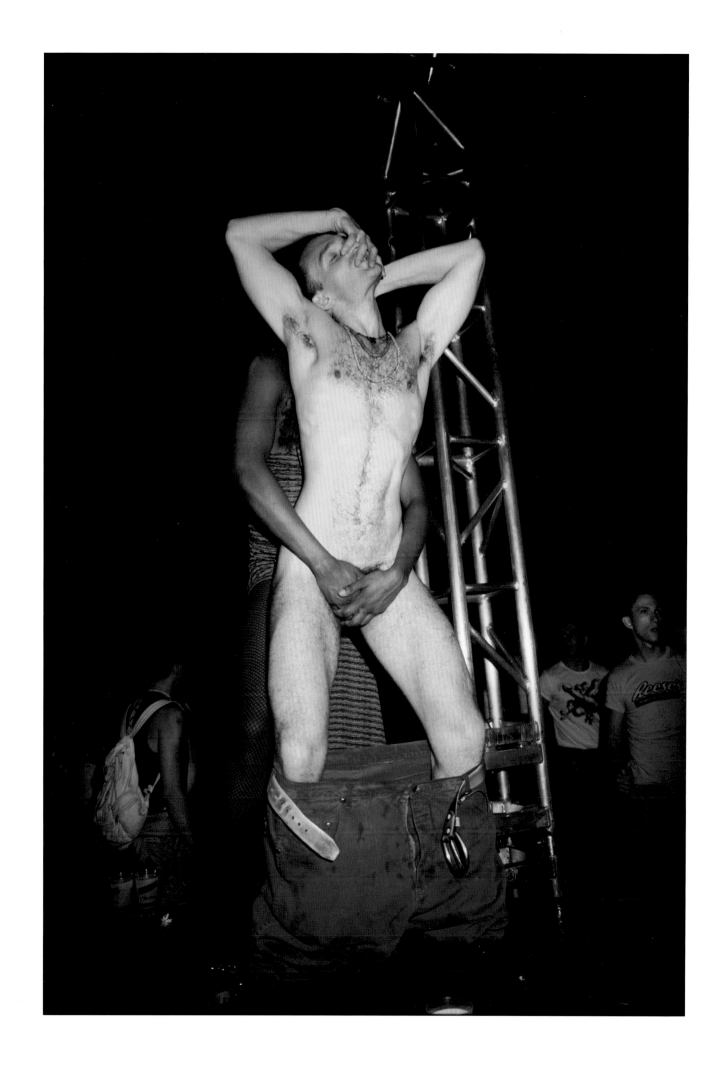

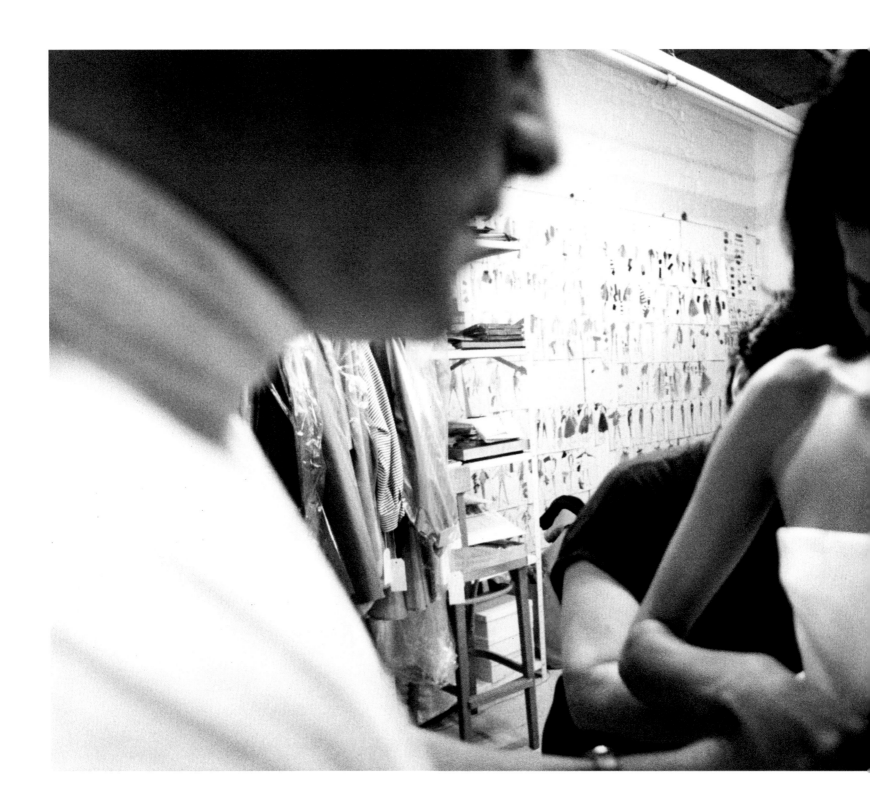

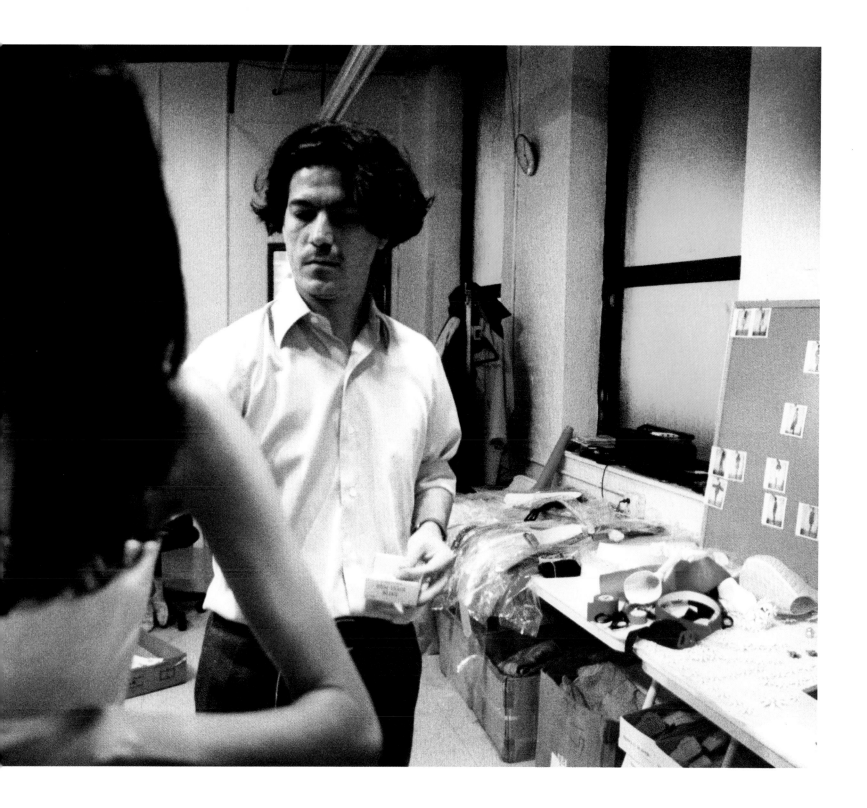

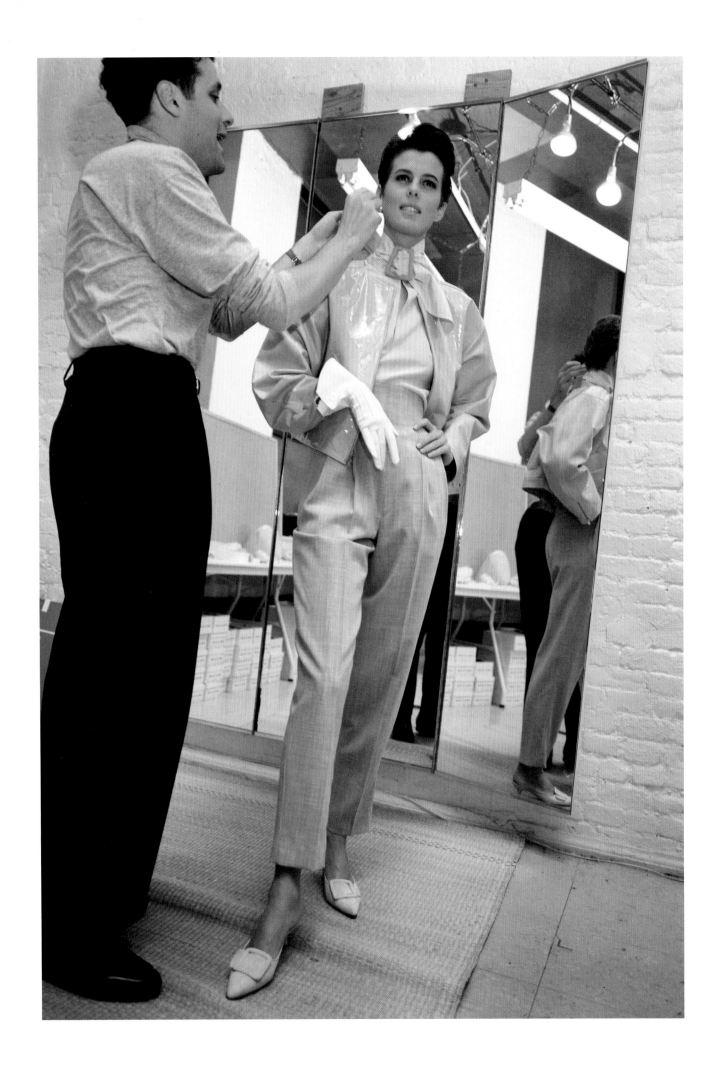

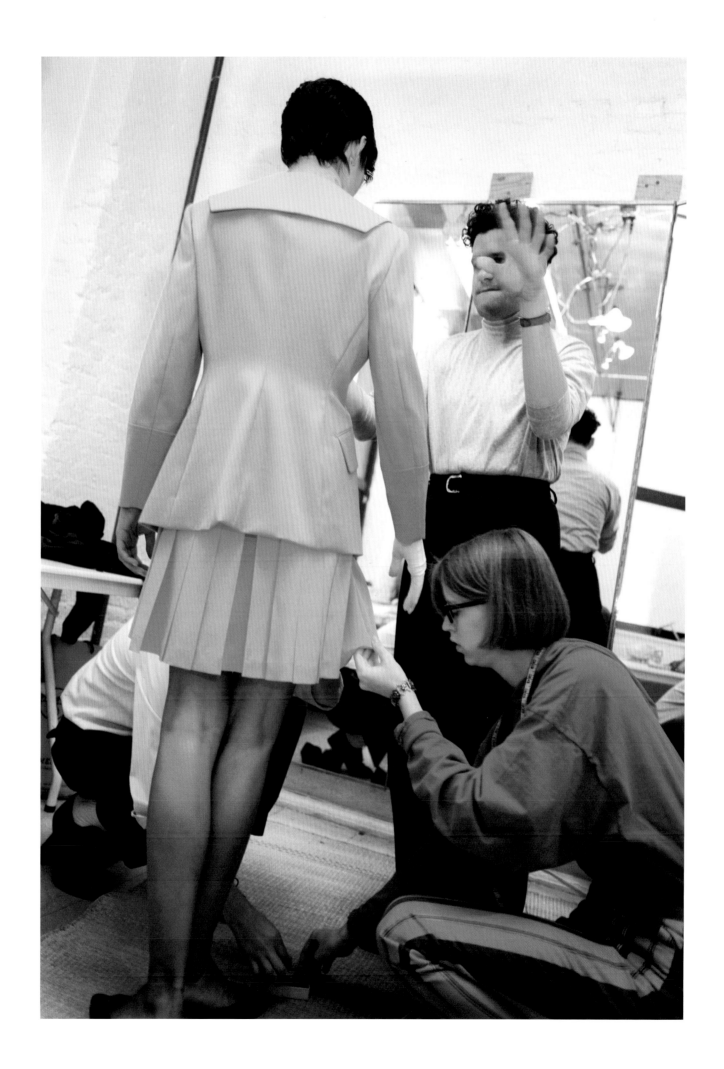

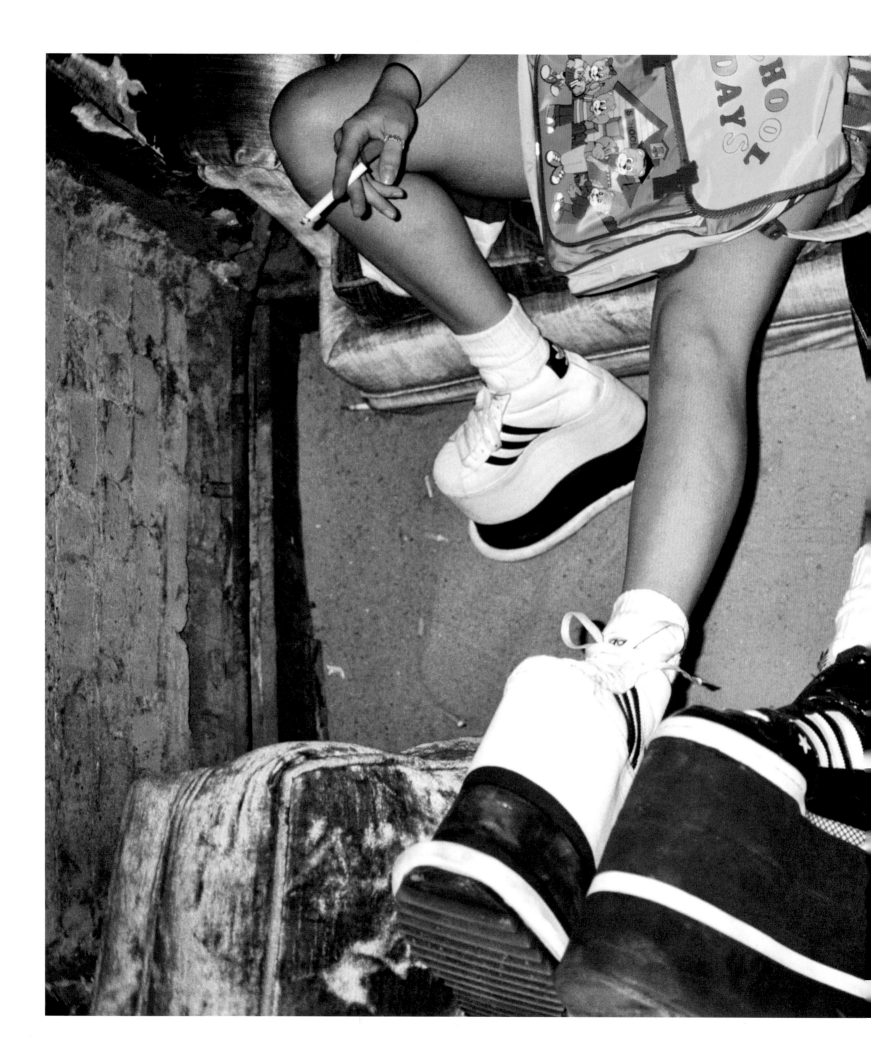

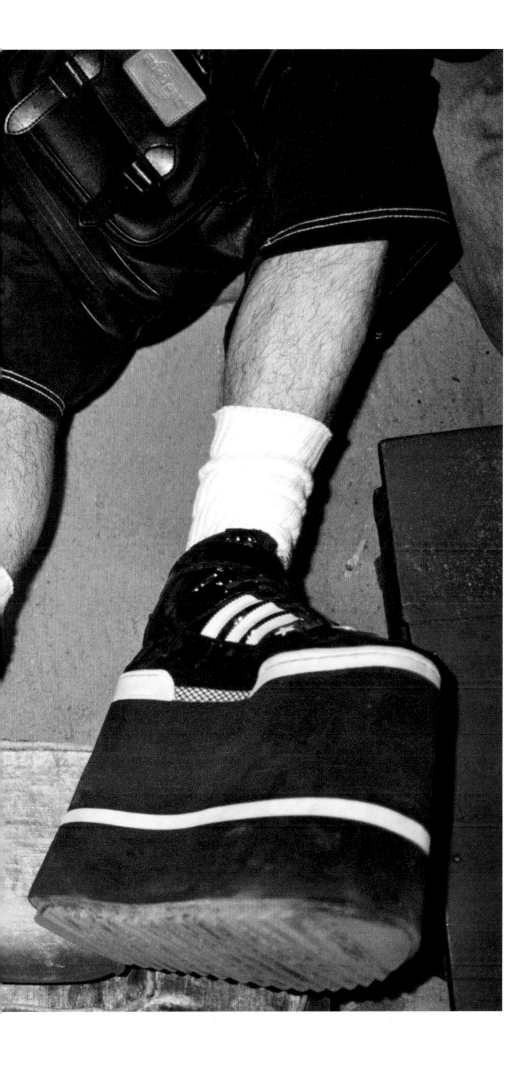

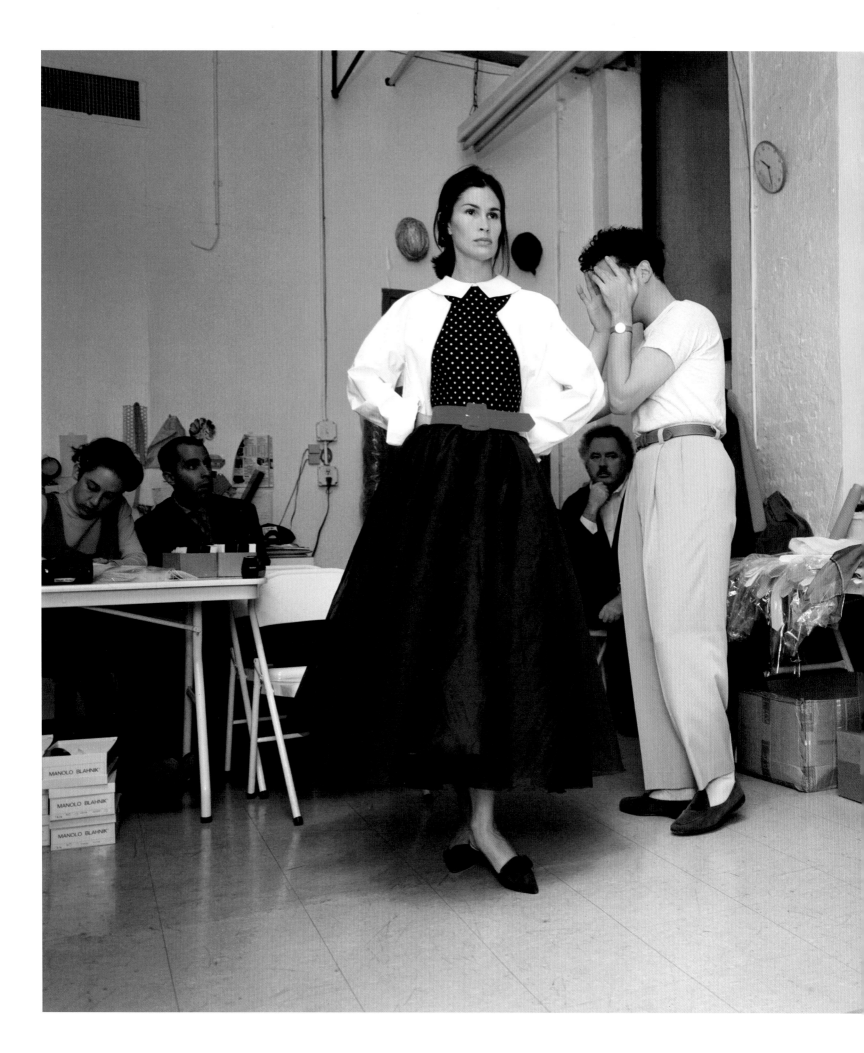

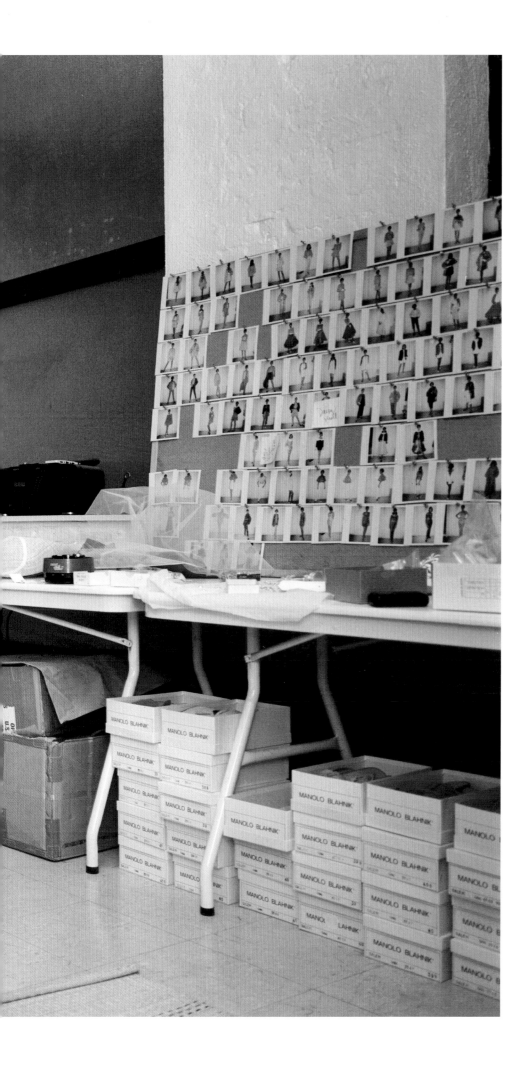

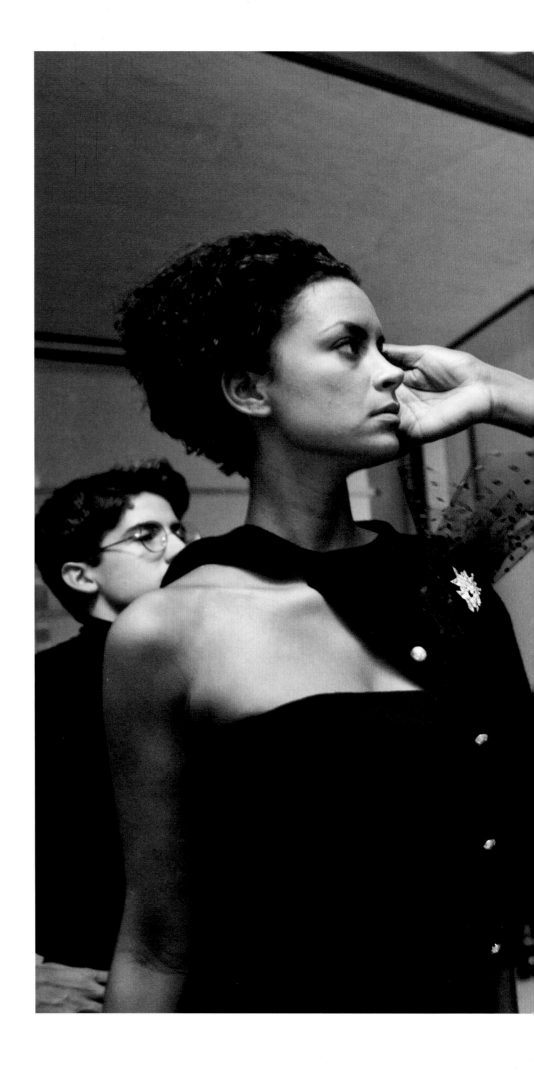

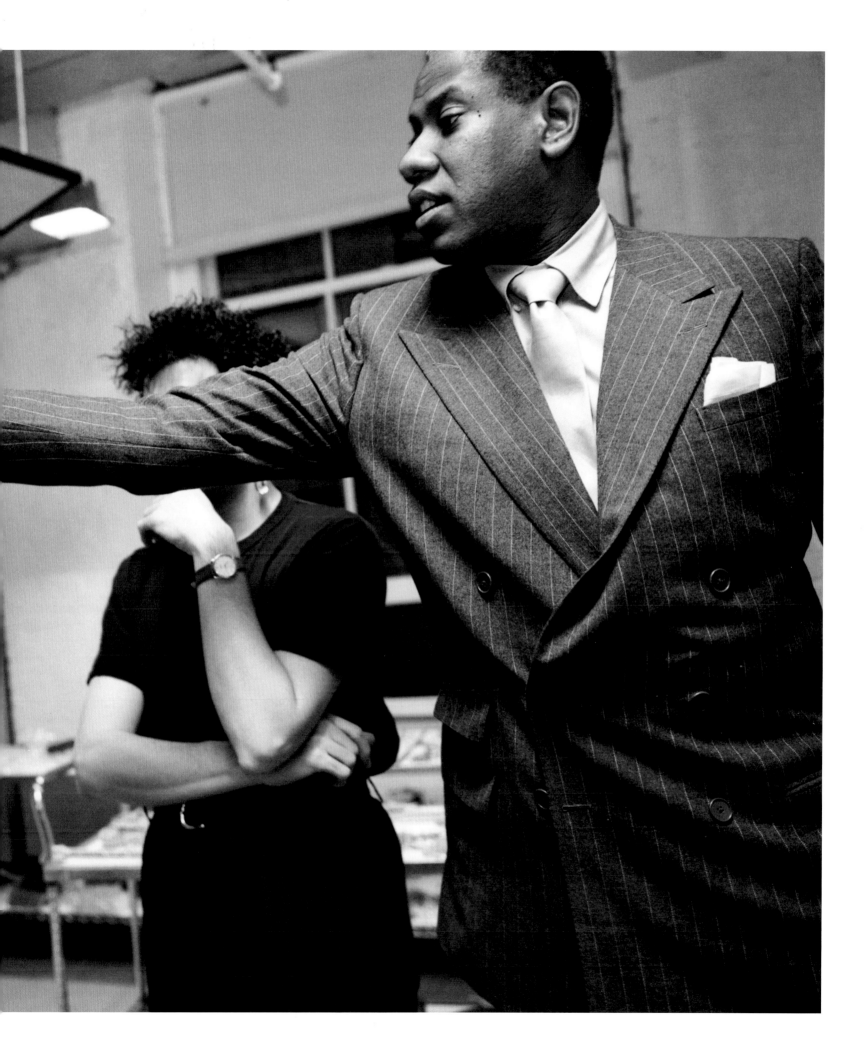

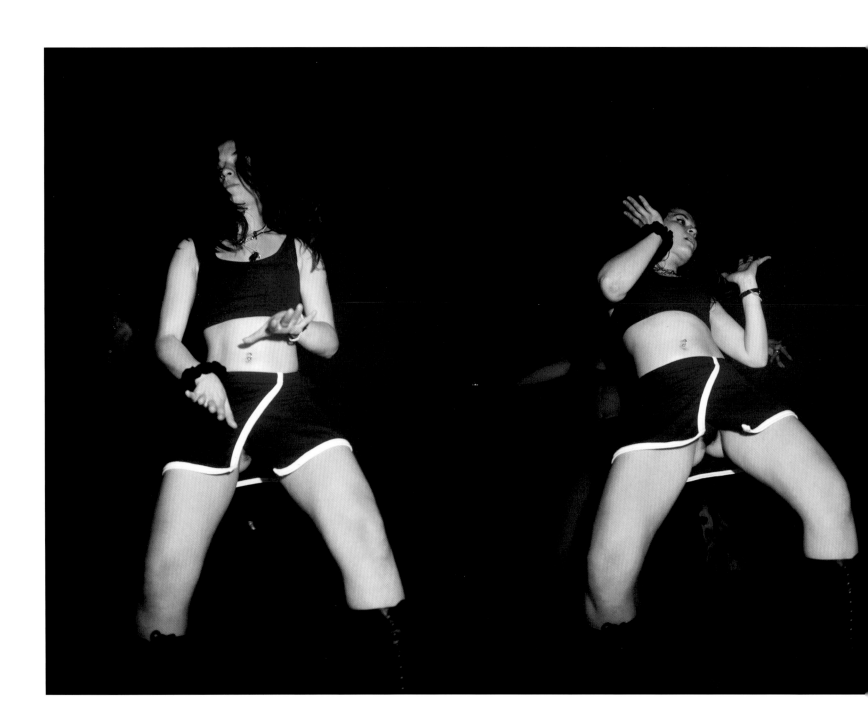

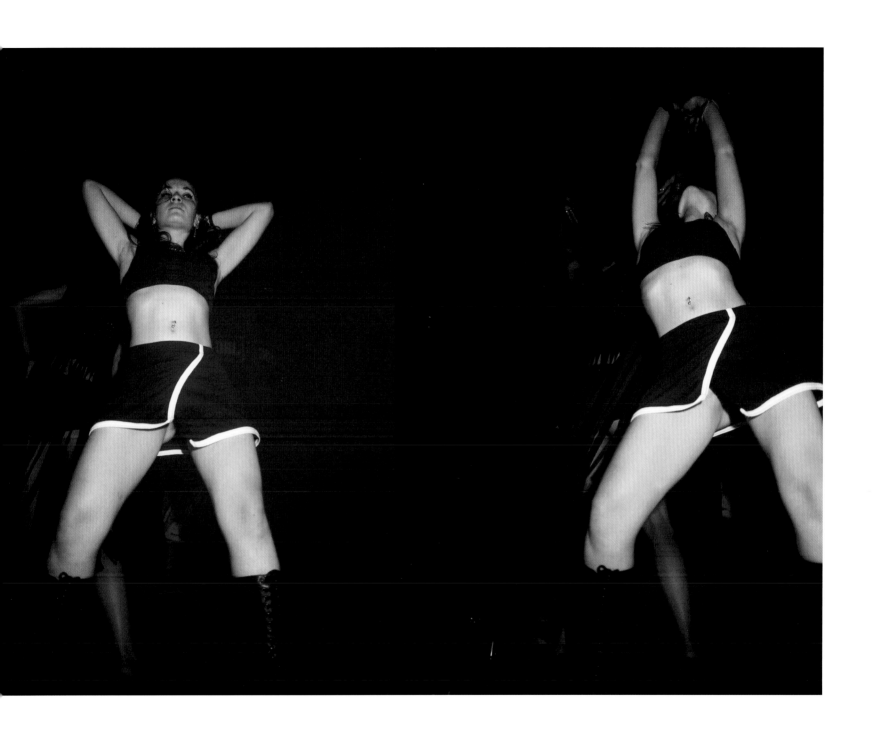

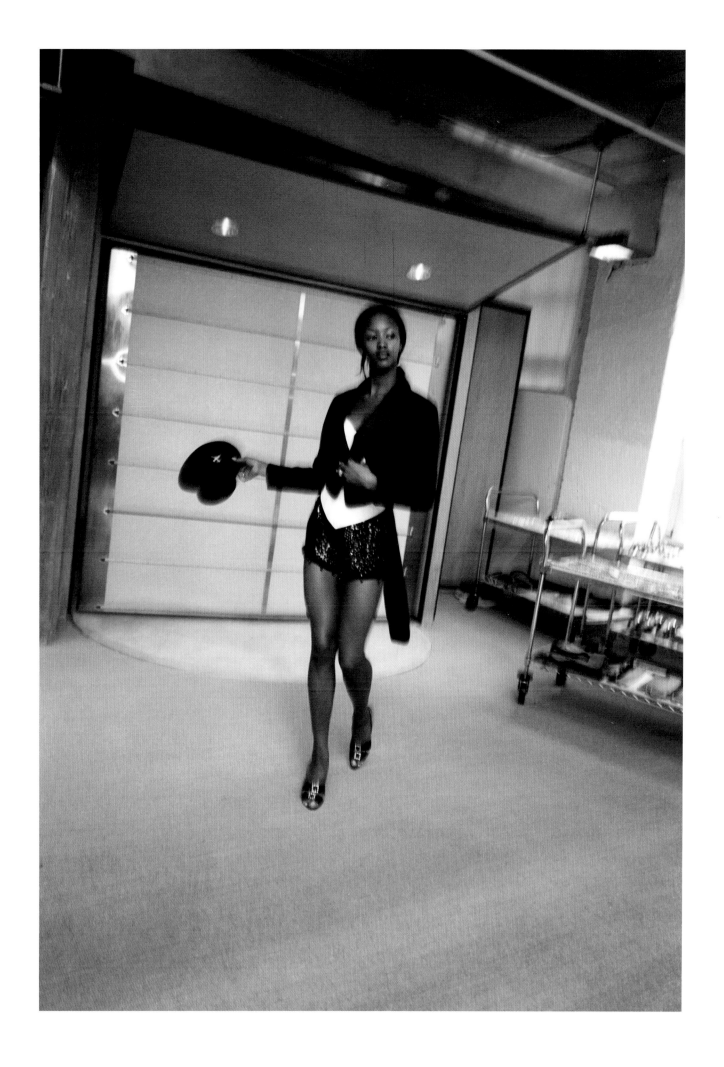

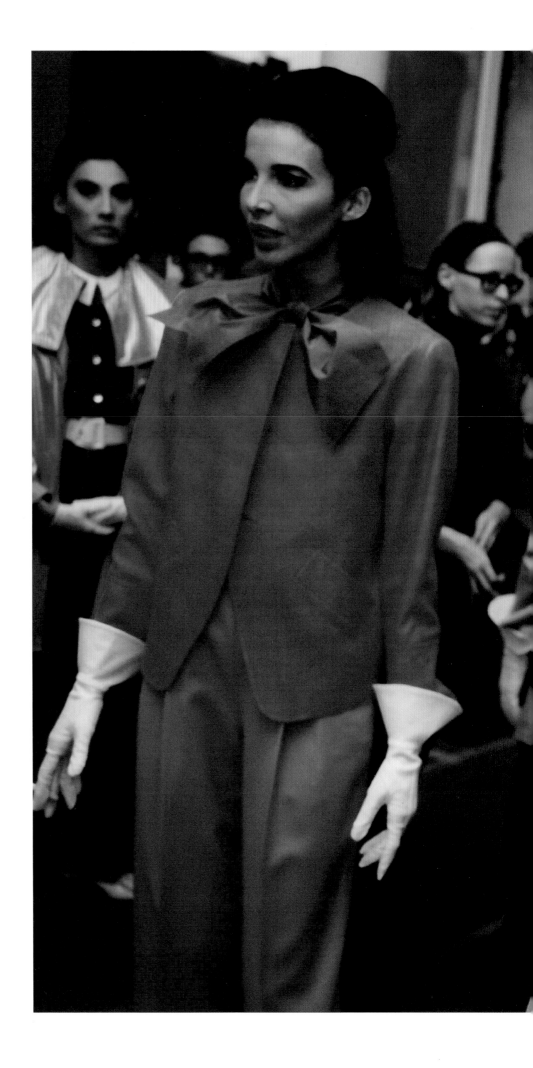

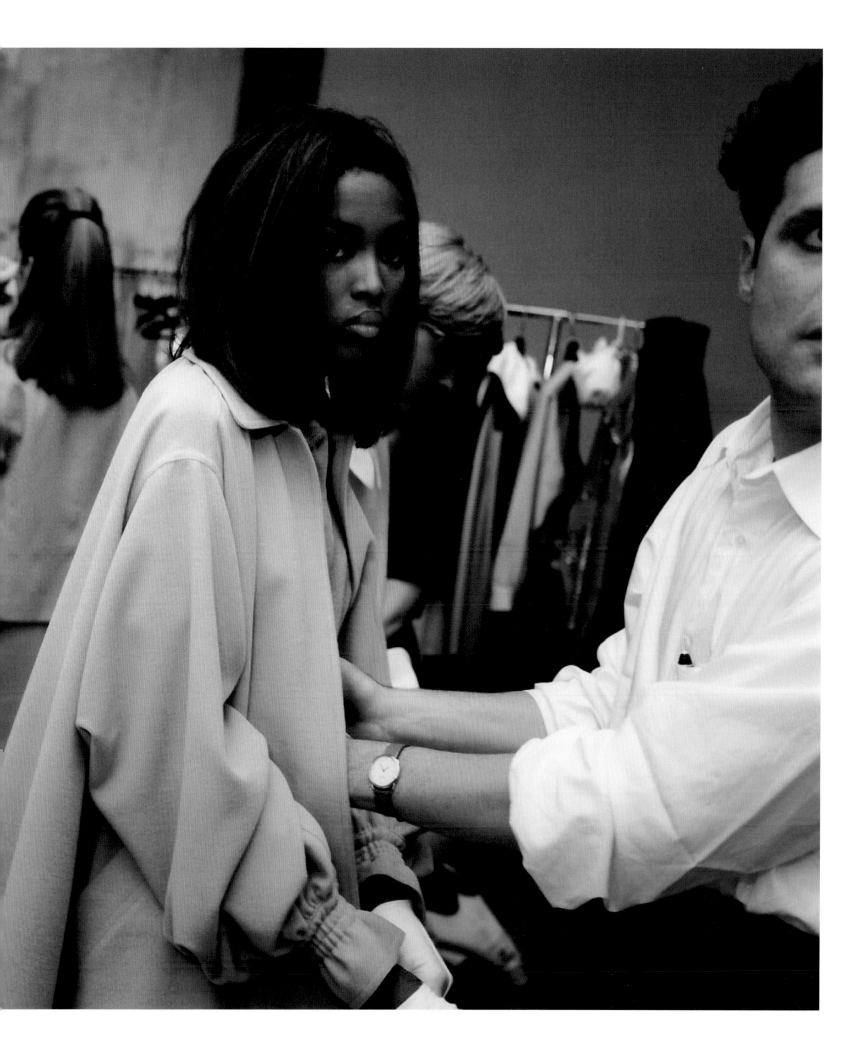

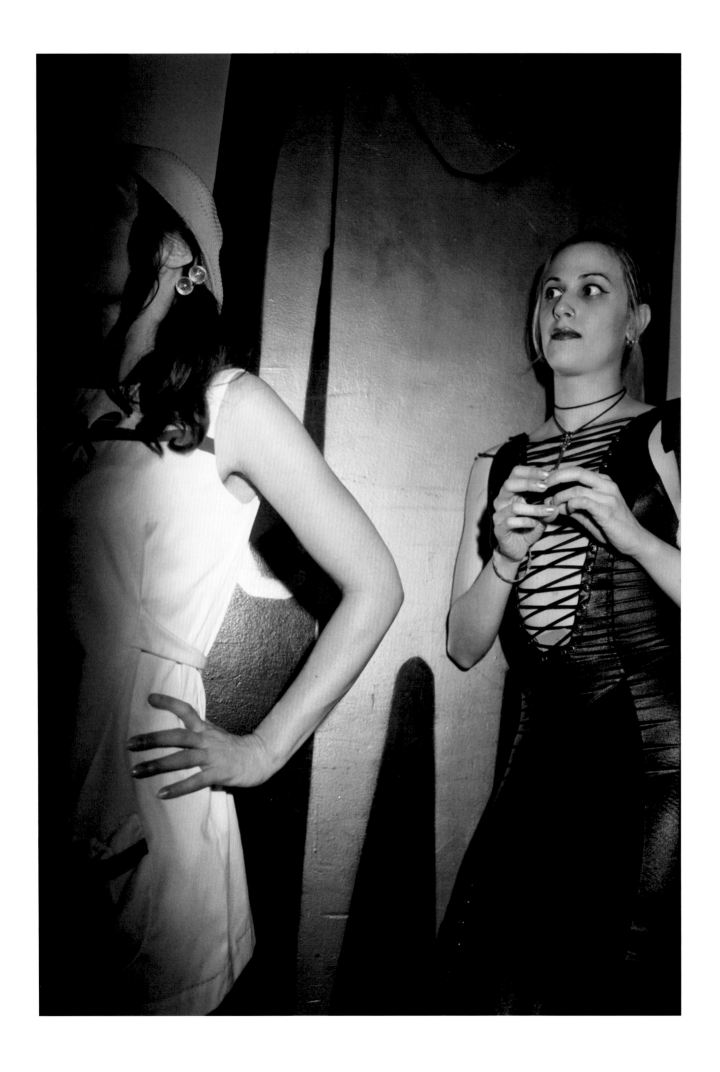

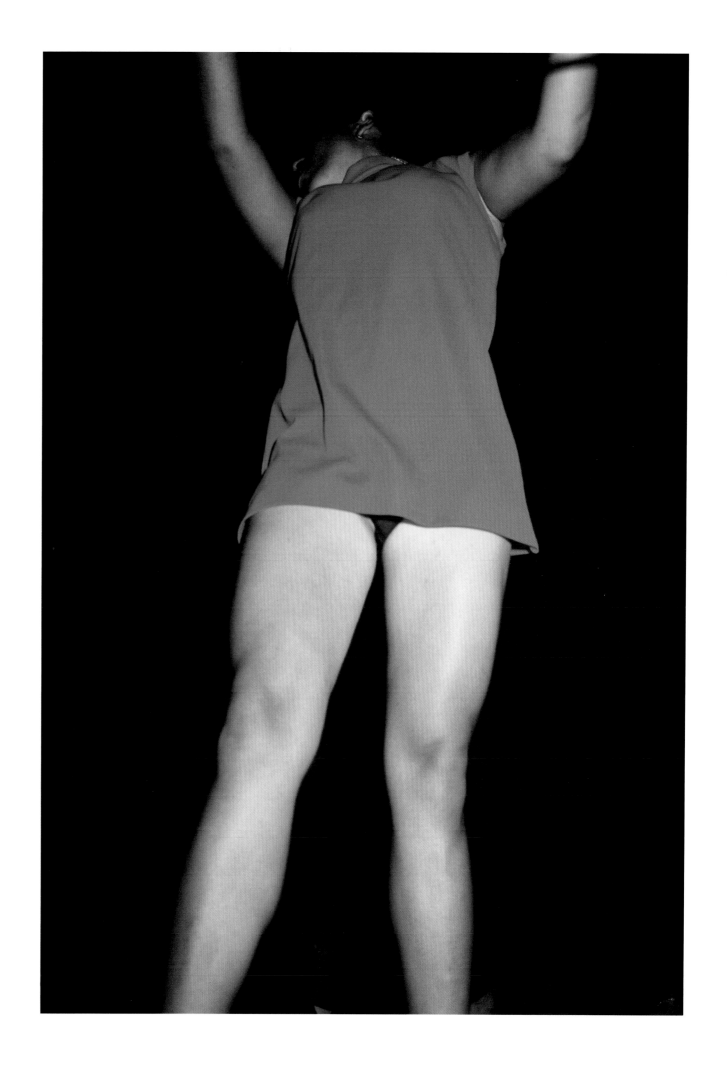

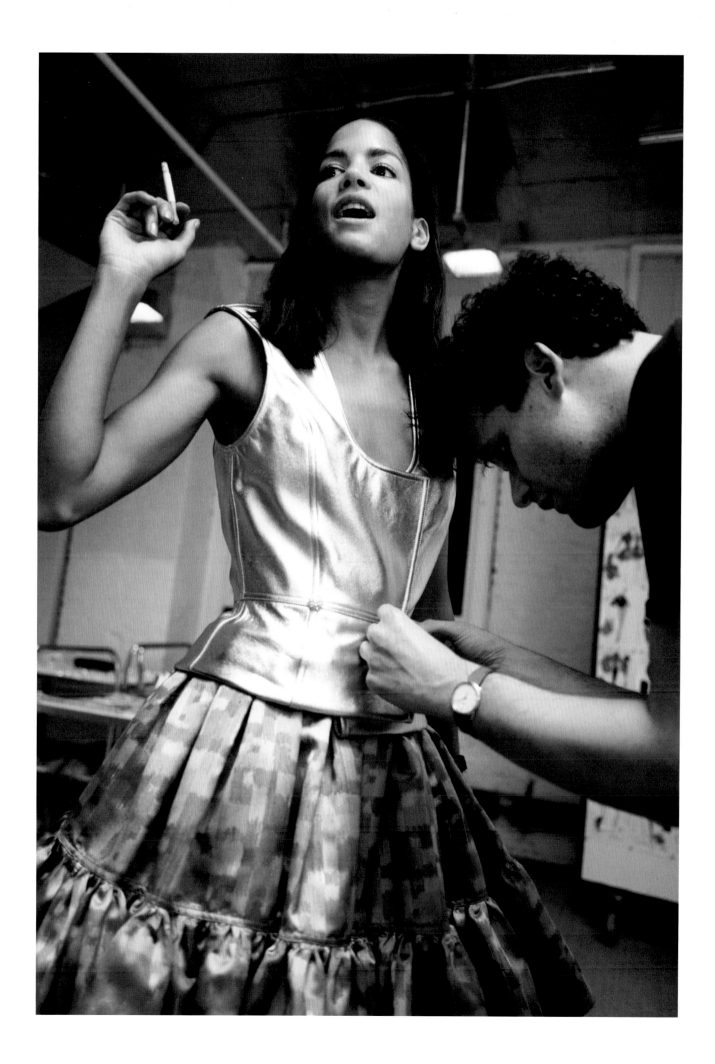

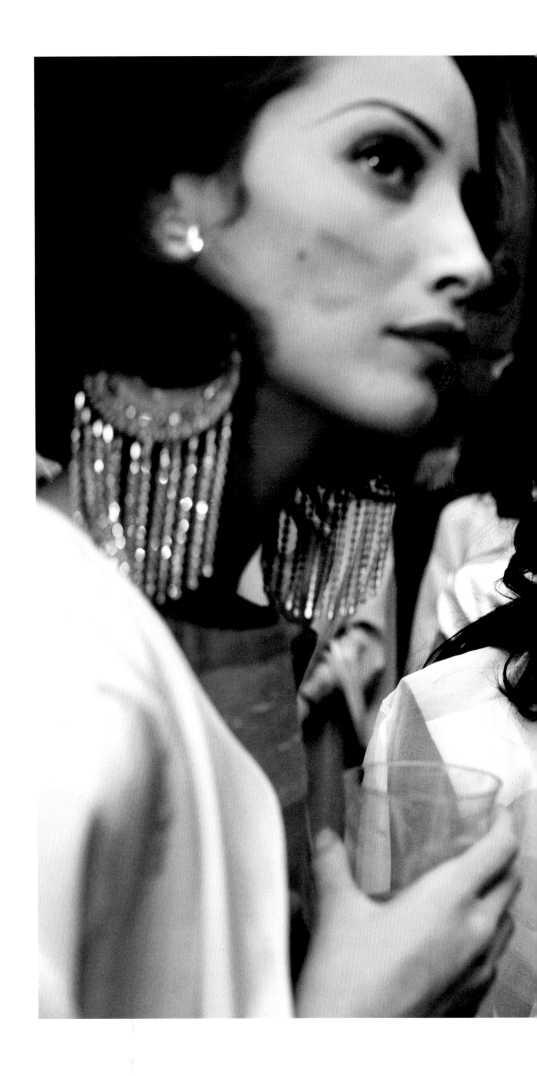

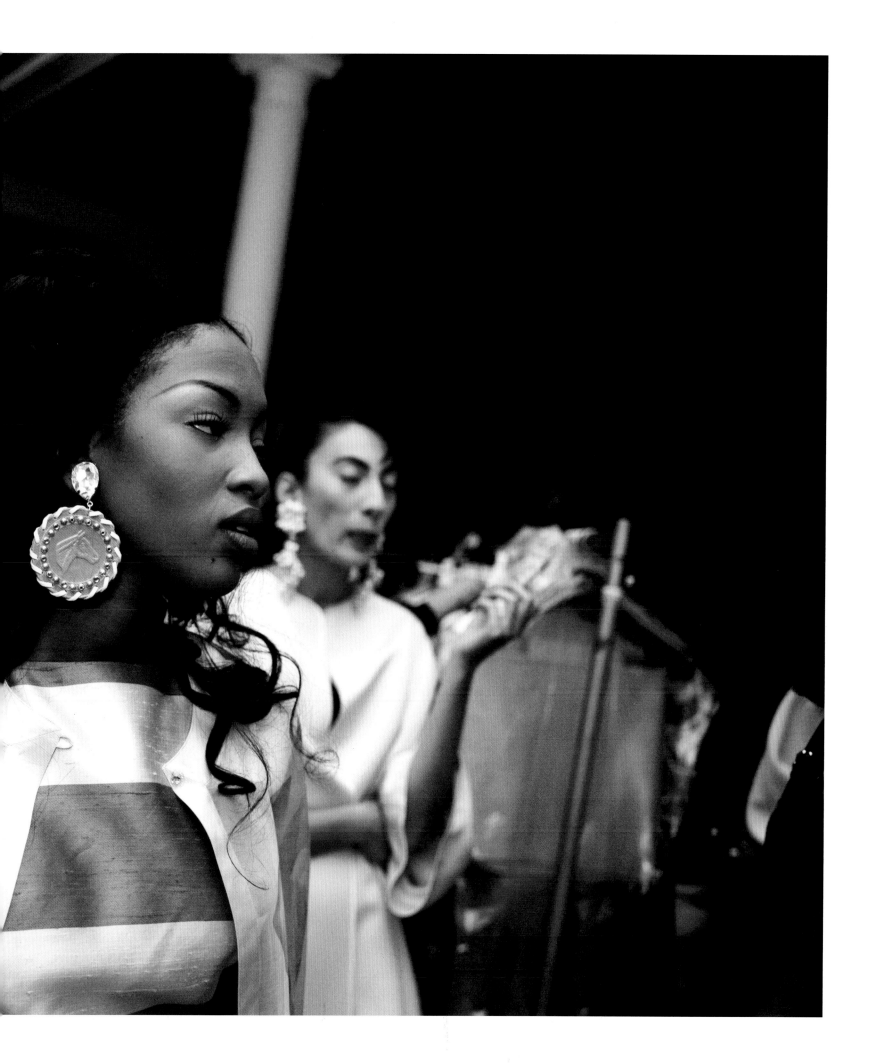

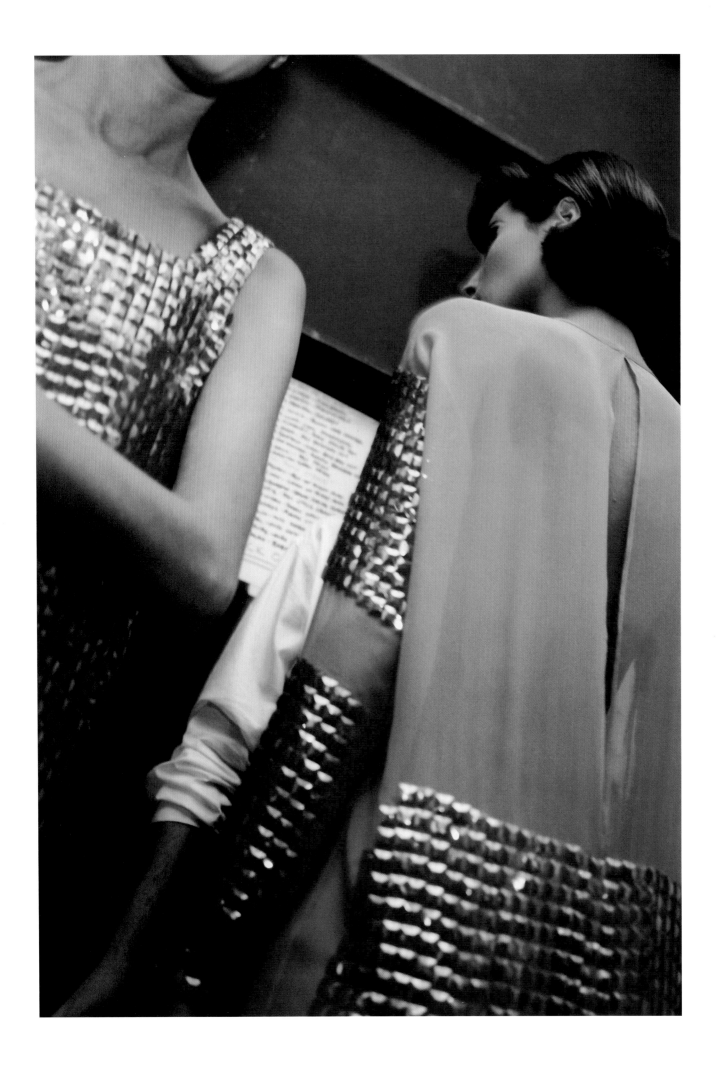

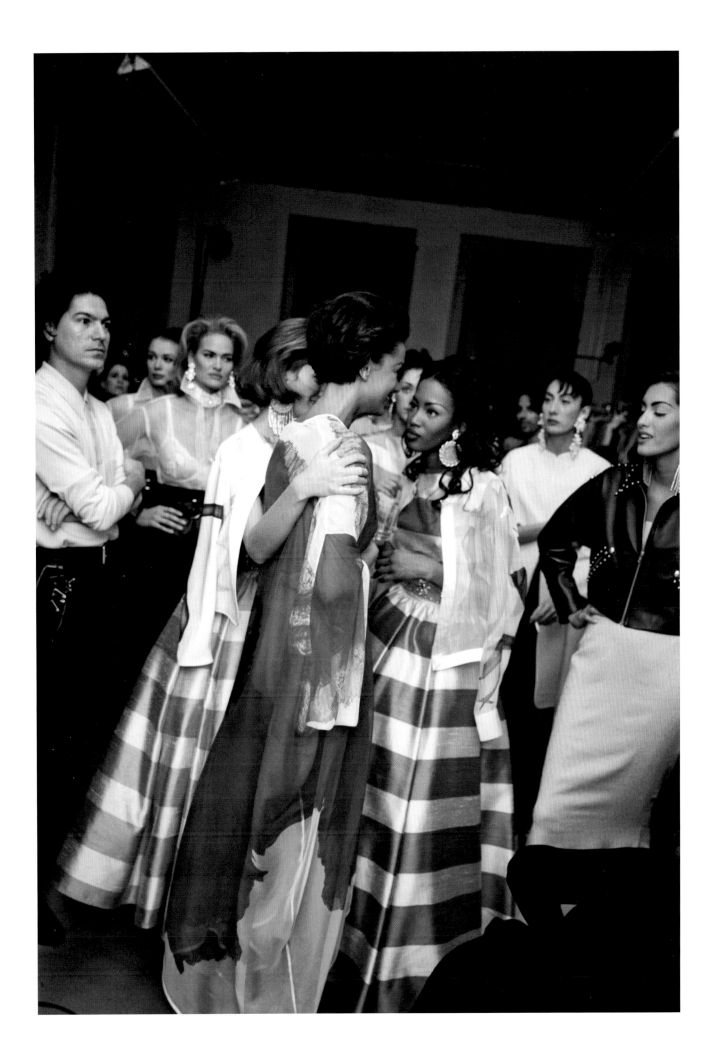

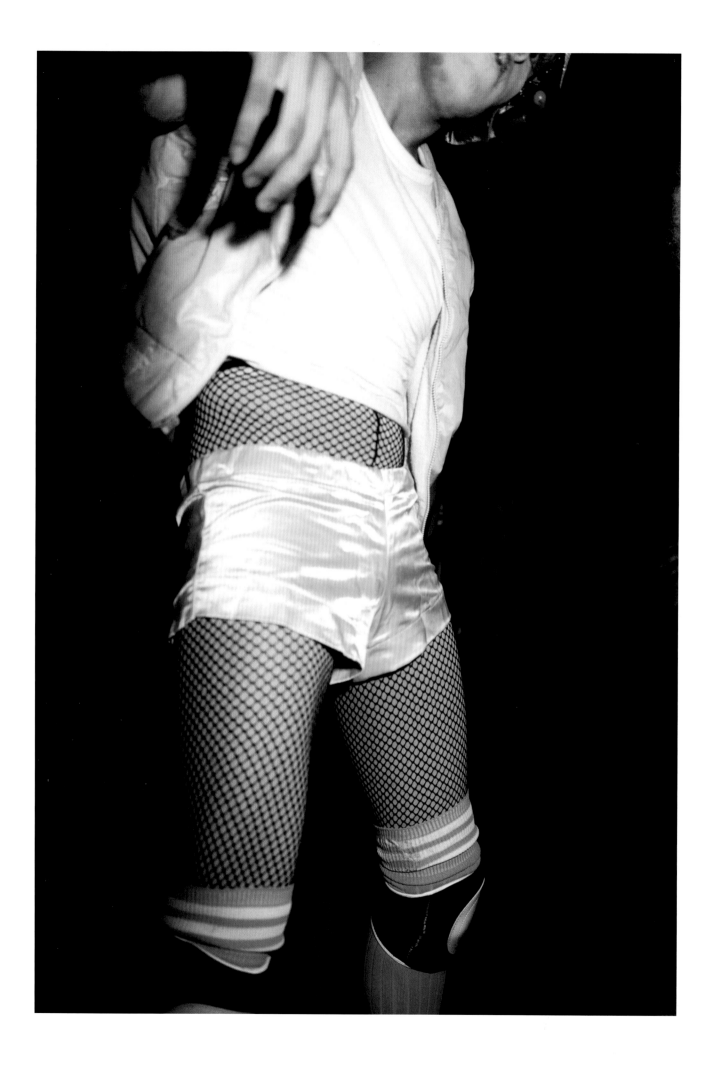

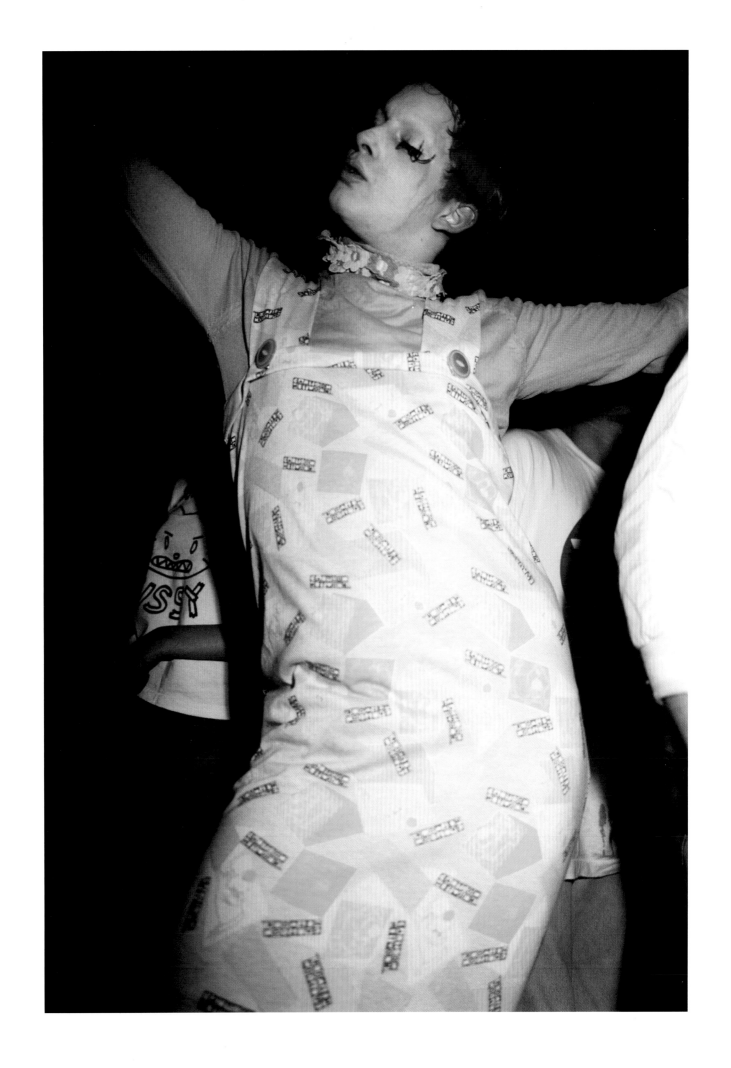

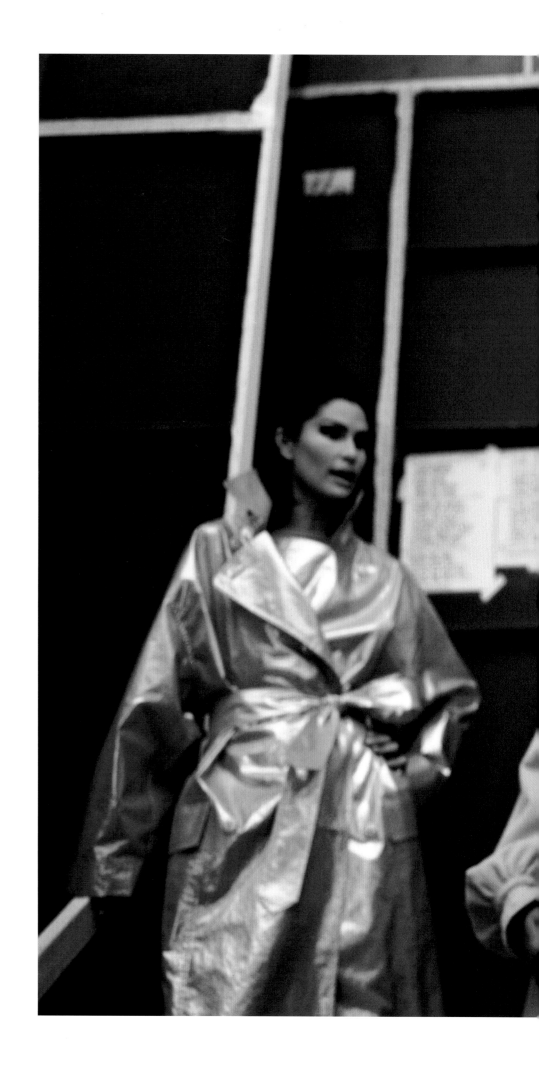

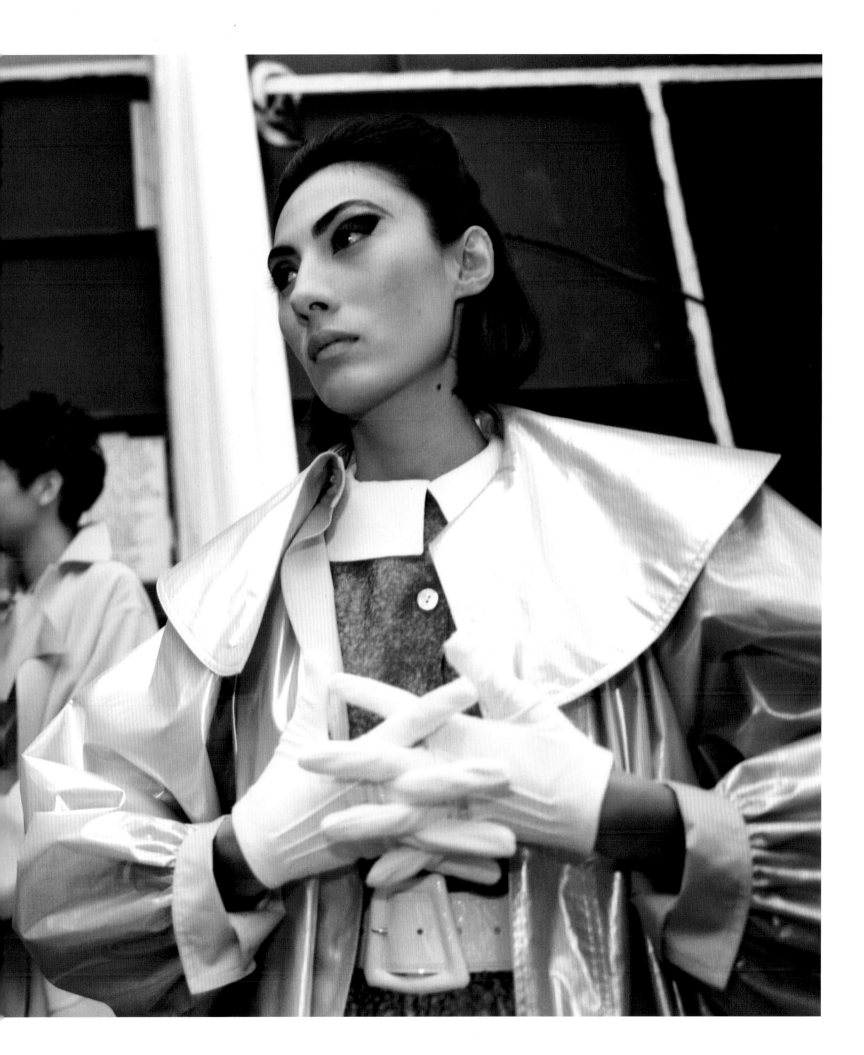

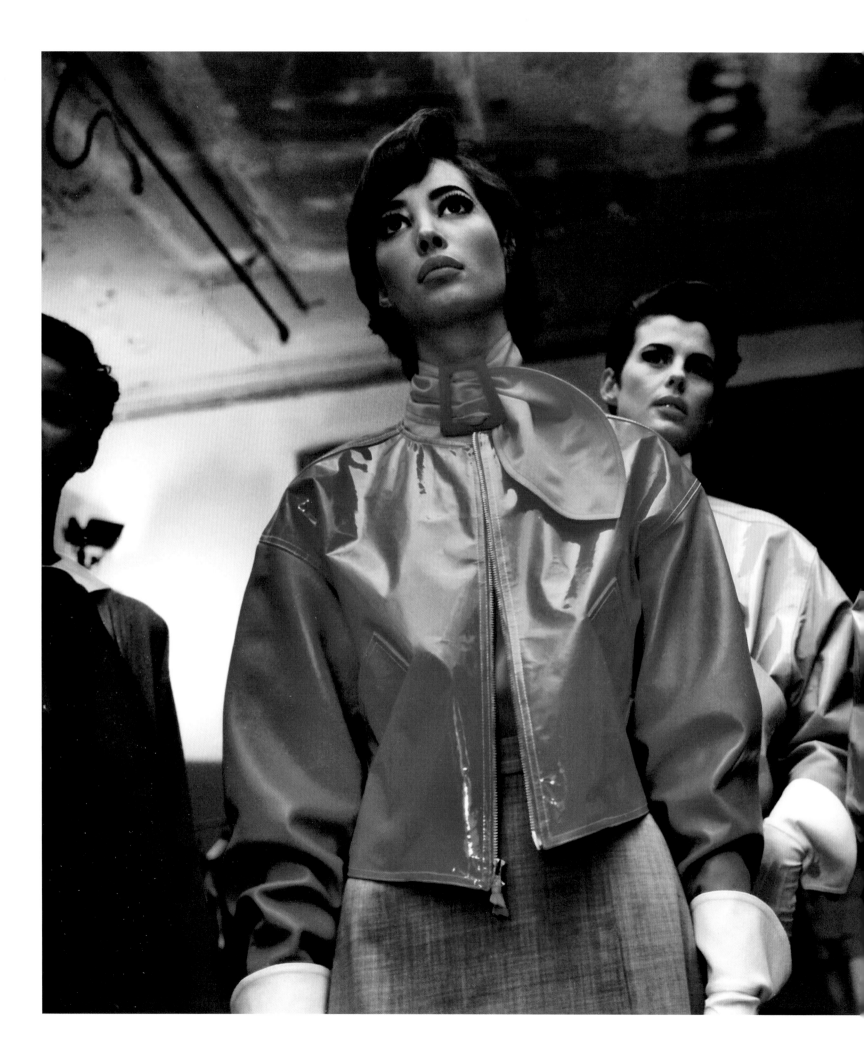

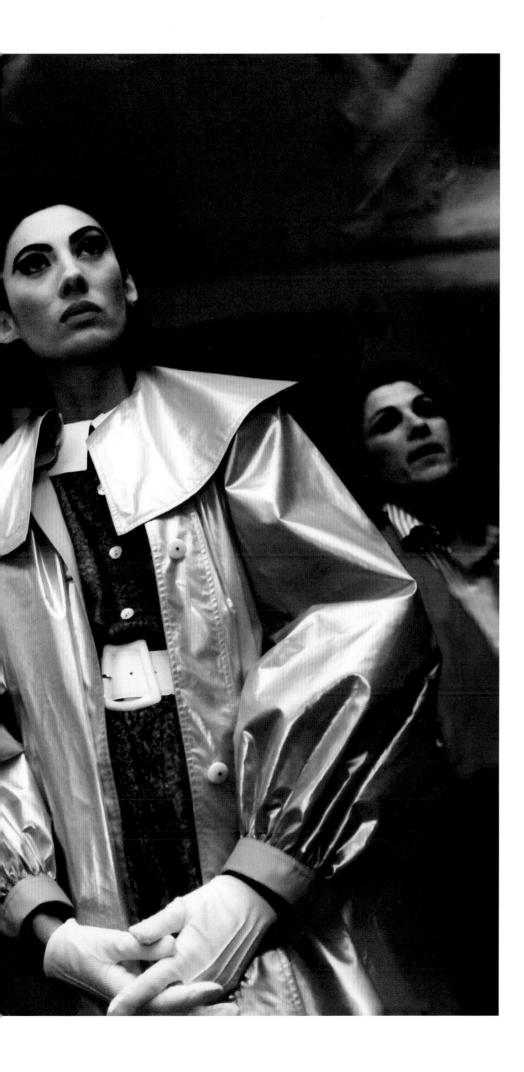

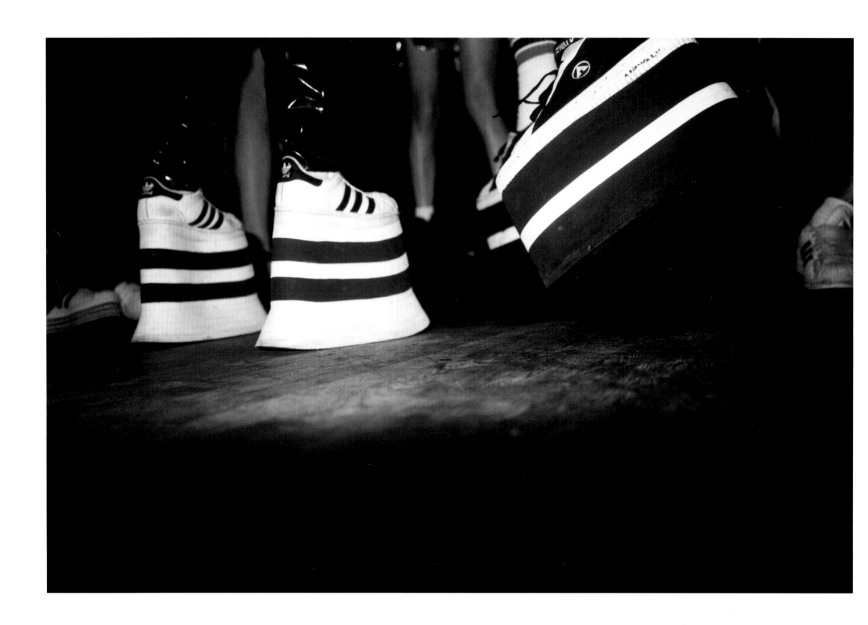

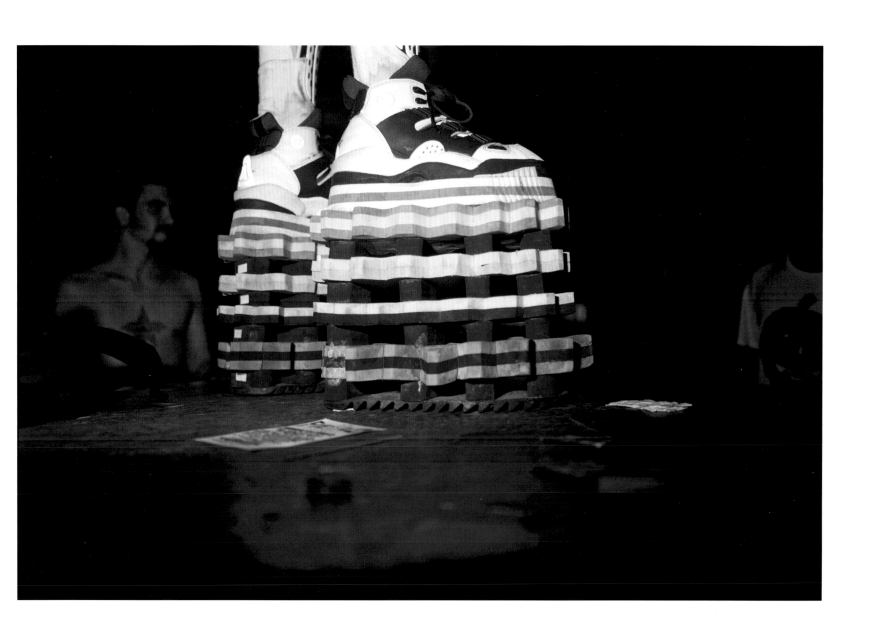

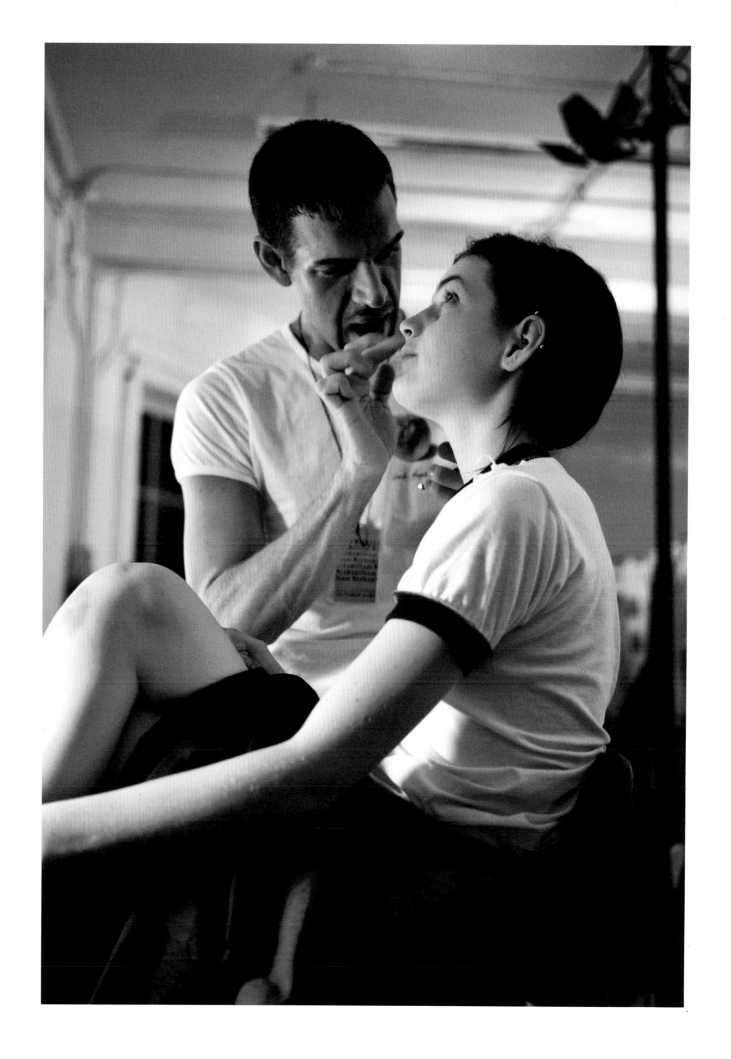

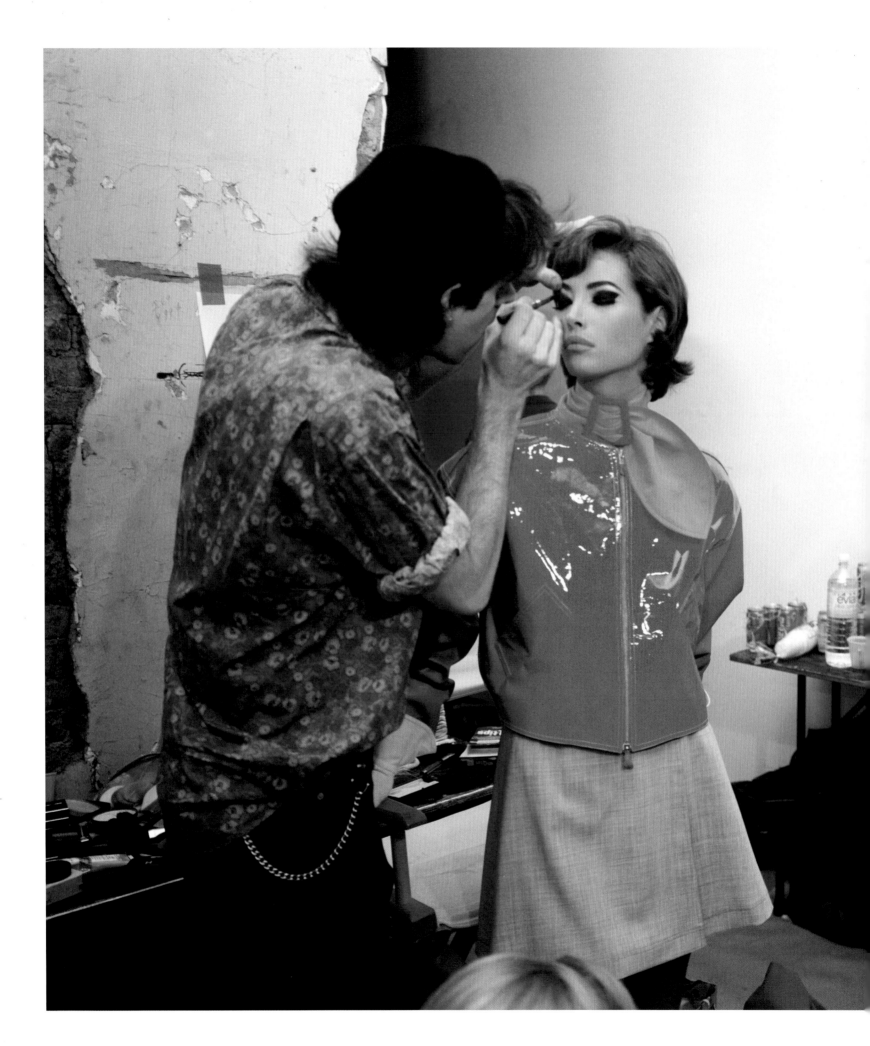

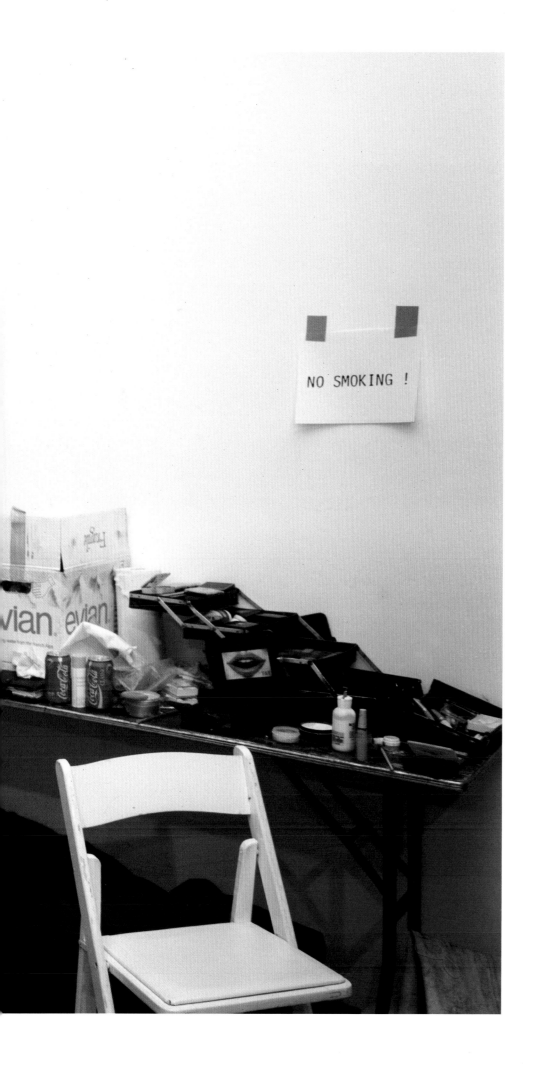

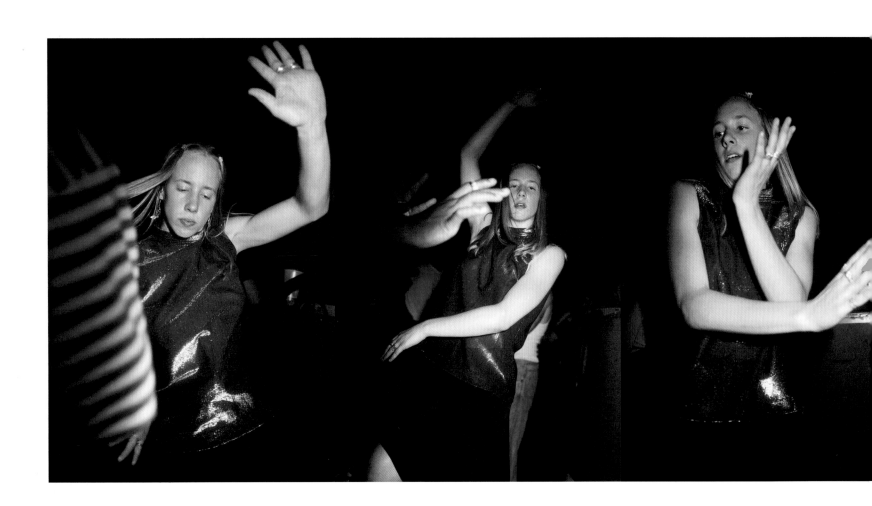

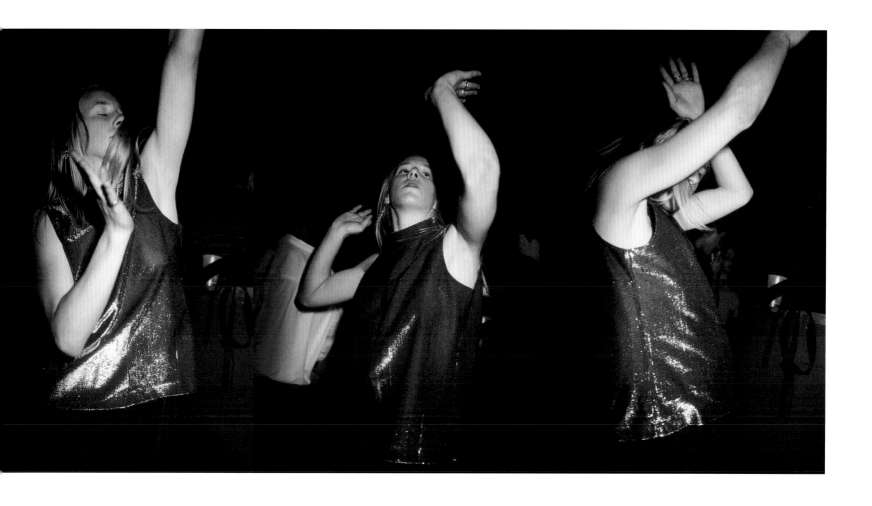

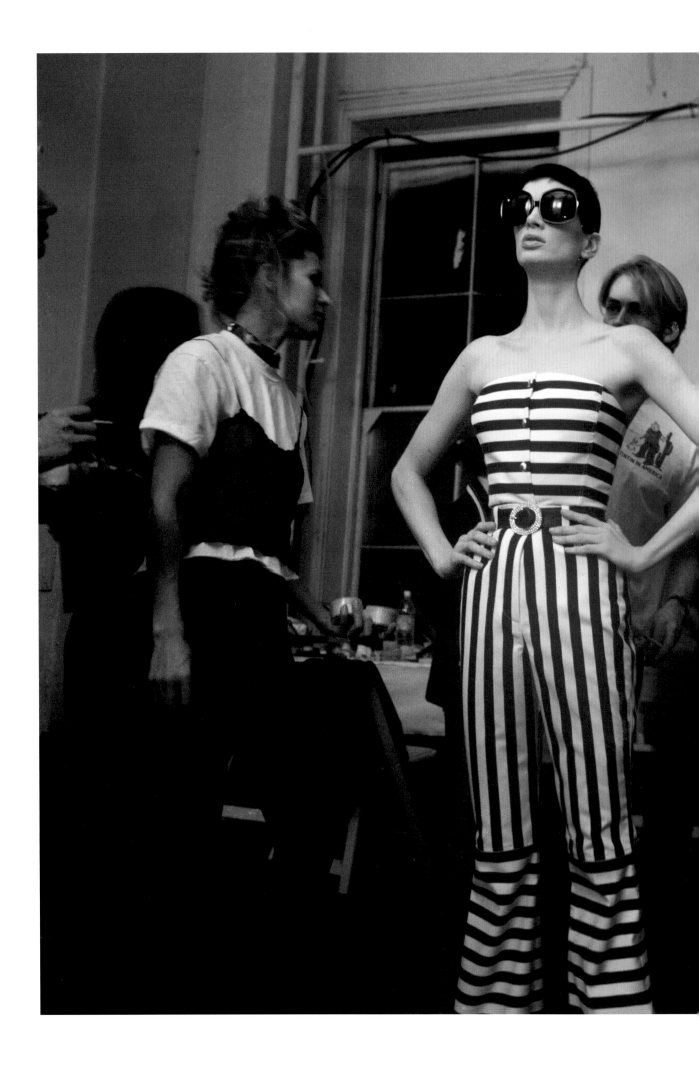

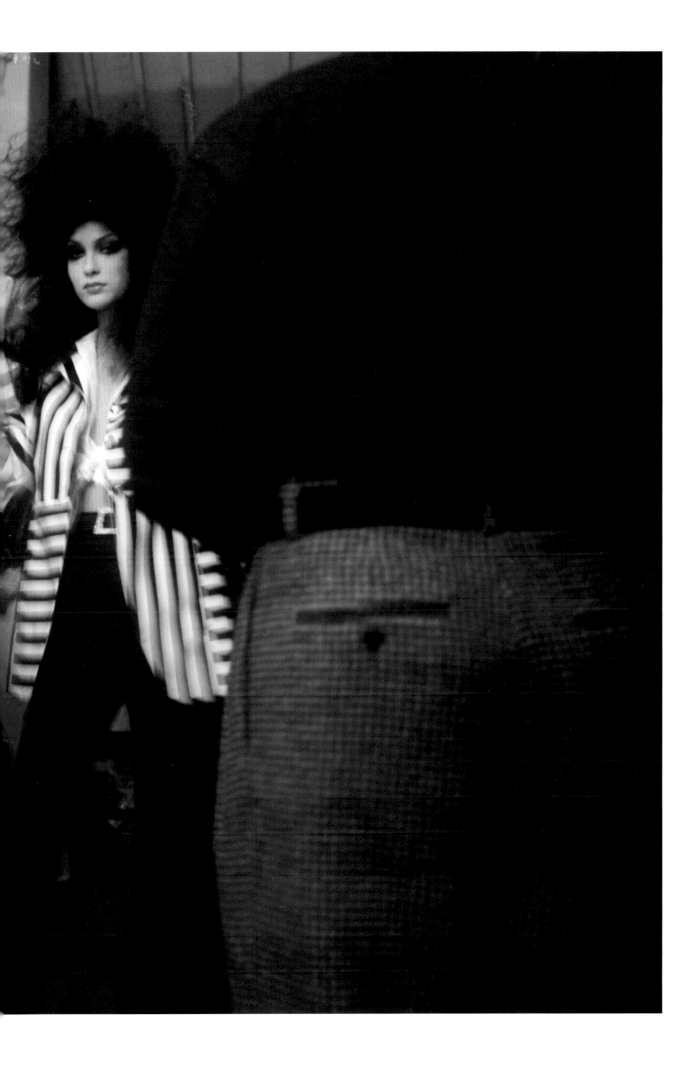

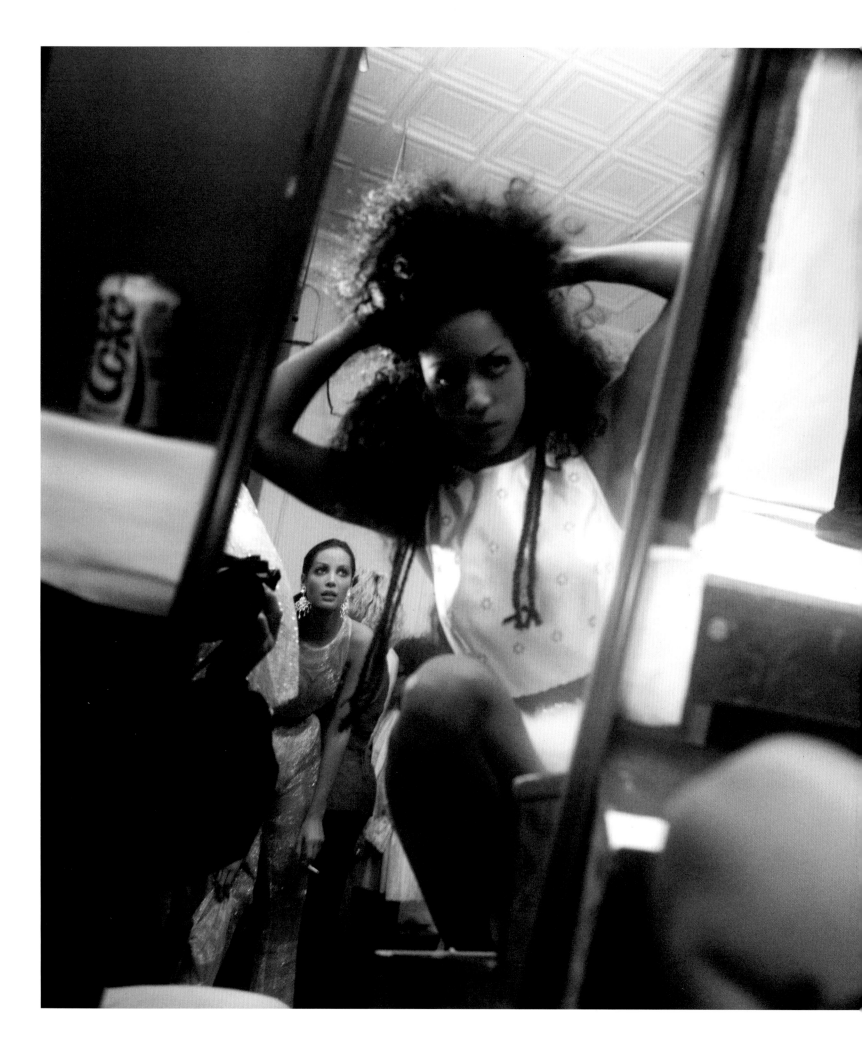

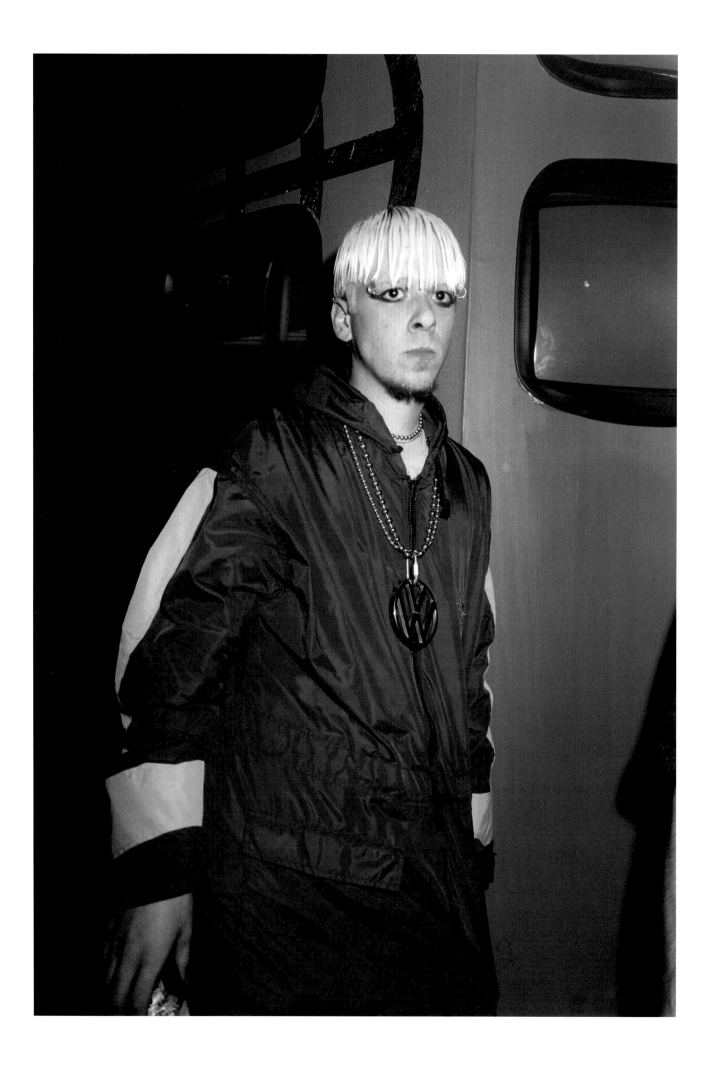

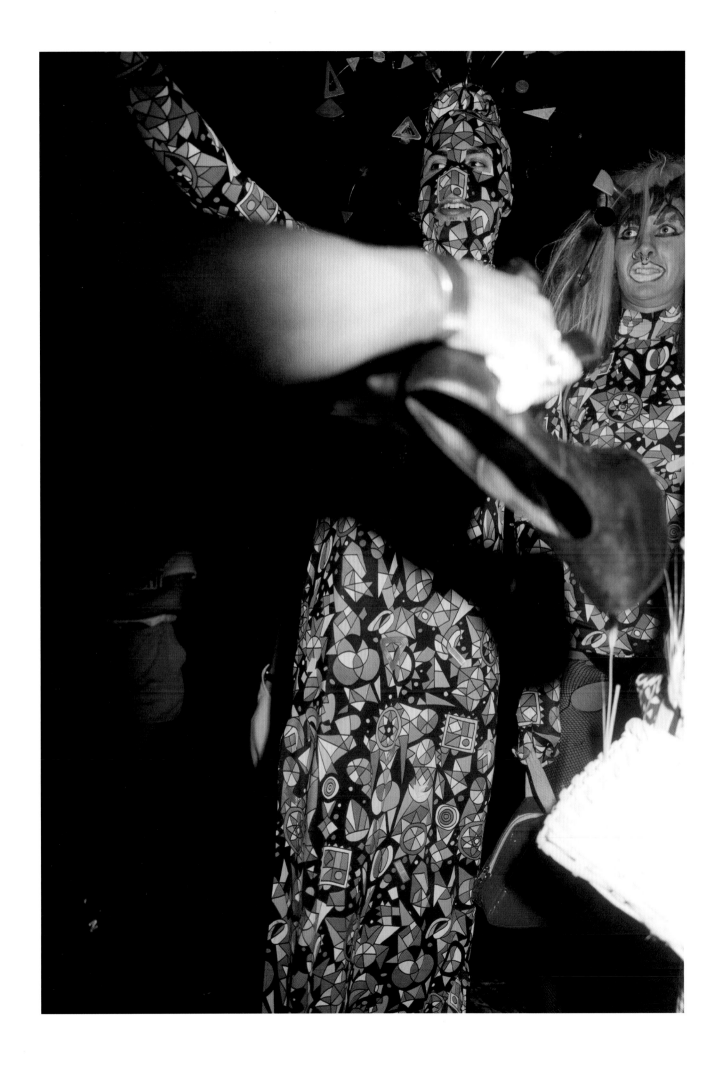

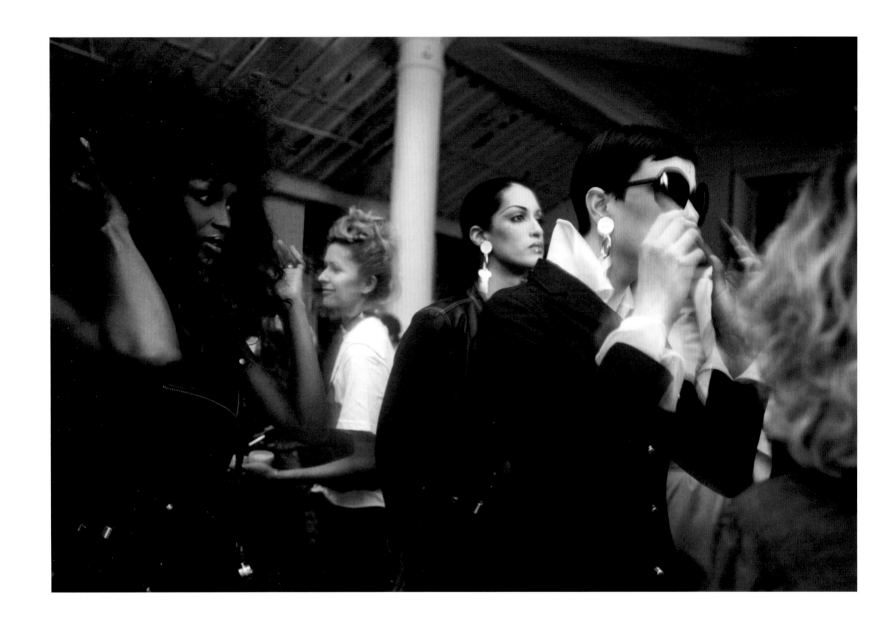

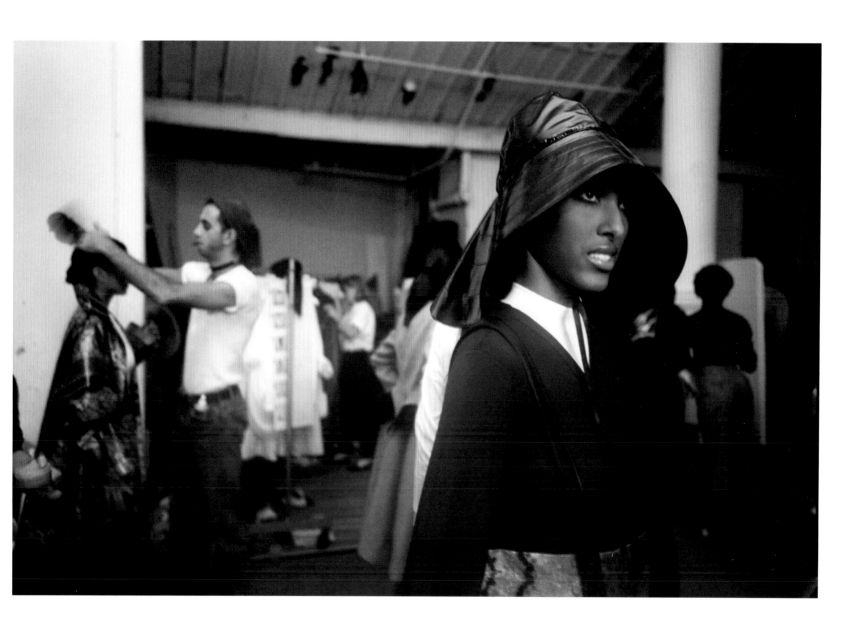

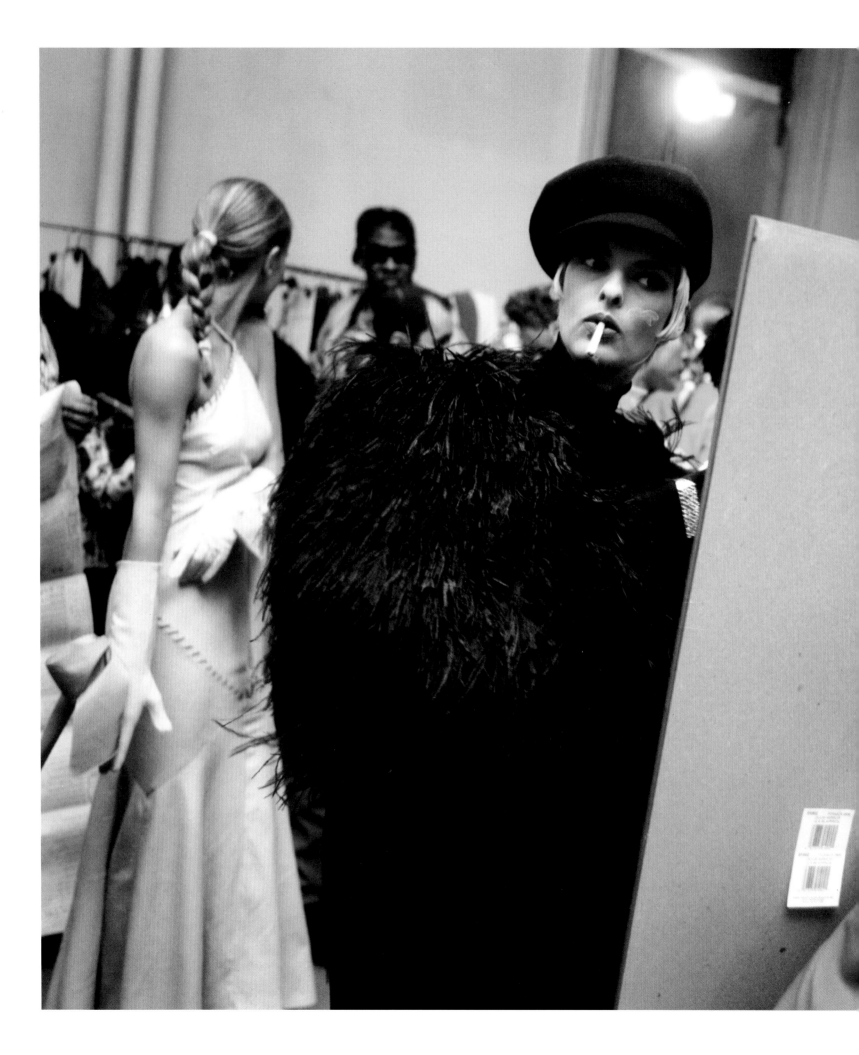

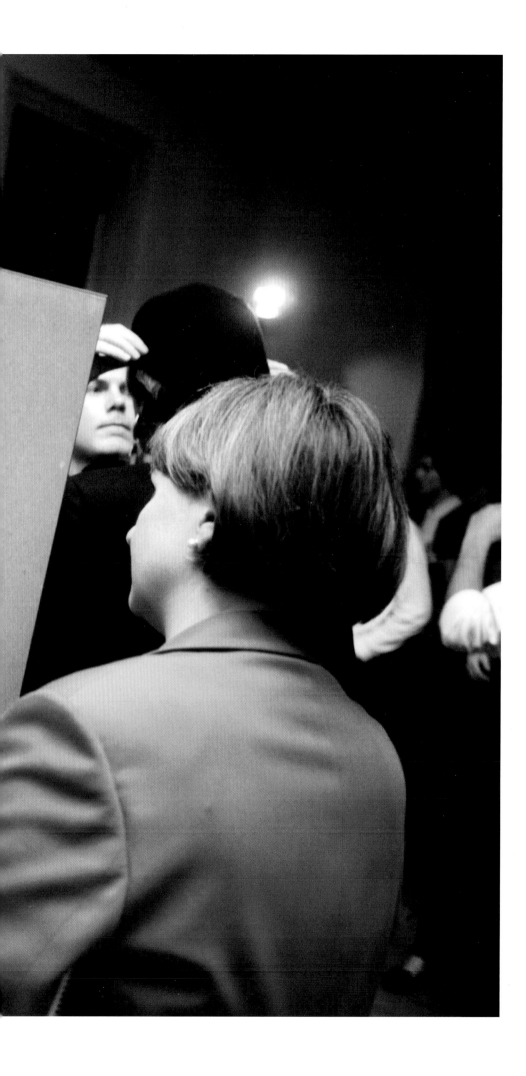

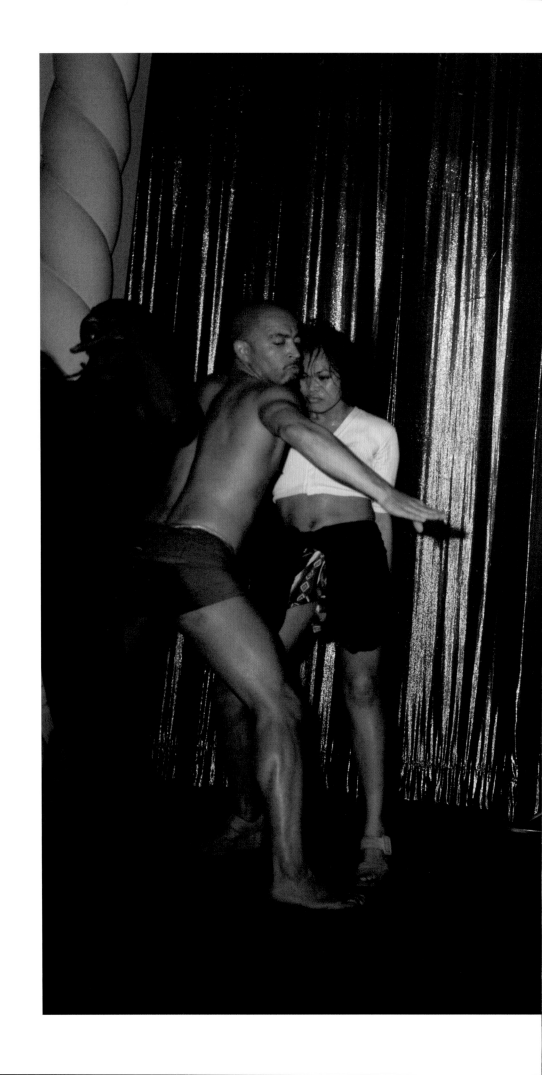

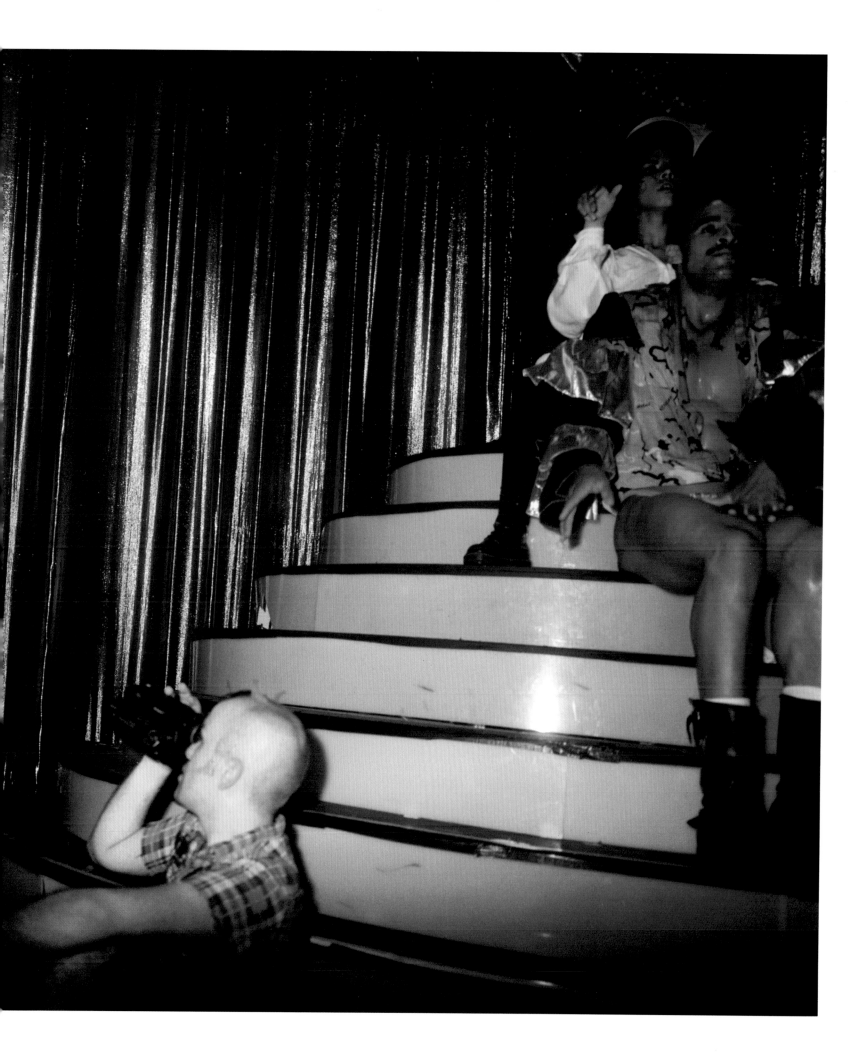

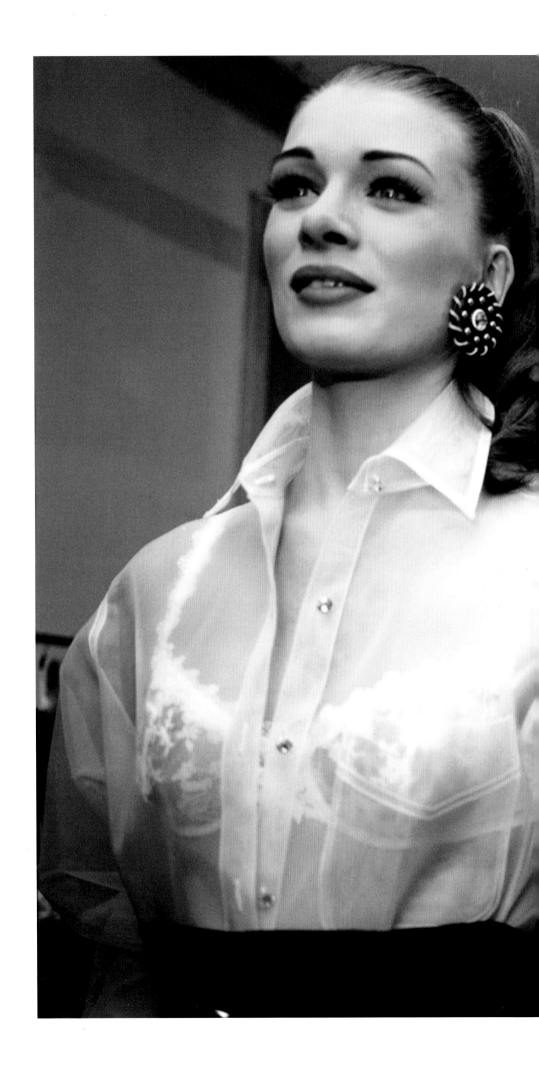

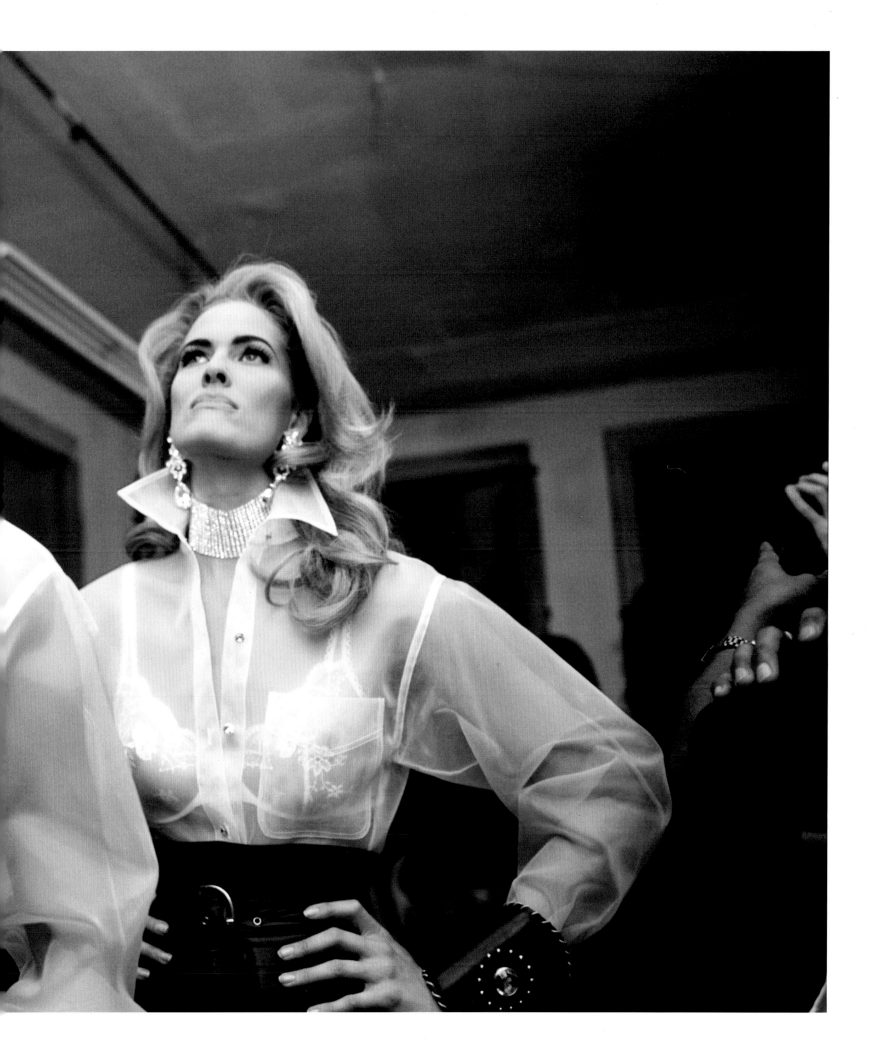

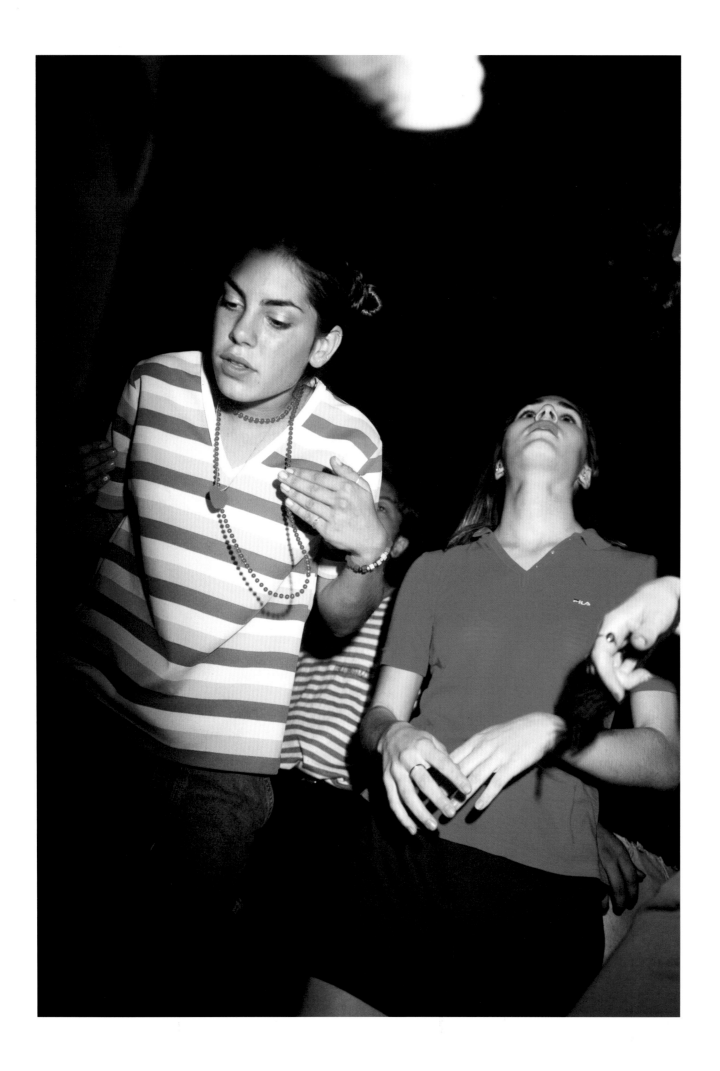

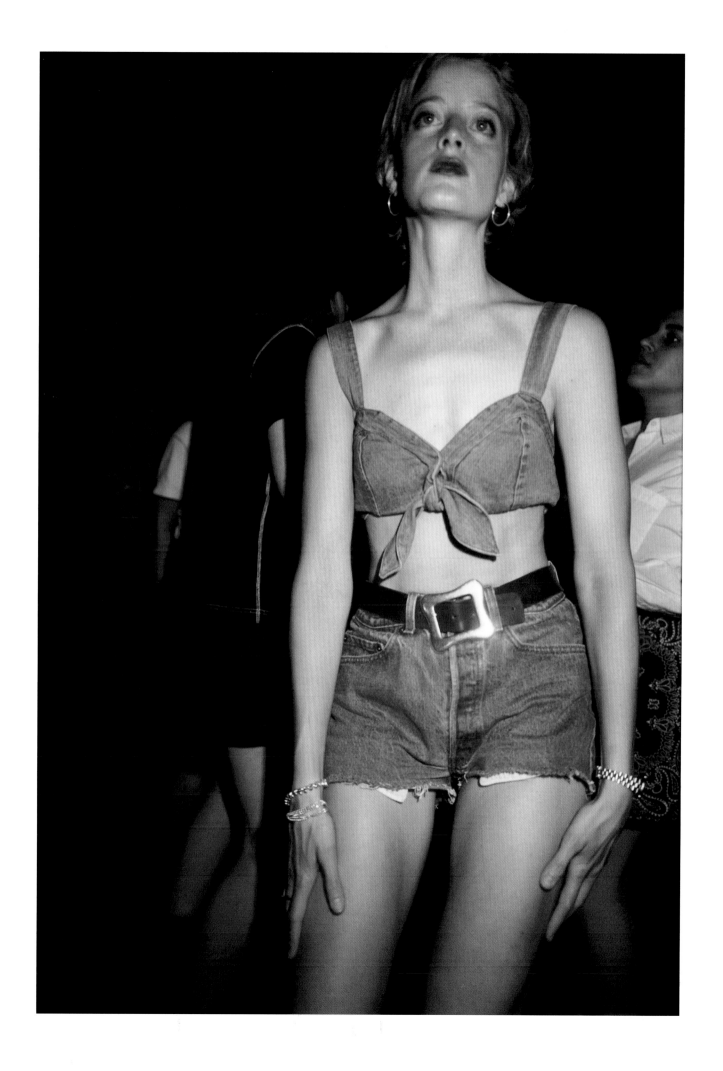

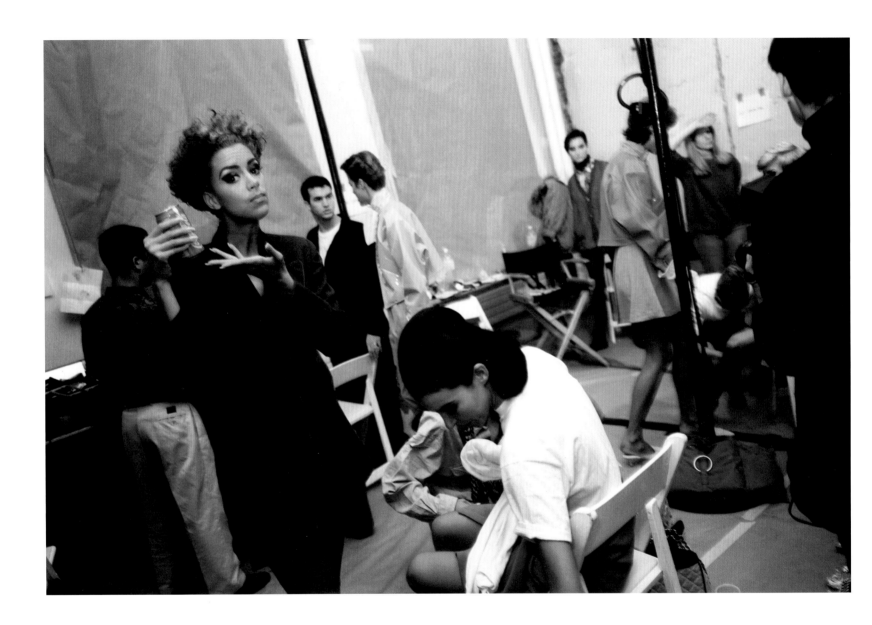

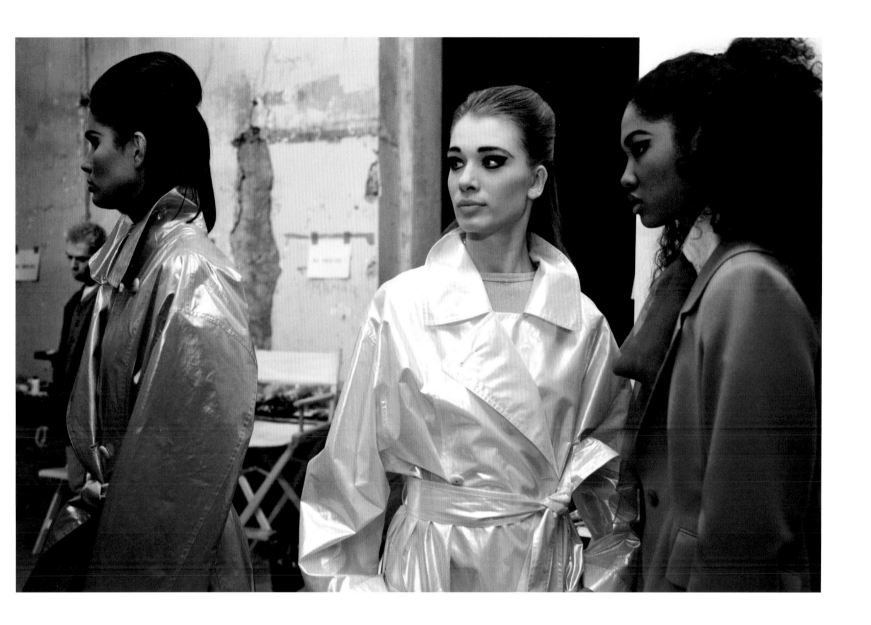

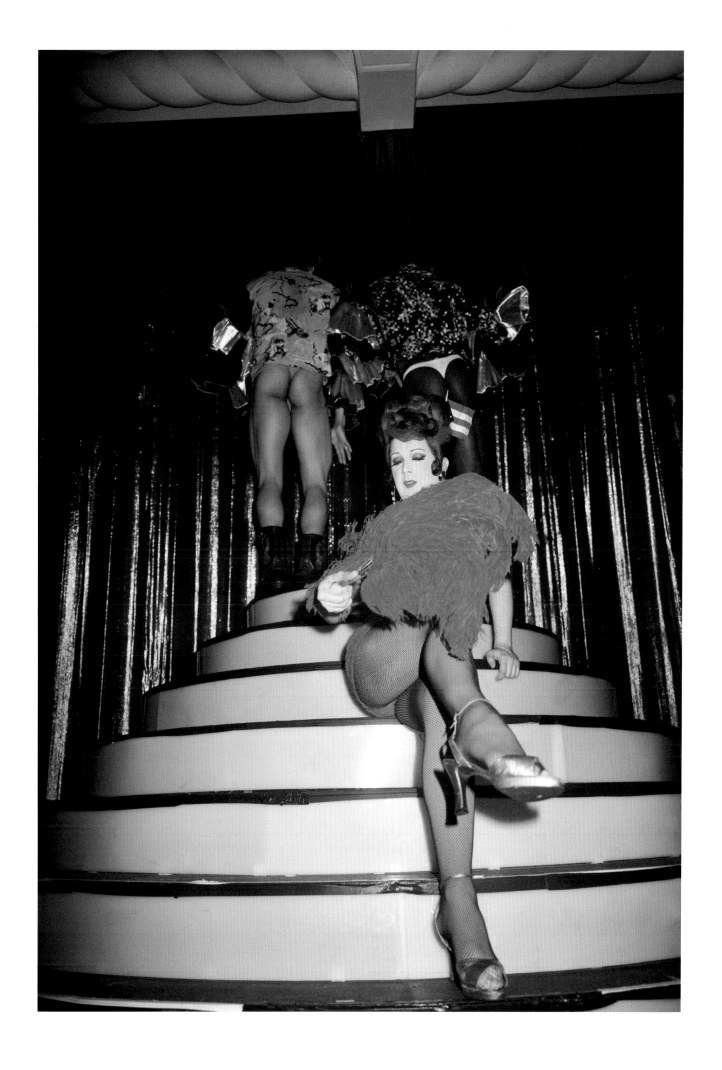

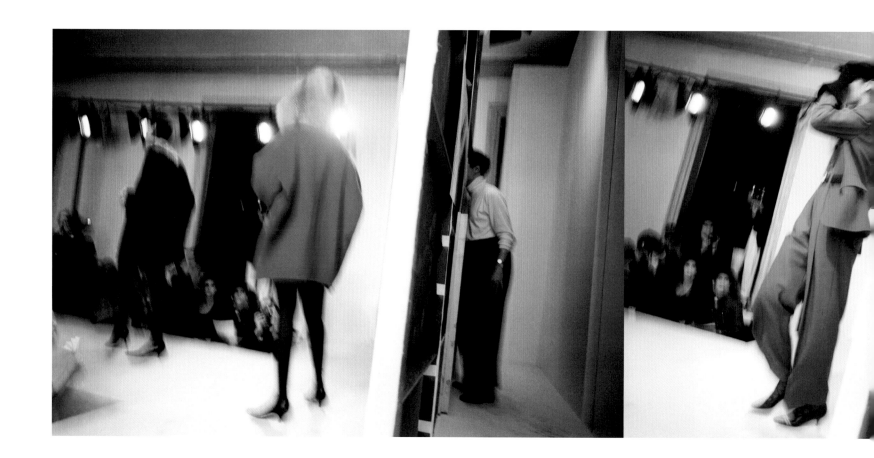

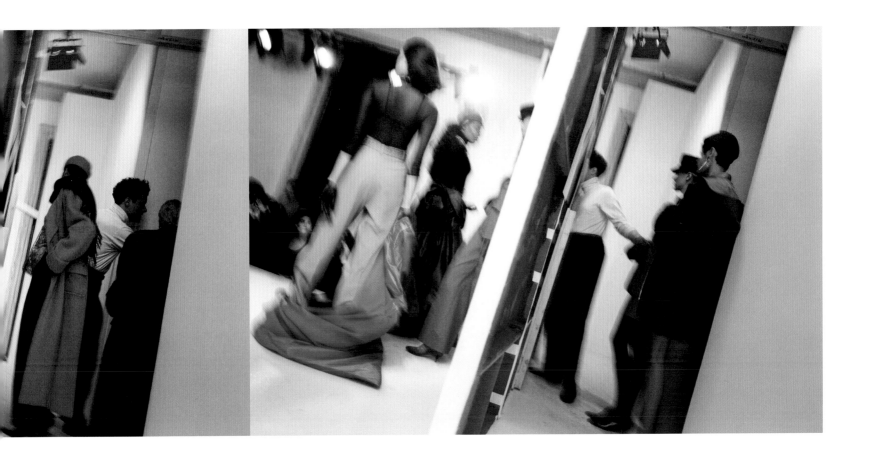

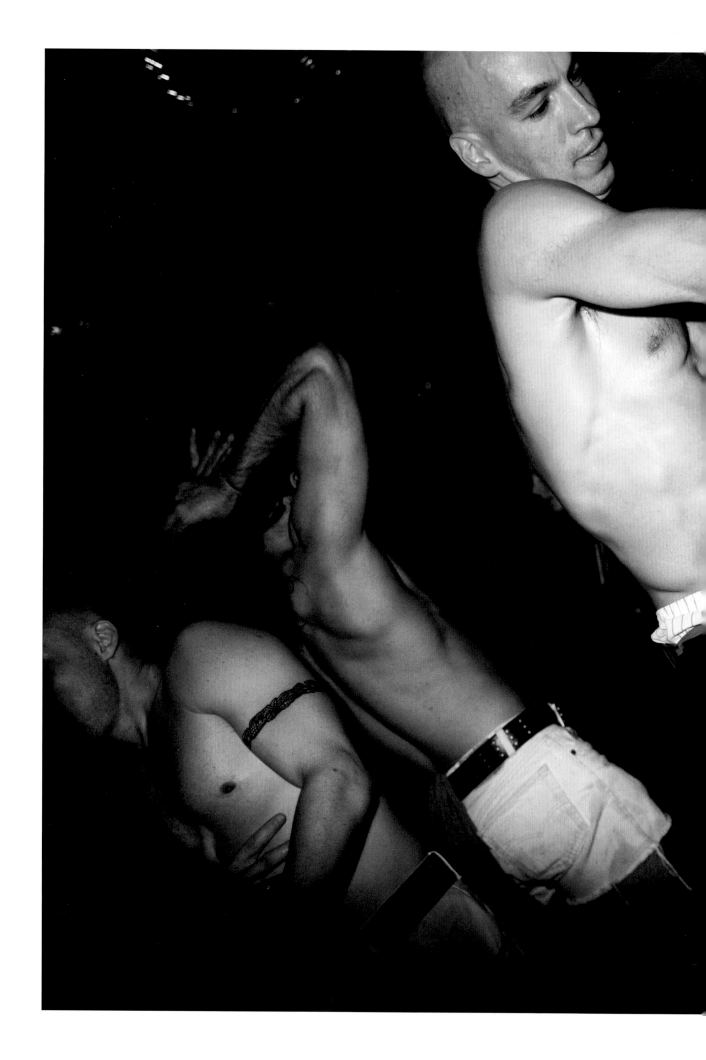

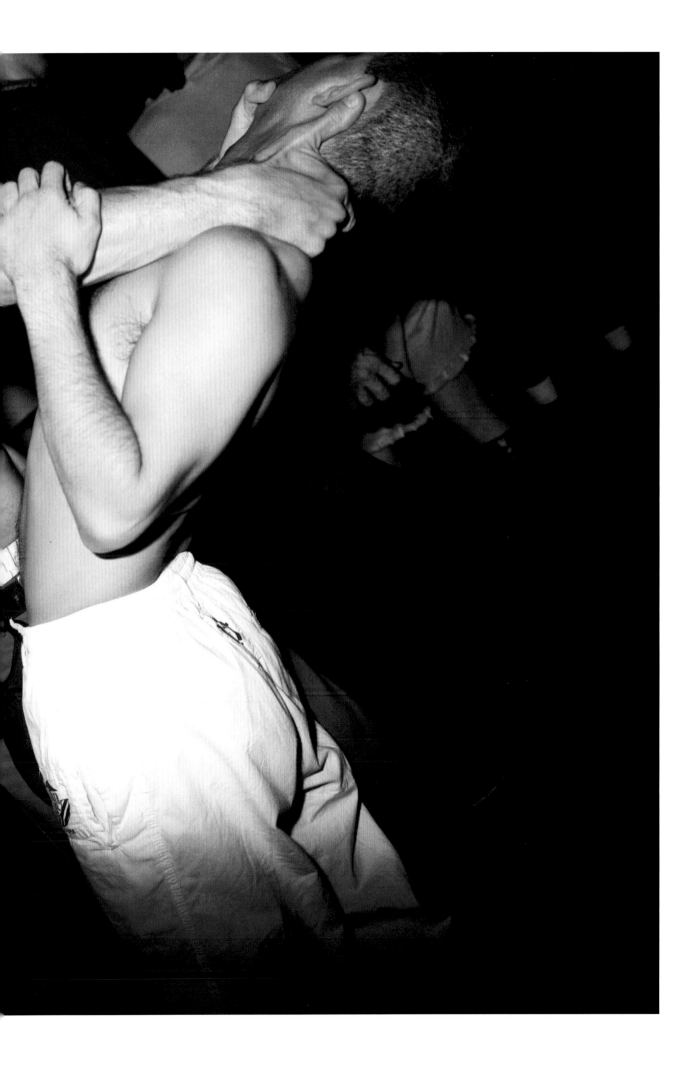

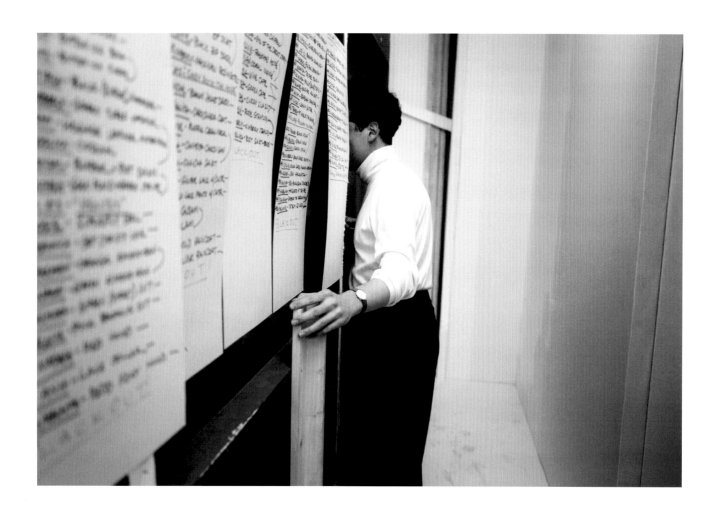

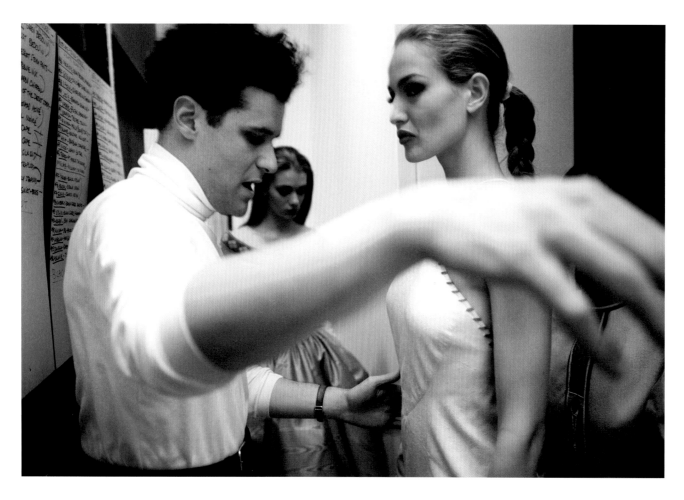

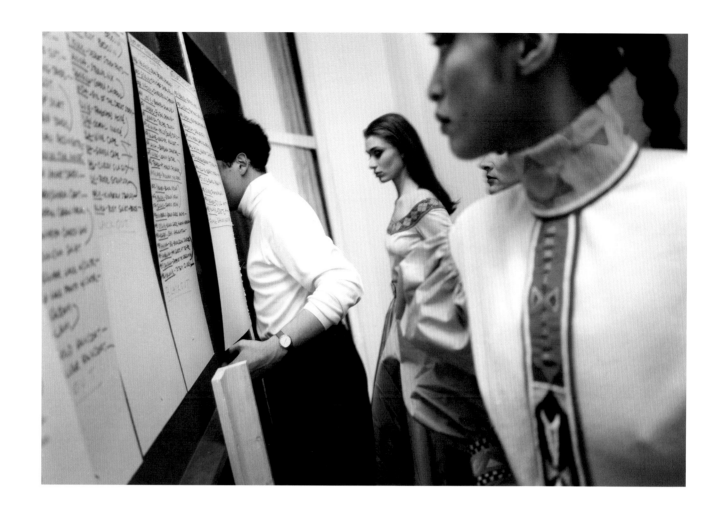

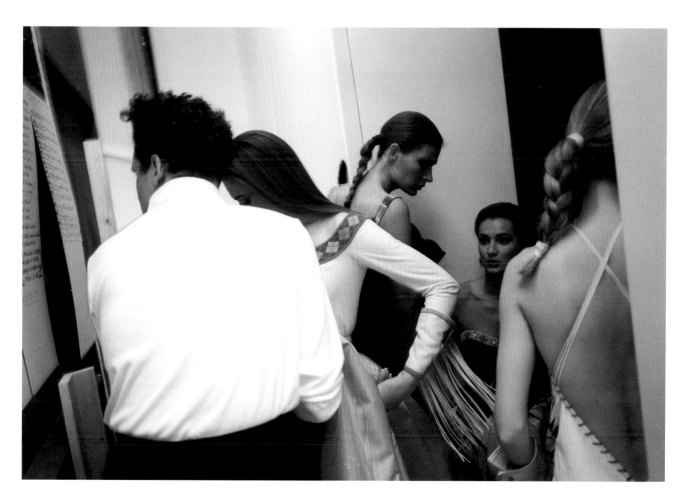

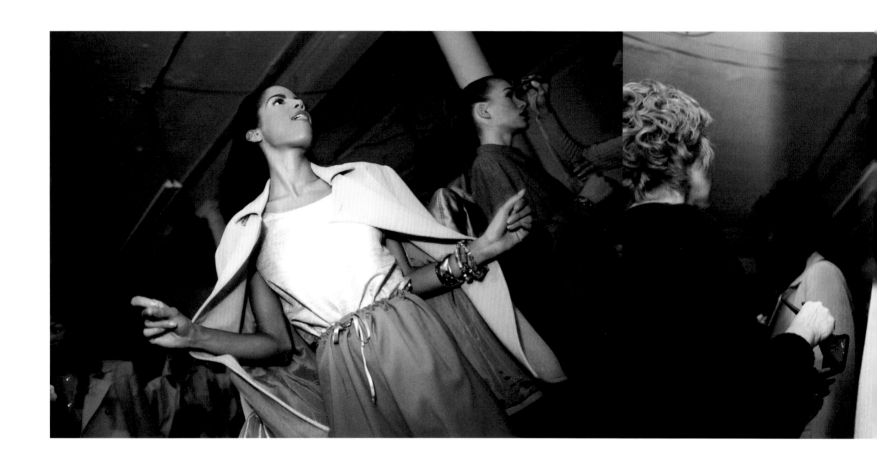

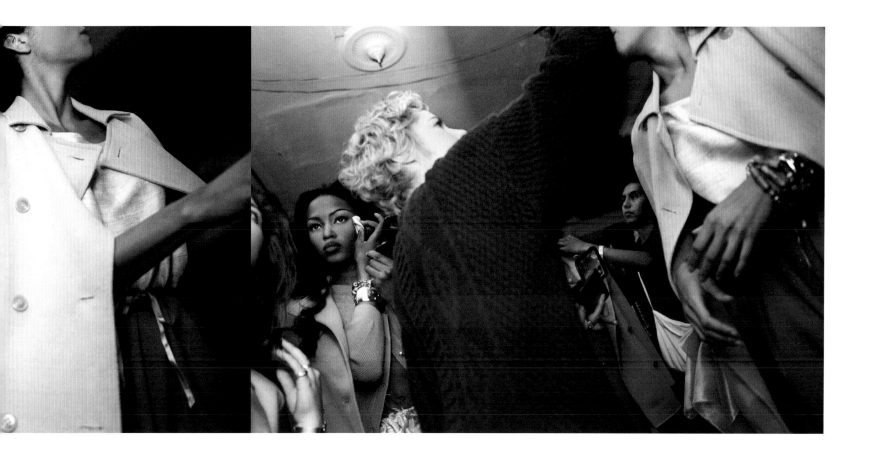

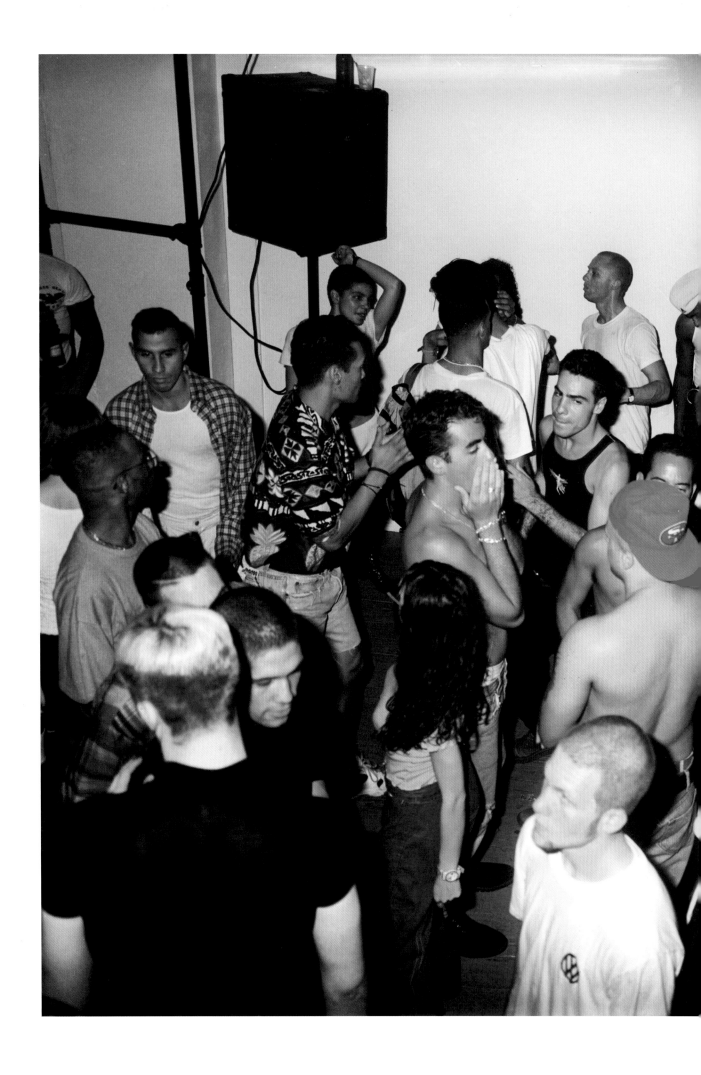

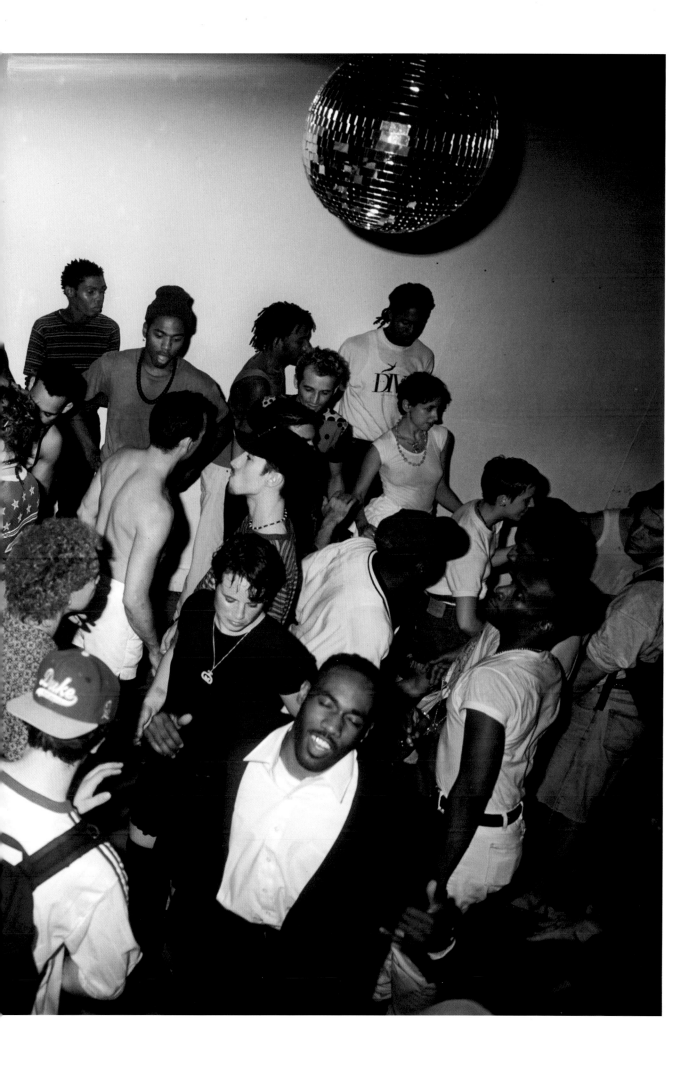

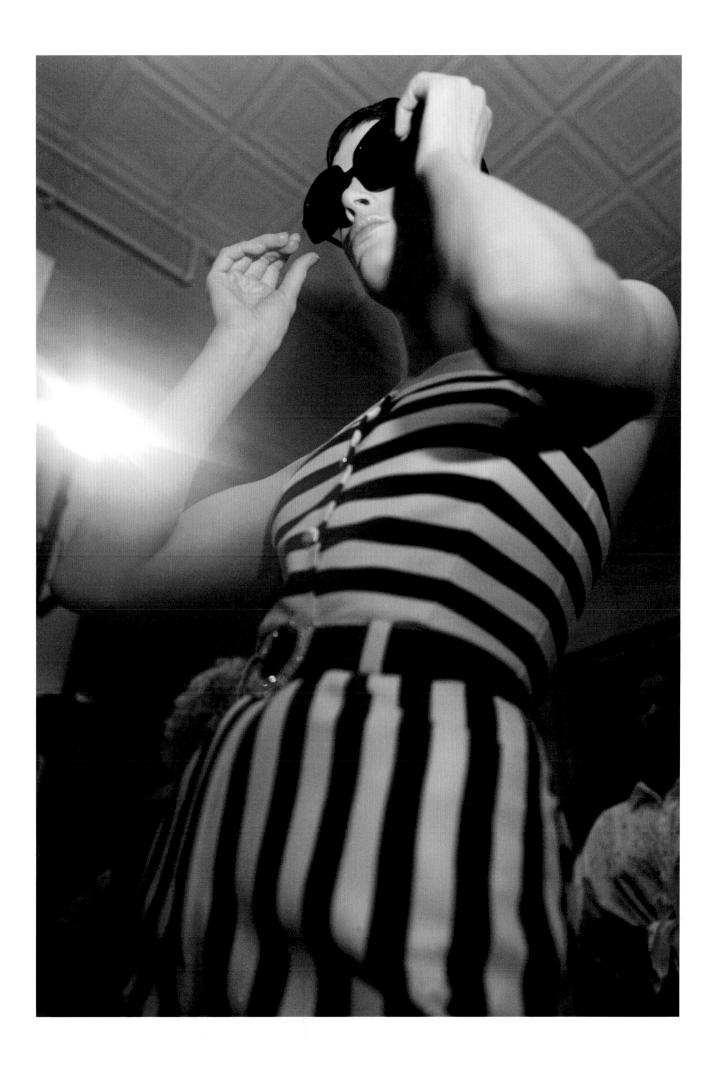

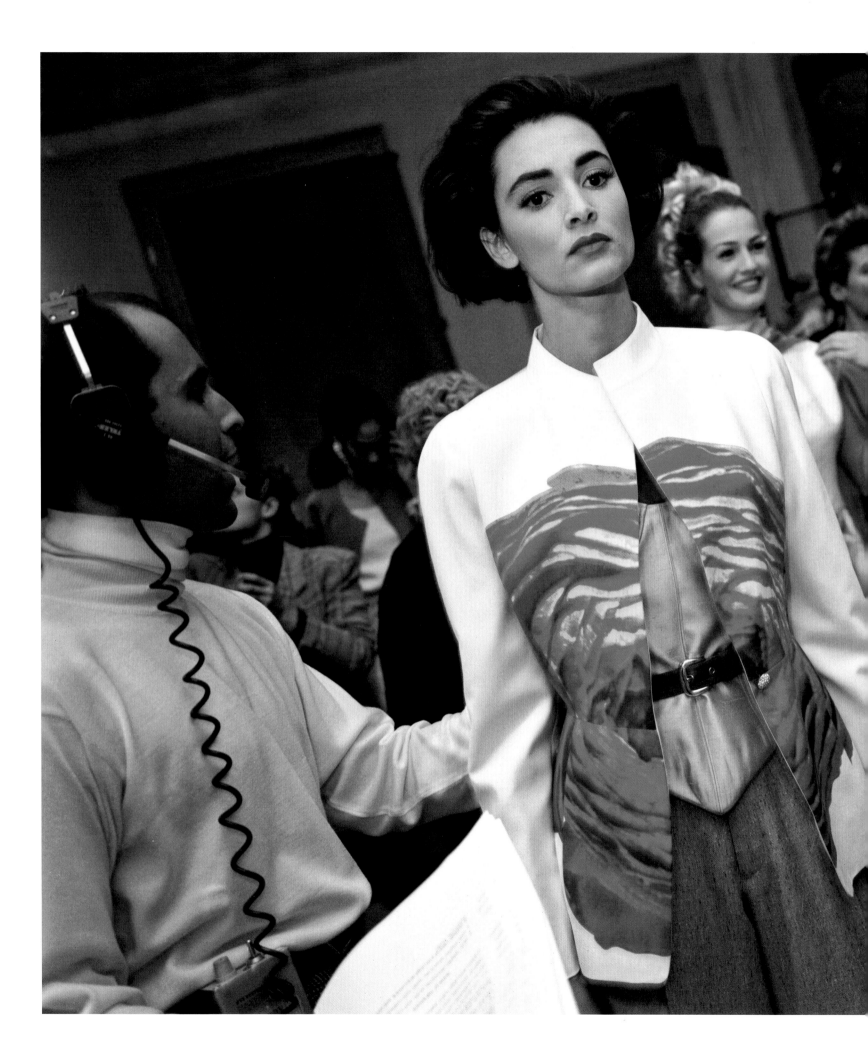

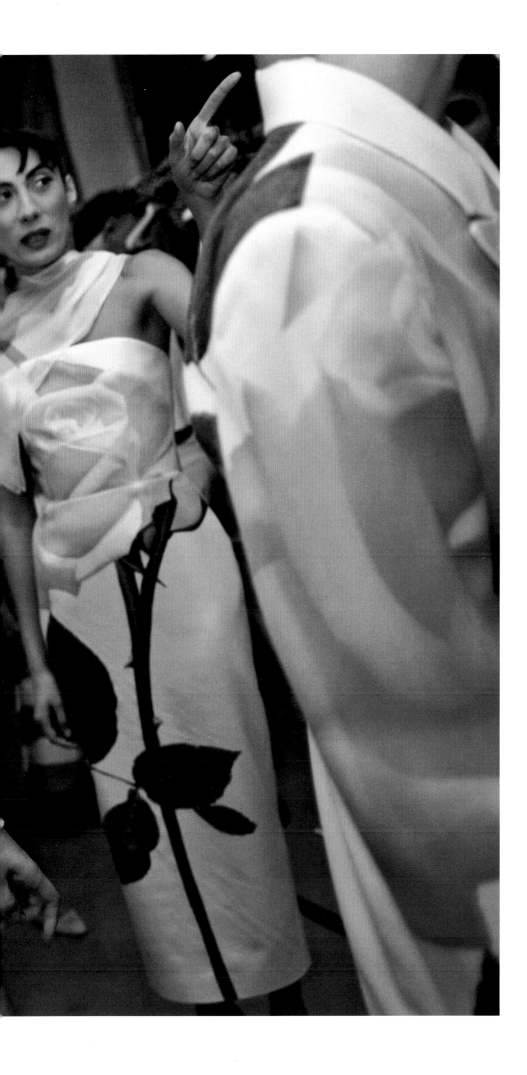

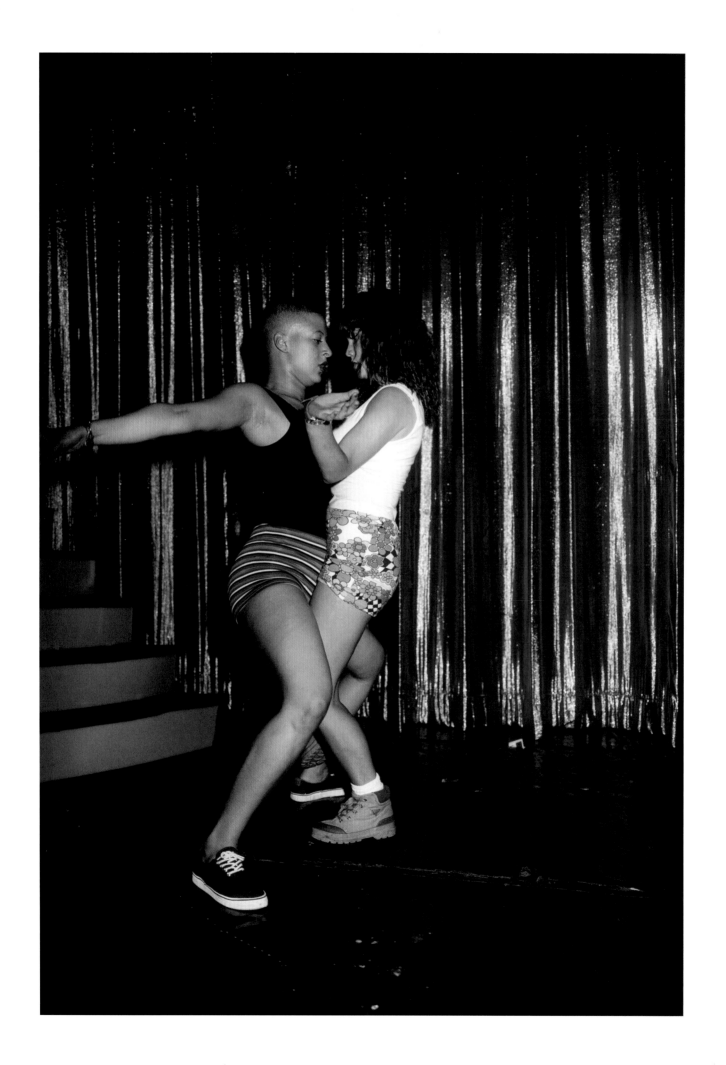

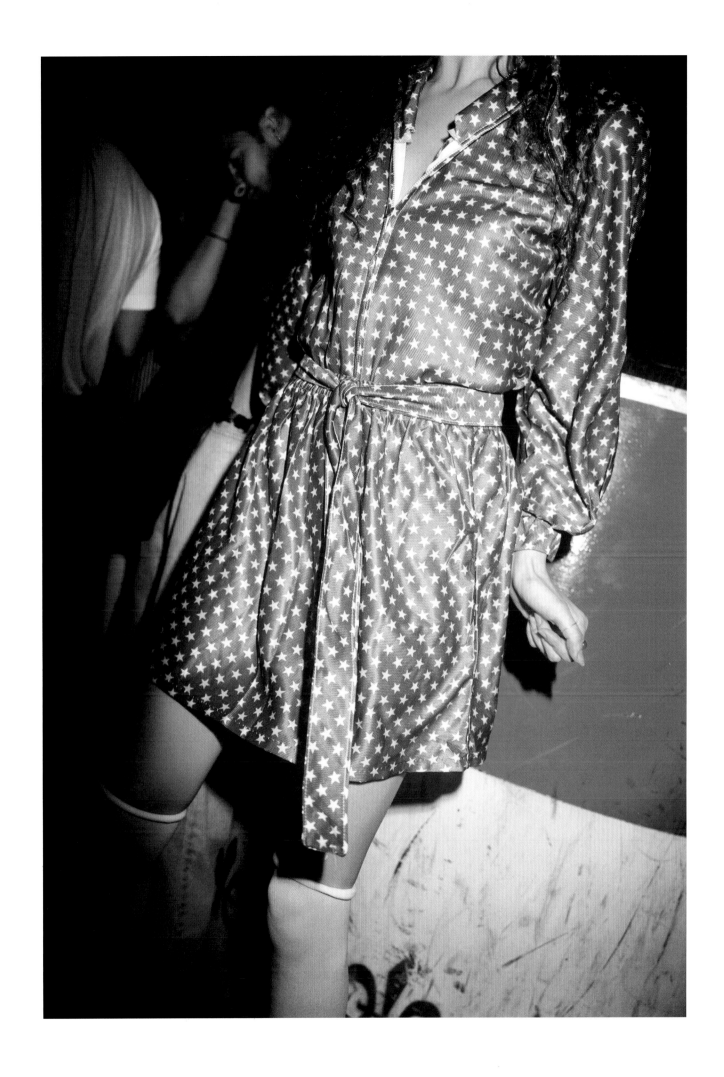

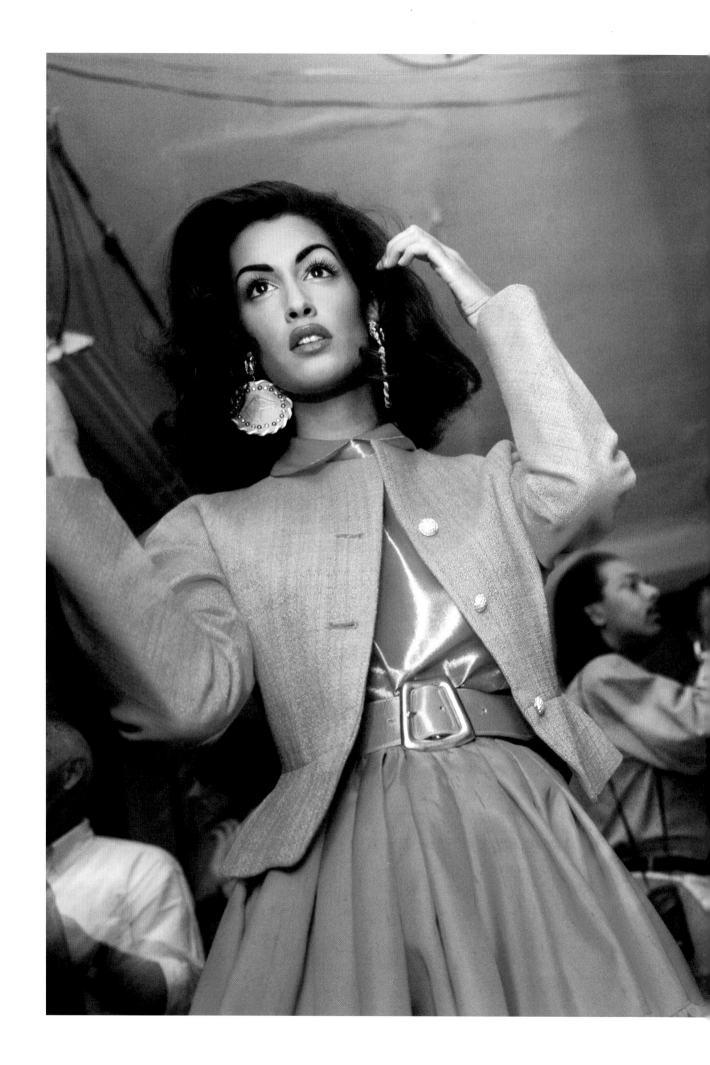

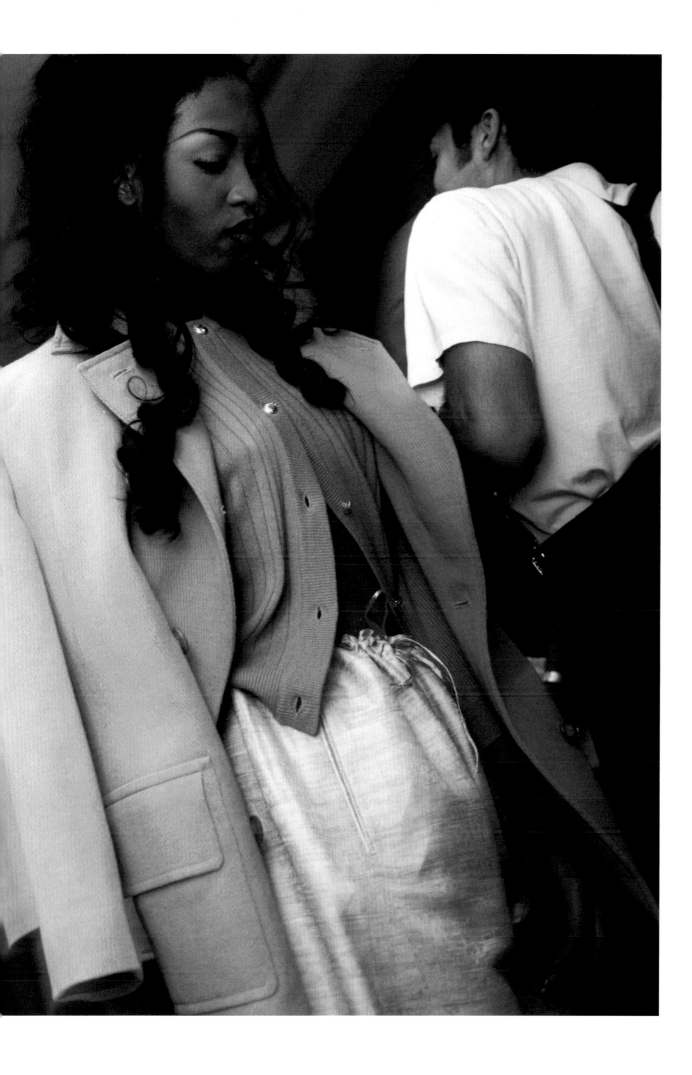

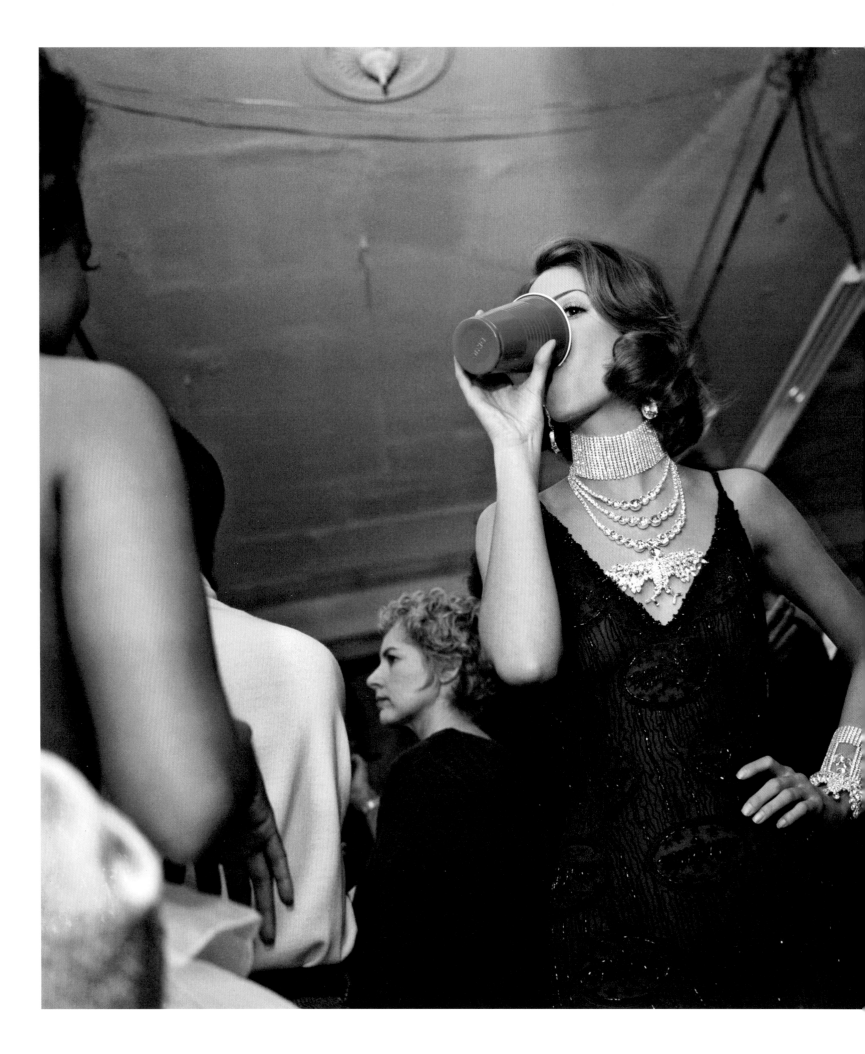

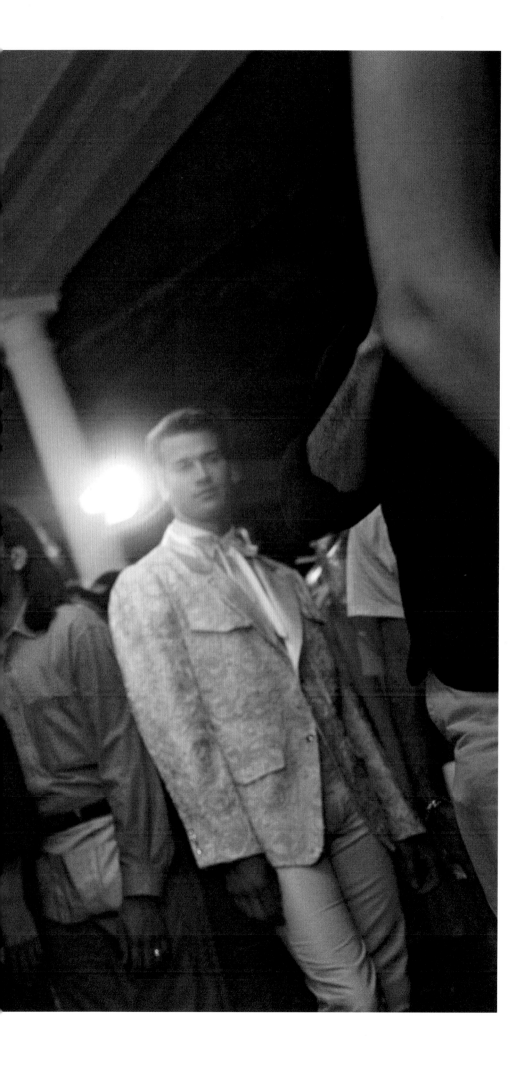

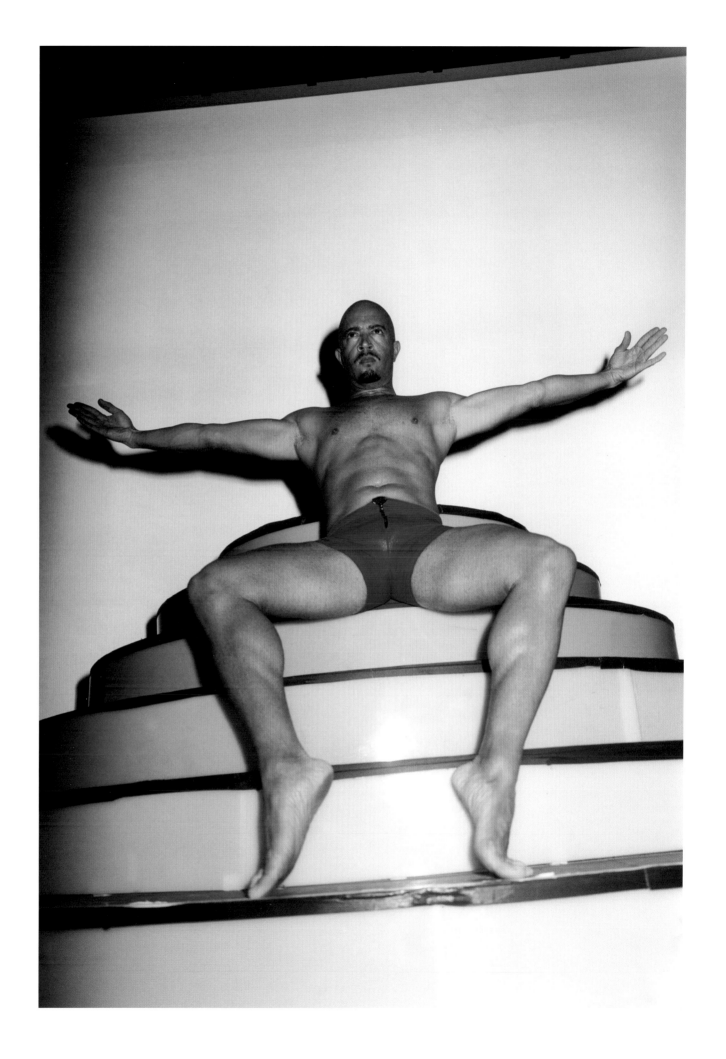

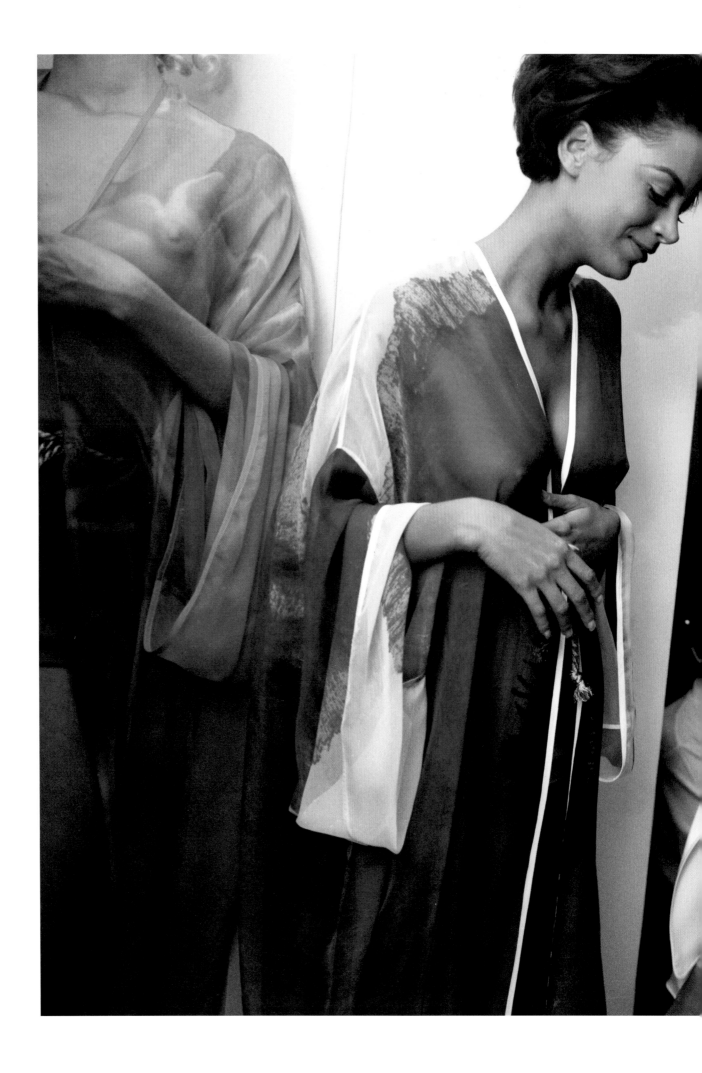

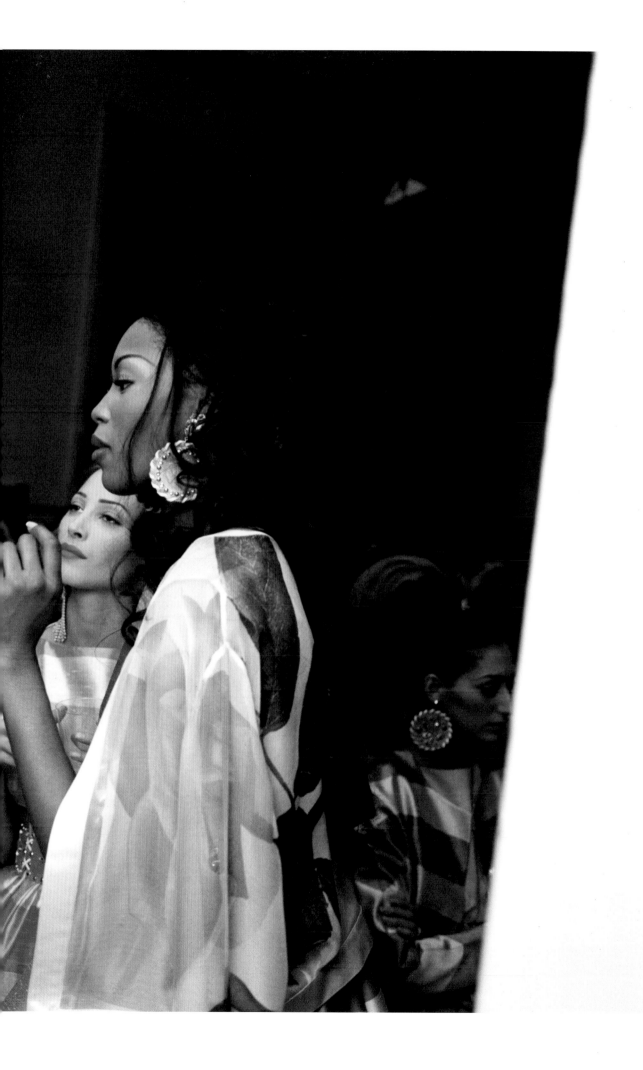

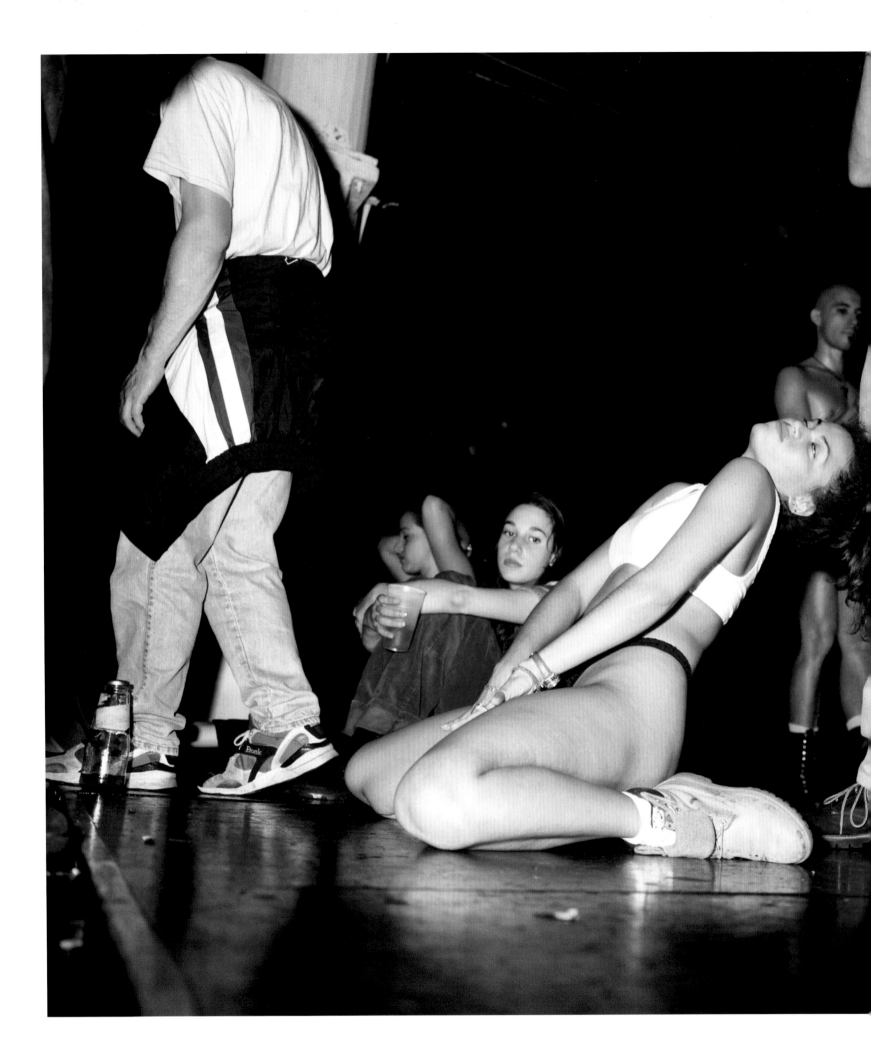

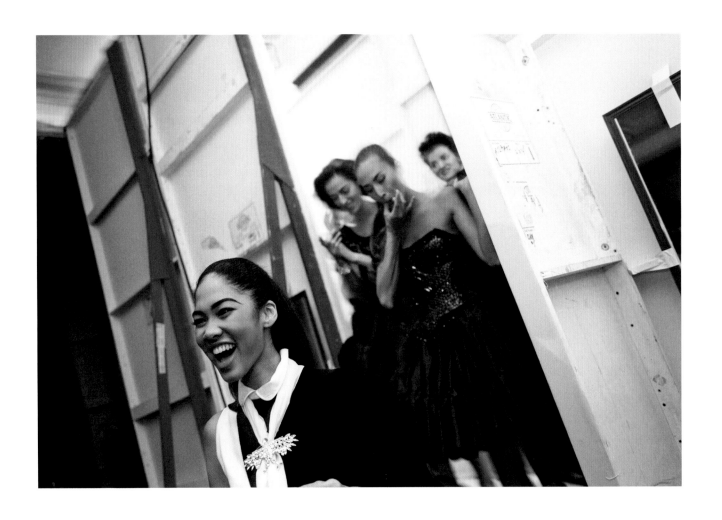

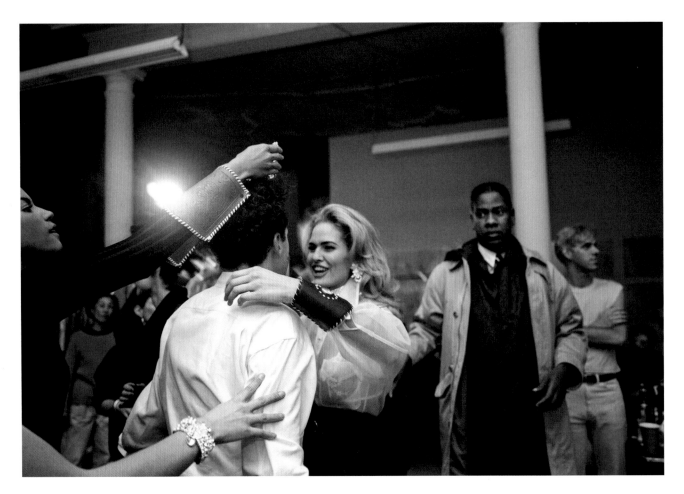

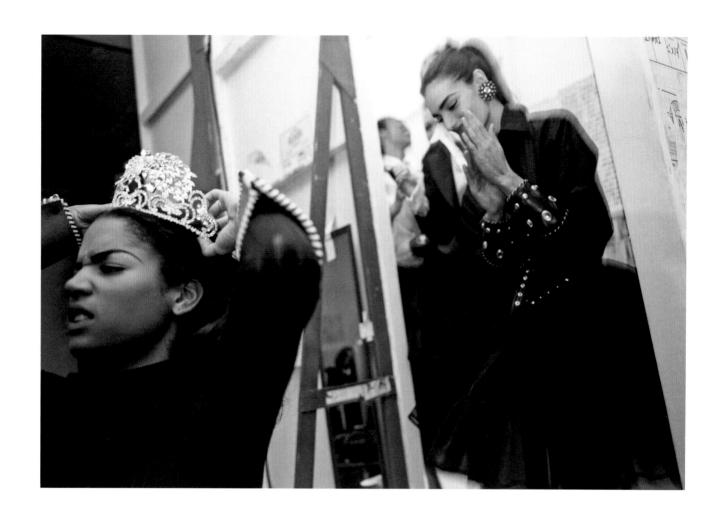

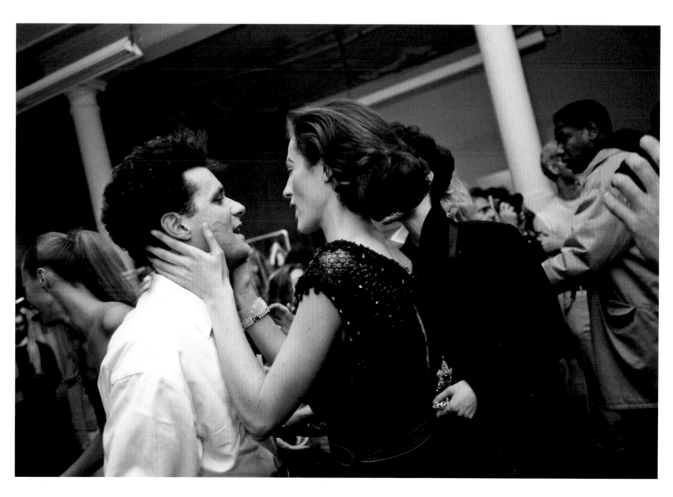

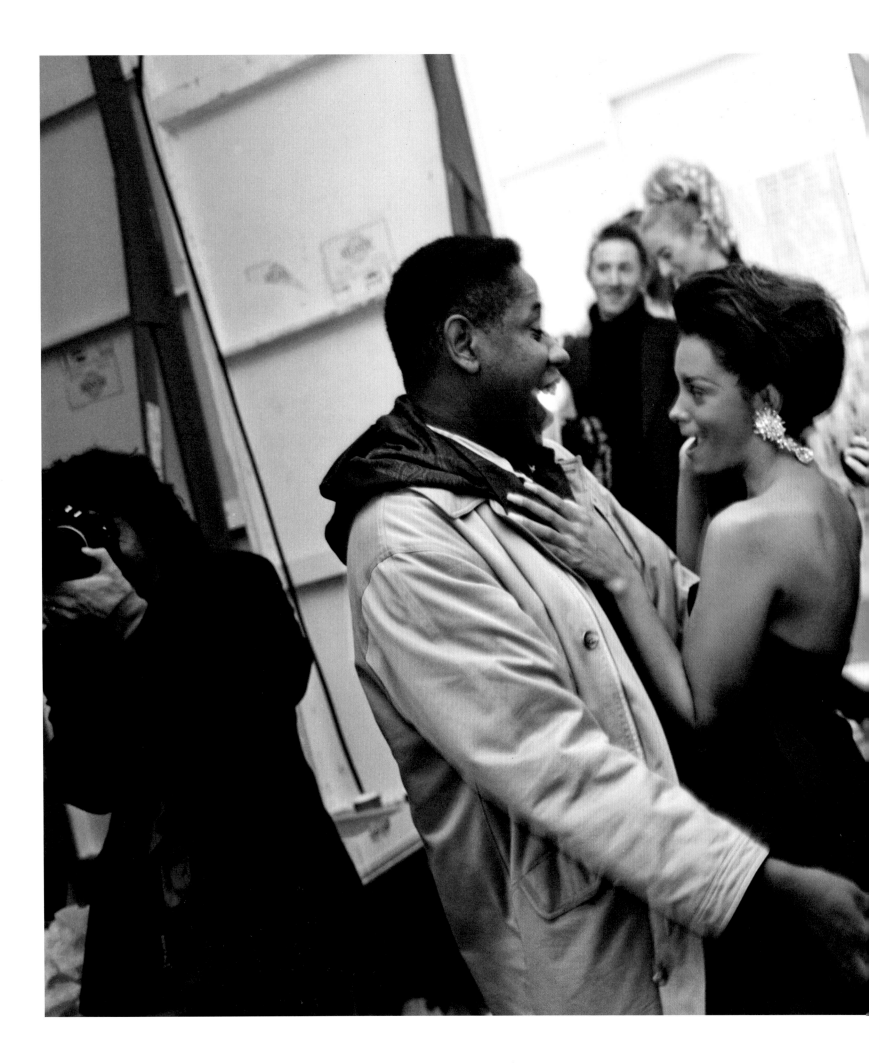

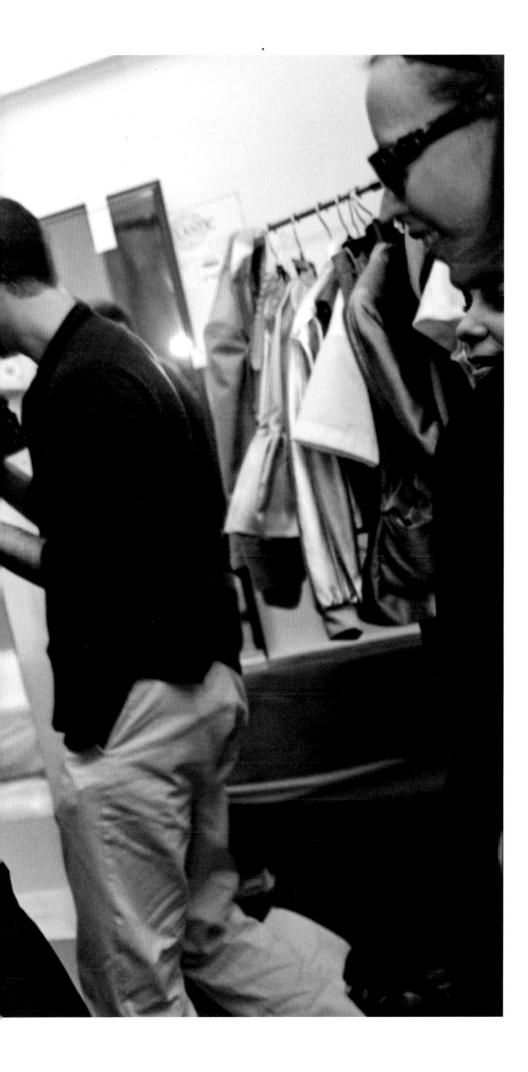

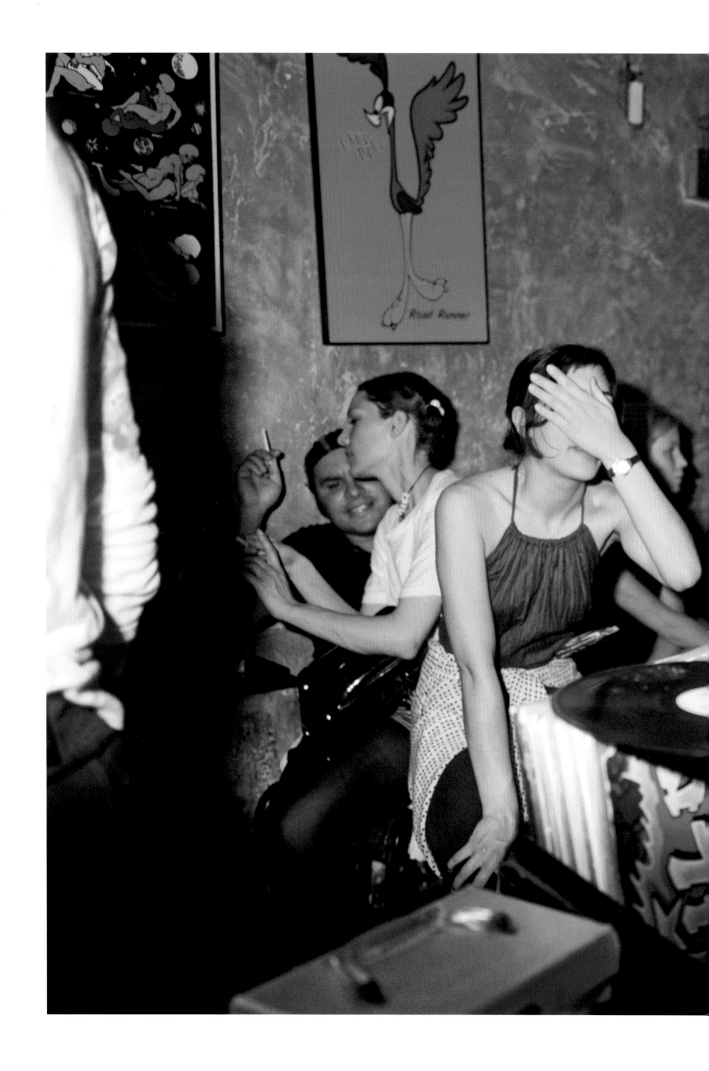

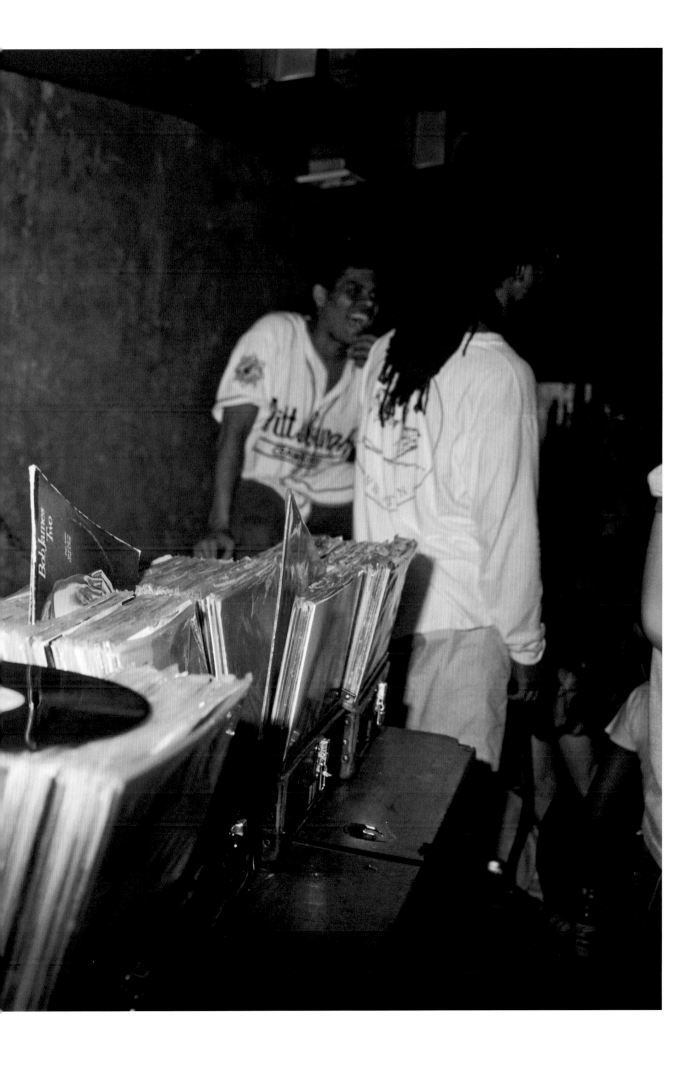

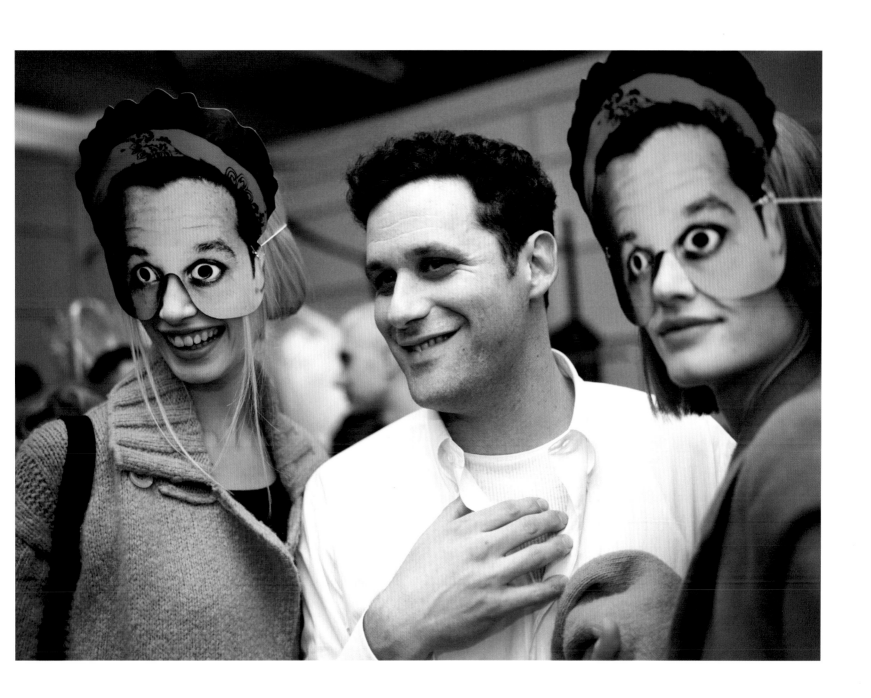

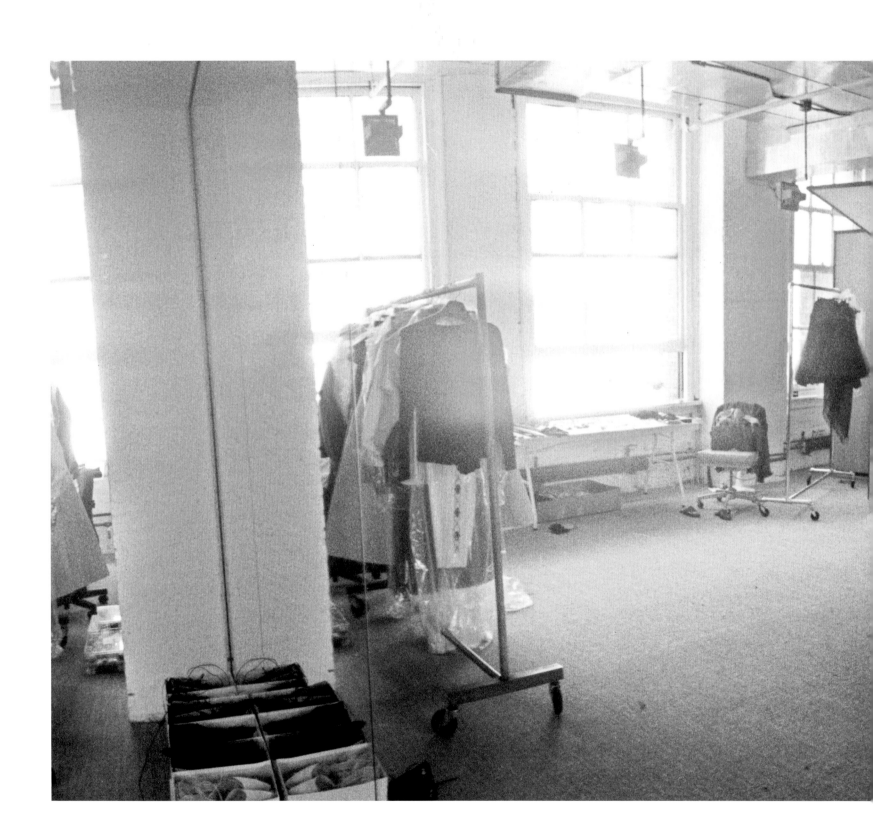

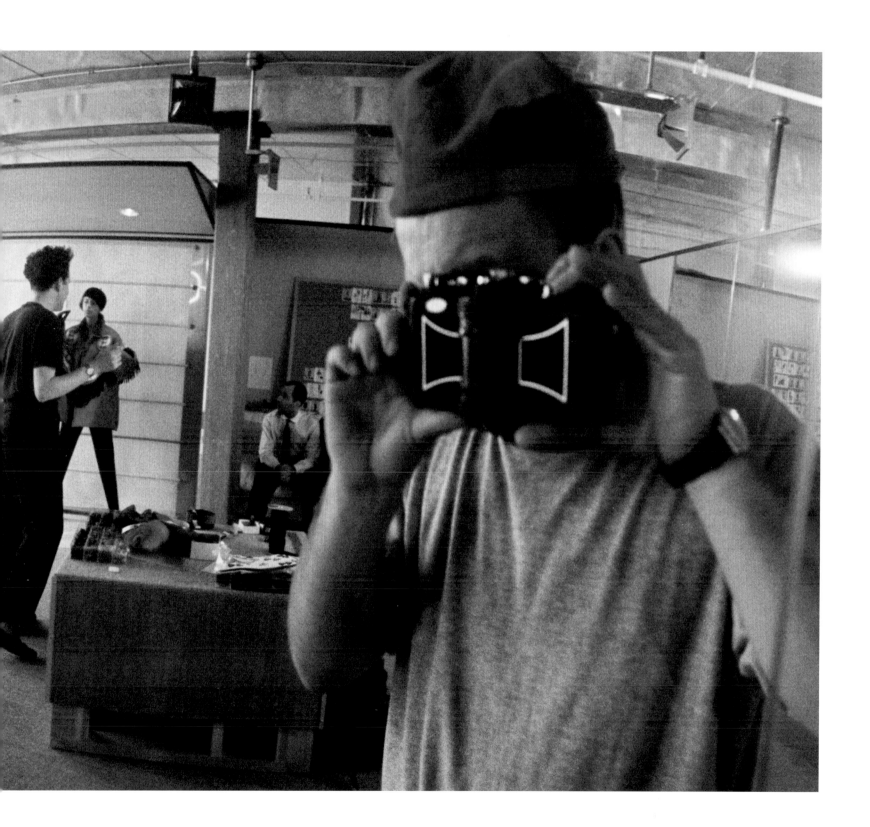

ACKNOWLEDGMENTS

Thanks to Molly Murray for the text edit, Alex Galan for helping the project come to fruition. Isaac Mizrahi for his invaluable help both now and at the time. I should also say thank you to everyone who made this work so much fun to produce all those years ago, the Mizrahi staff, Tibor Kalman and the staff at M&CO, the models many of whom came to my Living Room show at Aperture and had me sign books for them, that was certainly a moment! Also the the club kids, drag queens, freaks and weirdoes who loved the night life the city had to offer back then and welcomed me into their world this book is for you. Lastly it is dedicated to the memory of Richard Avedon who made it all happen in the first place. Thank you everyone.

© Damiani 2015
© Photographs, Nick Waplington
© Text, Nick Waplington
Design: Martin Bell, Fruitmachinedesign.com

DAMIANI

Bologna, Italy
info@damianieditore.com
www.damianieditore.com

Printed in December 2015 by Grafiche Damiani - Faenza Group, Italy

IISBN 978-88-6208-451-2

Published in Italy 2015 By Damiani